_Y AMERICAN DAGUERREOTYPE

LEMELSON CENTER STUDIES IN INVENTION AND INNOVATION
ARTHUR P. MOLELLA AND JOYCE BEDI, GENERAL EDITORS

ARTHUR P. MOLELLA AND JOYCE BEDI, EDITORS, *INVENTING FOR THE ENVI*

PAUL E. CERUZZI, *INTERNET ALLEY: HIGH TECHNOLOGY IN TYSONS CORNER*
2005

ROBERT H. KARGON AND ARTHUR P. MOLELLA, *INVENTED EDENS: TECHNO-CI*
THE TWENTIETH CENTURY

KURT BEYER, *GRACE HOPPER AND THE INVENTION OF THE INFORMATION AGE*

MICHAEL BRIAN SCHIFFER, *POWER STRUGGLES: SCIENTIFIC AUTHORITY AND TH*
CREATION OF PRACTICAL ELECTRICITY BEFORE EDISON

REGINA LEE BLASZCZYK, *THE COLOR REVOLUTION.*

SARAH KATE GILLESPIE, *THE EARLY AMERICAN DAGUERREOTYPE: CROSS-CURRENTS*
IN ART AND TECHNOLOGY

THE EARLY AMERICAN DAGUERREOTYPE

CROSS-CURRENTS IN ART AND TECHNOLOGY

SARAH KATE GILLESPIE

THE MIT PRESS
CAMBRIDGE, MASSACHUSETTS
LONDON, ENGLAND

IN ASSOCIATION WITH
THE LEMELSON CENTER
SMITHSONIAN INSTITUTION
WASHINGTON, DC

© 2016 Smithsonian Institution

All rights reserved. No part of this book may be reproduced in any form by any electronic or mechanical means (including photocopying, recording, or information storage and retrieval) without permission in writing from the publisher.

Set in Stone Sans and Copperplate by the MIT Press. Printed and bound in the United States of America.

Cataloging-in-Publication information is available from the Library of Congress.

ISBN: 978-0-262-03410-4

10 9 8 7 6 5 4 3 2 1

CONTENTS

FOREWORD VII

ACKNOWLEDGMENTS IX

INTRODUCTION 1

1 "REMBRANDT PERFECTED": THE ART, SCIENCE, AND TECHNOLOGY OF SAMUEL F. B. MORSE 15

2 "ALL NATURE SHALL BE HENCEFORTH ITS OWN PAINTER": THE INTERSECTION OF ART AND DAGUERREOTYPING 57

3 "WE WILL NOT BORE OUR READERS WITH ANY MORE CHEMISTRY": SCIENCE AND THE DAGUERREOTYPE 109

4 "THE AMERICAN PROCESS": THE DAGUERREOTYPE AND TECHNOLOGY 135

CONCLUSION 167

NOTES 171

BIBLIOGRAPHY 203

INDEX 211

FOREWORD

As the manuscript of this book is being prepared, the idea of "disruptive" innovation is very much in the news. The term, coined by Professor Clayton Christensen of Harvard University, is familiarly applied to very recent technologies and methods that have displaced established ones, yet the history of disruptive invention and innovation is long and multifaceted. The invention and dissemination of photography, the subject of this volume, illustrates this point. In just a few years in the middle of the nineteenth century, photography reframed how we looked at the world and ourselves.

Invention and innovation have long been recognized as transformational forces in American history, not only in technological realms but also as models in politics, society, and culture, and they are arguably more important than was previously thought in other societies as well. What there is no question about is that they have become the universal watchwords of the twenty-first century, so much so that nations are banking their futures on them.

Since 1995, the Smithsonian Institution's Lemelson Center has been investigating the history of invention and innovation from broad interdisciplinary perspectives. So, too, does this series. The Lemelson Center Studies in Invention and Innovation explores the work of inventors and the technologies they create in order to advance scholarship in history, engineering, science, and related fields with a direct connection to technological invention, such as urban planning, architecture, and the arts. It is hoped that this series, by opening channels of communication between the various disciplines and sectors of society concerned with technological innovation, will enhance our understanding of humanity's inventive impulse.

Arthur Molella and Joyce Bedi
series editors, Lemelson Center Studies in Invention and Innovation

ACKNOWLEDGMENTS

This book has been many years in the making, and I have benefited deeply from the generosity of several institutions that have supported my research. Residential fellowships at the American Antiquarian Society, the Library Company of Philadelphia, the Smithsonian Institution's Lemelson Center for the Study of Invention and Innovation, and the Photographic History Collection at the Smithsonian Institution's National Museum of American History allowed me to study the topic and formulate connections while immersing myself in a scholarly environment.

Georgia Barnhill and Lauren B. Hewes ably guided me through the American Antiquarian Society's vast resources toward the collections that would prove most helpful. Sarah Weatherwax, Erika Piola, and Rachel D'Agostino similarly assisted by pulling countless objects, books, and archival materials from the holdings of the Library Company of Philadelphia.

Particular thanks must go to Shannon Perich, Curator of the Photographic History Collection at the National Museum of American History, for allowing me unfettered access to the museum's rich collection, reading early drafts of various sections of my manuscript, and providing valuable insight into the topic. Michelle Delaney, Director of the Consortia for Humanities at the Smithsonian Institution, also has my thanks for her support of my research over the past ten years.

I was generously awarded a semester's leave from teaching at York College of the City University of New York to work on this book, and I thank my former colleagues in the Department of Performing and Fine Arts for their flexibility and generosity. Support for the project was provided by a PSC-CUNY Award, jointly funded by the City University of New York and its Professional Staff Congress. Thanks are also due to Katherine Manthorne, who has provided patient guidance on this topic and many others since my time as a doctoral student.

Much of the research on which this book is based has been presented at symposia and conferences over the years, and I am grateful for feedback from audience members and fellow presenters, especially at the 2010 College Art Association session "Photography in Theory and Practice: Medium Specificity and its Discontents," at a 2011 Visual Culture Lecture at the Library Company of Philadelphia, and at a 2012 Art at Lunch lecture at the Pennsylvania Academy of the Fine Arts. I am also grateful to the journal *History of Photography* for allowing me to reproduce some previously published material from my article "John William Draper and the Reception of Early Scientific Photography," which appears in the July 2012 issue.

I have been doubly fortunate to have the expertise of two distinguished presses at my disposal. The anonymous reviewers for the MIT Press provided insightful feedback that enriched the text immeasurably, and Marguerite Avery, Katie Persons, and Katie Helke, all formerly or currently of the MIT Press, ably shepherded the manuscript though the editorial and production process. I thank Arthur Molella, co-editor of the Lemelson Center Studies in Invention and Innovation series, for his close reading, particularly of chapter 3, and I owe a huge debt of gratitude to Joyce Bedi, the other co-editor of the series, for competently editing the full manuscript and providing valuable suggestions, making it an altogether more concise and readable final product.

Finally, I must thank my family for their constant support, in particular my husband Marc Belli, to whom this book is dedicated.

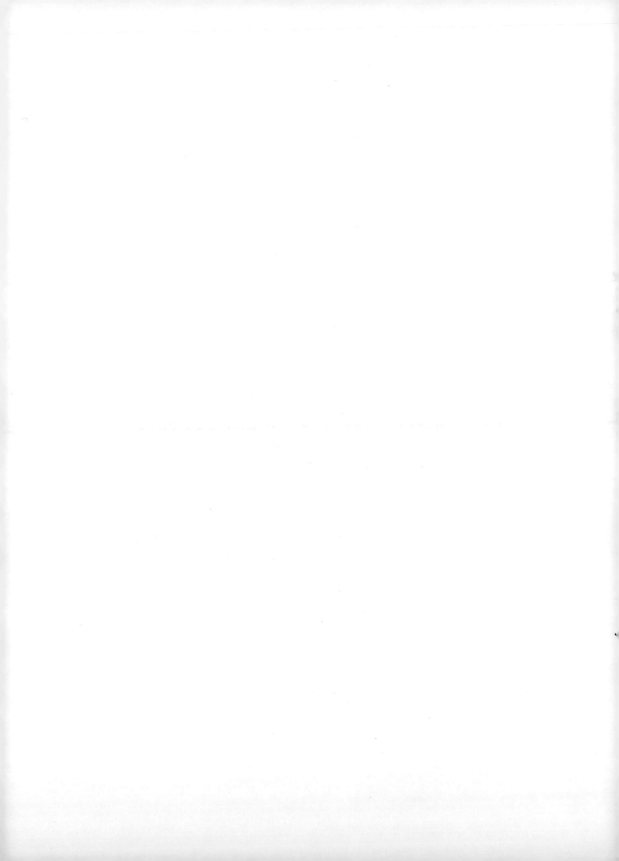

INTRODUCTION

A commentator in the September 1851 *Bulletin of the American Art Union* complained that, as was typical in New York City in late summer, everyone was out of town. "Artists are as rare as cool breezes," the writer grumbled. "The Daguerreotypists even have assembled in grand convention in some country town. We seem to have lost both taste and curiosity."[1] Clearly, to that author, the artists represented taste and the daguerreotypists represented curiosity. It was this very reputation of lacking taste, however, that the assembled daguerreians had gathered to fight.[2]

Through the summer of 1851, daguerreotypists from all over the state of New York convened, first in Syracuse in July, then in Utica, in Brooklyn, and in Manhattan in August, to discuss raising the standards for their field. The profession of daguerreotyping in the United States had risen so far and so fast that many complained the profession was debased by a lack of skill among their fellow operators, particularly the itinerants. The editor of the *Photographic Art Journal*, a daguerreotypist named Henry Hunt Snelling, scoffed at the "mere mechanics, dabsters, or whatever you are pleased to call those operators who jump from the stable, the fish-market, the kitchen or the poultry-yard into the operating room of the Daguerreotypist [and] set themselves up for Daguerreans."[3] Some called for the formation of local and national Photographic-Art Associations in which members could "meet occasionally in scientific organization ... to take into consideration the mysteries of our beautiful art, to promulgate all improvements, and to do away with all secresy and petty jealousy; for one and all to fraternise, to make strong a bond of union, and, if possible, to have a moderate, and but one standard price for pictures throughout the length and breadth of the land."[4] The message was clear: daguerreotyping as a profession had come of age, and it was now time for unity, standards, and professionalism throughout the field.

Originally a French invention, daguerreotyping—a photographic process that produces extremely detailed images—reached American shores in the fall of 1839.[5]

A daguerreotype is a direct-positive image on a silvered copper plate. Historically, the plate was polished until it had a mirror-like surface, then was treated with light-sensitive chemicals. The plate was then fitted into a camera and exposed to the subject. Once exposed, the plate was developed above a box of mercury fumes, and the image was fixed in a bath of hyposulfate of soda. The finished product was then washed and dried. Because the surface remained sensitive, it was placed under a plate of glass and usually put in a case.

The year 1851 was a momentous one for the American daguerreotyping, and there were several signs it had reached maturity. In addition to the first organized conventions and the calls for a national organization, 1851 saw the publication of the second American journal devoted exclusively to photography, the *Photographic and Fine-Art Journal*. Samuel Dwight Humphrey's *Daguerreian Journal* had come out a year earlier. Both publications promised to consider the technical, artistic, and scientific aspects of the medium and also to pay attention to insider's gossip. In addition, 1851 saw the opening of the Crystal Palace Exhibition in London, at which it was the general consensus that the American daguerreotypes were far superior to those exhibited by other countries. Indeed, it was in regard to the American daguerreotypes shown at the Crystal Palace that Horace Greeley, the editor of the *New York Tribune*, remarked: "In daguerreotypes, we beat the world."[6] And it wasn't only Americans who thought their country had "beaten the world" in the photographic department. One British guidebook to the exhibition remarked: "In photography, the American department was peculiarly rich; and it is but just to state, that many important improvements in the details of our photographic processes have been supplied by the skill and unwearied experimental research of our transatlantic cousins."[7] Americans hadn't invented the daguerreotype, but in the twelve years since it had been introduced to their shores they had improved upon it to such a degree that it was referred to as "the American process."[8]

The purpose of this study is to closely examine those first twelve years of daguerreotyping in America, when both the process and the profession matured. Specifically, the book seeks to understand the intersections of art, science, and technology in the early American daguerreotype, and to explore where and why there were overlaps among these fields in conjunction with the new medium. How did the introduction of the daguerreotype affect the growing professionalism in the arts, the sciences, and technology? It can be argued that by 1851 the American daguerreotype had a distinct identity within the broader popular culture. As the historian Alan Trachtenberg has noted, in its heyday, the daguerreotype, in America, came to stand for truthfulness, innovation, and modernity.[9] However, in 1839, when the daguerreotype was first introduced to America, it was something wholly and remarkably new: simultaneously a product of science and innovative technology, yet one that resulted in a *visual* object. It was, as an early remark on the process reminds us, "one

thing new under the sun" in an age of increasing technological innovation.[10] The identity of the medium did not yet exist; it had to be created. Of course, aspects of that identity came from pre-existing sources: conventions of painted portraiture, for example, or engraved scientific illustrations. But other aspects of the identity were created from scratch.

The photographer and theorist Allan Sekula has called art and science the "chattering ghosts" of photography's past, and indeed the daguerreotype has been haunted by those noisy spirits since its inception.[11] At the medium's public introduction in France in August of 1839, the details of the process were revealed to a joint meeting of the Académie des sciences and the Académie des Beaux-Arts. Rather than a hindrance, however, I argue that these two ghosts constitute a useful and necessary haunting. An equally important ghost, especially in relation to American photography, is technology.

"Fine art," "science" and "technology" have a variety of meanings and can be somewhat loaded terms. For the purposes of this study, I am using them as they are understood today, as today's definitions were essentially conceived before or concurrent with the daguerreian era. Indeed, one of my contentions is that the arrival of the daguerreotype helped cement and clarify those very definitions, even while the new medium straddled all three. By the eighteenth century, the "fine arts," referred to painting, drawing, printmaking, sculpture, and architecture, whereas an earlier definition of "art" encompassed craft and other decorative arts.[12] Similarly, by the early nineteenth century the term "science" was used much as it is today, referring both to the types of topics studied (the occurrences of the material universe) and to how those studies were conducted. The term "scientist" was first applied in 1834, certainly signifying the continuing professionalization of the field and, not entirely coincidentally, following a series of significant advances and debates on the nature of light and chemistry that had occurred in the preceding decades. Those advances—including Thomas Young's startling 1801 contention that light was a wave, rather than a particle as Isaac Newton had contended, and Antoine Lavoisier's revelations on the nature of combustion and identifying elements—excited the scientific imagination in a way that surely contributed to the development of early photography.[13]

The term "technology," on the other hand, is a more recent invention. Coined in 1828 by Professor Jacob Bigelow of Harvard University, it became increasingly commonplace in the early daguerreian era. As the historian of technology David E. Nye has explained, "in the middle of the nineteenth century ... the word began to take on the connotation of utilitarianism (as distinct from 'science'). Technology had to do with machines, patents, and systems of production; science was the province of 'pure' research into fundamentals and did not concern itself with applications."[14] Indeed, in many ways technology, or the mechanical aspects of the new medium, is the cement that holds the art and the science of early daguerreotyping together. As

many historians of technology have noted, in the first few decades of the nineteenth century invention and technology became synonymous with ideals of American progress as something open and available to any willing to work for it, particularly through innovation.[15] It was technology that made the hard sciences accessible, and therefore more democratic. Nye has described how nineteenth-century Americans relied on stories of technological foundation to justify their place in the New World, citing tales about the axe, the railroad, and the canal. As Nye explains, "the versions of the technological foundation story that emerged and circulated during the nineteenth century were literally about creating society by applying new technologies to the physical world."[16] Though the daguerreotype was not an American invention, and though it didn't alter the shape of the physical landscape, I contend that American society created a sort of technological foundation story around this new invention as it had around other inventions, celebrating its qualities that were believed to be consistent with ideals of American innovation and progress.

Of course, art, the sciences, and technology have always been connected, and the photographic imagery associated with these three fields has been a topic of some contentious debate among art historians.[17] Although we think of some images (particularly photographic images) as "artistic" and some as "scientific," there have always been some images that cross boundaries, sometimes deliberately. This book certainly pays attention to why particular daguerreotypes were created, but it also argues that in the very early period under consideration there was considerable overlap between daguerreotypes that were thought of as artistic and daguerreotypes that were created purely for scientific or technological purposes, as the early daguerreotype itself was both a visual and a scientific object. The first daguerreotypists in the United States mirrored the disciplinary interweaving of the daguerreotype itself—in the medium's very early days, ideas about what constituted a typical daguerreotypist (and a typical daguerreotype) were only beginning to form. This book considers what happened when experimenters as diverse as a medical doctor, a chemist, a lamp maker, a man who made weighted scales, a metallurgist, a fine artist, and a dentist formed the vanguard of a new technology and became the creators of a new form of visual imagery. What sorts of images did they produce?

One of the connections among art, science, and technology in mid-nineteenth-century America is that they are rooted in verisimilitude and reality, in what is *knowable*, particularly in the minds of the general public. Though nineteenth-century science in America was steeped in an Enlightenment-based emphasis on empirical evidence, it was becoming increasingly professionalized. Scientific advances abounded, making the fields themselves more complex and necessitating a growing body of professionals. For example, whereas in 1802 Yale University employed one professor of mathematics and natural philosophy, who also taught chemistry and natural history, by 1864 Yale had separate professorships for chemistry, natural

history, natural philosophy, botany, and geology.[18] Such growth, however, alienated many who were not professionally employed by universities and who could not keep up with the ever-expanding bodies of research. As a result, tension grew between professionals and an educated body of amateur researchers. While amateurs complained that they could no longer understand the esoteric nature of many of the new texts being written (particularly in fields such as chemistry), those writing the texts, such as the University of Pennsylvania professor and chemist Robert Hare, complained that their work was being criticized as incomprehensible by people who lacked proper training.[19] Science, the public protested, was becoming unknowable.

In the middle of the nineteenth century, the idea that certain knowledge would become accessible only to the specialized few went against American ideals. Technology was meant to make that knowledge accessible to anyone, to advance the nation as a whole. This idea of the accessible can also be applied to the fine arts in that period. There was an interest in imagery that reflected truth, and that in turn was easily understood by the average viewer. Painting, like photography, was seen as a potential leveler; it became democratic when anyone could understand it. A prime example is William Sidney Mount's 1838 painting *The Painter's Triumph*, shown here as figure I.1. Mount himself discussed in his diary the importance of producing work that would be easily understood by the general public, and *The Painter's Triumph* has been read as embodying that motivation.[20] In the work, an artist is showing a painting on an easel to a farmer, clearly identifiable by his clothing and the whip he holds in his hand. The farmer leans forward excitedly as the painter gestures toward the canvas with a dramatic sweep of his arms. William T. Oedel and Todd S. Gernes have labeled this painting as democratizing in that it is "emblematic of the artist's moral obligation to produce art available to the emerging middle class."[21] It also seems no accident that the American Art Union, an institution that disseminated prints to its members and gave away paintings by lottery in an effort to make fine art accessible to a wider public, was established in 1839, the same year that photography came into existence. This is not to suggest there was a cause-and-effect relationship between the two, but rather that there was a cultural pull toward imagery that was understandable to a wide audience.

Thus, in mid-nineteenth-century America both art and science were experiencing a tension between what was thought of as "democratic" and what was thought of (in popular culture, at least) as "elite." Democratic art and science were knowable, understandable, and easily digestible for a middle-class population; elitist practices were inscrutable, unfathomable, and required special education to understand. The daguerreotype contained elements of both the "democratic" and the "elite." It was clearly populist in that nearly anyone, of any means, could have a portrait taken. It was believed to be a form of direct representation, as the images plainly revealed the sitter's accurate likeness, accessible to any viewer. The daguerreotype had an aura of

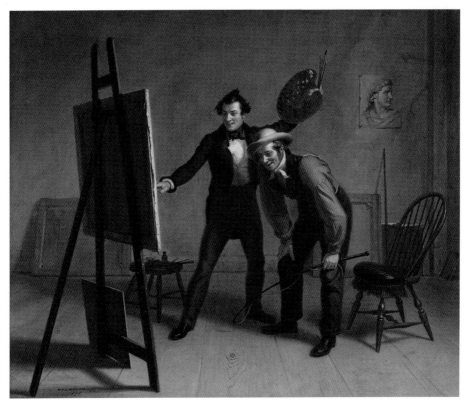

FIGURE I.1
William Sidney Mount, *The Painter's Triumph*, oil on wood, 1838. Bequest of Henry C. Carey. Courtesy of the Pennsylvania Academy of the Fine Arts, Philadelphia.

reality due to its indexical nature—its causal relationship with the referent, which led to the medium's gaining a reputation for telling not only the truth of about someone's appearance but also the truth about someone's nature.[22] "The Daguerreotype exercises no discrimination, and reflects the sitter just as he presents himself," the author Timothy Shay Arthur observed. In another contemporary comment, a newspaper journalist advised: "Those so plain that their portraits need flattery, had better not attend [the daguerreotype studio], as the apparatus cannot be adapted to such an end."[23] The notion that the medium could reveal a sitter's inner self has been discussed by Alan Trachtenberg in his analysis of Nathaniel Hawthorne's *House of the Seven Gables*; it is also evident in a host of essays, poems, and stories—for example, in these lines from an 1846 poem in the New York literary monthly *The Knickerbocker* titled "Lines Suggested by a Daguerreotype Portrait": "So beautiful a portrait, and so true / The hand of mortal artist never drew ... / Where the glad waters of salvation roll / A truer portrait still—the portrait of the soul!"[24]

Particularly when compared with portrait painting, the daguerreotype was thought of as a great leveling agent, a truly democratic form of imagery. "Your sun is no parasite," one writer commented an 1849 essay on daguerreotyping. "He pours his rays as freely and willingly into the cottage of the peasant, as into the palace of the peer; and he vouchsafes no brighter or purer light to the disdainful mistress than to her humble maid. Let it once become the bon ton for plain-looking, homely, and ugly people to sit for likenesses that are likenesses—let a few hideous men and women of distinction consent to be daguerreotyped—in fine, let nature and art in their combined efforts be suffered to have fair play."[25] Yet there was simultaneously an aura of magic, the supernatural, and the inscrutable around the daguerreotype. For example, a commentator writing about daguerreotyping in the *New York Morning Herald* admitted: "I am aware that you will think that this is a second moon hoax, and so I thought till sufficient reasons were adduced, when I was forced to the belief."[26] A magazine called *The Pathfinder* contained a similar remark: "When [the daguerreotype was] first announced, most persons imagined it to be a delusion. It seemed at the time utterly incredible."[27] Language of the strange, the unfamiliar, and the otherworldly is often apparent in early commentaries about the daguerreotype; it was characterized as having "magic power," and the camera itself was referred to as the "magic box."[28] A well-known article by Timothy Shay Arthur about the daguerreotypist Marcus Aurelius Root recounts a story of a farmer who was so unsettled by the "mysterious" process of the daguerreotype that he suddenly ran from the studio and "dashed down stairs as if a legion of evil spirits were after him." The article goes on to attribute a "magnetic attraction" to the daguerreotype camera, noting that "many good ladies actually feel their eyes 'drawn' towards the lens while the operation is in progress!" And "other [sitters] perceive an impression as if a draft of cold air were blowing on their faces, while a few are affected with a prickling sensation,

while the perspiration starts from every pore."[29] Though it was true that anyone who could afford the equipment could learn the process and become a daguerreotypist, the operator still had the slight aura of a conjurer, disappearing behind a curtain to eventually emerge and reveal, as if by magic, the image floating upon the silvered, finished plate. Adding to the strangeness of the experience, one of the biggest complaints about early daguerreotypes was that the final image rarely resembled the subject: "We should not ... be surprised to find the reflection of one single look in the mirror of the photograph strange and unresemblant and the miniature that is taken, entirely or partially from it, unsatisfactory."[30]

In the middle of the nineteenth century, these ideas of the uncanny extended beyond photography into larger concerns about technology. In one of the earliest articles to discuss the new medium (the same one that labeled photography as "one thing new under the sun"), the author attributes a kind of societal whiplash to an ever-increasing stream of technological innovations: "There is no breathing space—all is one great movement. Where are we going? Who can tell? The phantasmagoria of inventions passes rapidly before us—are we to see them no more?"[31] This sensation of life moving at an ever-quickening, bewildering pace because of proliferating technologies such as photography, telegraphy, and the railroad was often described by period commentators as "the annihilation of space and time": new inventions were bringing the distant close. That very wording appeared in the *Philadelphia Ledger*'s report on Samuel F. B. Morse's 1844 demonstration of the telegraph: "This is indeed the annihilation of space." Walt Whitman applied the same words to photography, remarking, as he stood before a gallery of daguerreotype portraits, "Time, space, are thus annihilated, and we identify the semblance with the reality."[32]

This book seeks to understand the early American daguerreotype as a site of confluence among these societal trends and among the disciplines of art, science, and technology, and to examine how daguerreotyping might have affected the divergence of those disciplines. What, for example, was the daguerreotype's role in the larger cultural shift from the eighteenth century's "arts and sciences" model of knowledge, embodied by institutions such as the American Philosophical Society, to the development of separate, distinct fields of the arts, sciences, and technology? In the United States, the rise of daguerreotyping was concurrent with the rise of artistic, scientific, and eventually photographic professional societies. How were daguerreotypists and daguerreotypes positioned within such societies as the medium's popularity spread and as the images it produced were widely disseminated? What, if any, were the formal and ideological demarcations that directed particular images (and image makers) into particular discursive categories, and were such strictures always in place? How did early daguerreotypists relate their practice to contemporary notions of artistic production and the sciences as they were understood at that time? These questions have yet to be fully considered by scholars.

In recent years there has been a welcome flurry of re-positioning, re-casting, and re-examining of many of the long-held tenets of the histories of photography and American art, notably in the work of Robin Kelsey, Rachael DeLue, Wendy Bellion, Margaretta Lovell, and Jennifer Roberts.[33] Much of this work has incorporated a move toward situating American art within a more international context.[34] However, a fresh evaluation of daguerreotyping, particularly American daguerreotyping, is notably absent.

Much of the important early work on American daguerreotypes consists of social histories that established an initial framework for a scholarly approach to the history of photography in the United States. For example, Robert Taft, William Welling, George and Marion Rinhart, Beaumont Newhall, and Richard Rudisill unearthed essential primary-source documentation about the practices of early American daguerreotypists, providing rich source material for future researchers and contextualizing the daguerreotype's emergence within its cultural and social constructs. Rudisill in particular theorized the status of the daguerreotype as particularly reflective of what he identified as American cultural traits. Although fundamental to the growth of a new topic within the history of art and the emerging field of American Studies, these formative texts did not tend to consider the formal characteristics of the images themselves and of the daguerreotype's status as both image and material object. Merry Foresta and John Wood's 1995 exhibition catalog *Secrets of the Dark Chamber: The Art of the American Daguerreotype* continued the trend by gathering and publishing important primary- source documents.[35] The daguerreotype as a commercial venture was discussed by Reese Jenkins, who documented the technical changes and economic factors that propelled photography toward George Eastman's development of the Kodak camera for amateurs in the late 1880s.[36] John Wood's edited volume *America and the Daguerreotype* gathered essays treating various aspects of the medium, many of them previously untreated.[37] Alan Trachtenberg significantly expanded upon these sources and successfully contextualized the American daguerreotype within a cultural framework larger than those his predecessors had used, drawing predominantly upon contemporary literature.[38] Marcy J. Dinius has expanded on Trachtenberg's analysis, examining the larger print culture in antebellum America and charting the daguerreotype's societal construction.[39] There have also been several excellent studies on different aspects of early photography produced as museum exhibitions, some focusing on the daguerreotype in France and some on early photography in America, as well as important monographic treatments of several of the major figures from the early period of photography, among them Louis-Jacques-Mandé Daguerre in France and Albert Sands Southworth and Josiah Johnson Hawes in the United States.[40]

Yet there is more to be done, particularly within the fields of art history and the history of technology. The daguerreotype's relationship with American painting has

received initial consideration by Dolores Kilgo, and is sometimes discussed in relation to a particular artist or daguerreotypist, such as Thomas Easterly or Mathew Brady.[41] The correlations between photography and other forms of art in the nineteenth century have been treated by scholars looking at non-American art; two examples are Stephen Bann's examination of the intersections of French prints, paintings, and photography and Jennifer Tucker's consideration of British Victorian scientific photography as images and products of science.[42] In this book I add to and expand upon this conversation by approaching the early American daguerreotype as a product of technology, mechanics, and science, but also *formally* as an image. Early daguerreotypists should be contextually analyzed not only as experimenters and products of their cultural period but also as image makers within a dynamic and shifting paradigm in which the boundaries between art, science, and technology were being established and were continually in flux.

Somewhat paradoxically, the most efficient way to discuss the cross-currents of the varying disciplines is to break them down into a series of case studies. But even though the chapters in this book focus primarily on different disciplines and their relationship to the daguerreotype, the intent is to keep the connection of the fields through photography at the forefront of any discussion. The photographic career of Samuel F. B. Morse is an ideal place to start such an inquiry. Morse, whose daguerreian activity is the subject of chapter 1, is best known for the invention of the electromagnetic telegraph. He was also an important nineteenth-century artist and a co-founder of the National Academy of Design, the first arts institution in the United States to be run by artists. Morse was also one of the first in the United States to experiment with the daguerreotype, eventually acquiring (rightfully or not) the nickname "Father of American Photography" for his vanguard work with the new medium. Morse is uniquely positioned between the differing disciplines I treat in this study, having shown an interest in technologies related to mechanical replication and having had a career in the visual arts for many years before his experimentation with the daguerreotype. He worked with photography during a transitional period in his life, when he was shifting identities between artist and inventor, and the daguerreotype provided a continuum across these activities. Most scholars have tended to treat Morse as either an artist or an inventor without exploring the convergence of art and invention in mid-nineteenth-century American culture. Morse's daguerreian activity can serve as a stand-in, then, for the larger cultural phenomenon of the intersections between these fields. Simultaneously, what became of Morse's efforts to link these activities is indicative of the divergence of the varying disciplines, as his shift embodied the transformation of knowledge from a "Renaissance man" model to increasingly specialized fields. While working on the daguerreotype, he was attempting to continue his work as an artist, as president of the National Academy of Design, and as an instructor of painting, and to gain

respect as an inventor for the electromagnetic telegraph. Morse found that he was unable to be both an artist and an inventor in the changing intellectual environment of the period: his artistic colleagues accused him of abandoning his craft for invention, and fellow inventors declared that, having spent several decades working as an artist, he was not a true scientist. At the time, American culture was privileging the idea of American technological inventiveness over artistic expression; because Morse desired above all else to be seen as having contributed something of worth to the country, he chose technology.

That Morse worked with the daguerreotype only in the first two years of its existence makes him a compelling figure to study when considering the developing identity of the new medium. The artist and inventor had very specific ideas about the best uses to which the daguerreotype could be put, especially as a tool for artists. Shifting his focus away from the visual so soon into photography's maturation, however, Morse did not actively participate in how American artists continued to conceptualize and use the daguerreotype throughout the 1840s. The second chapter examines the intersection of the fine arts and the daguerreotype within a society interested in reproductive technologies and greater access to imagery, beginning with the initial reaction of artists to the new medium. Some, like Morse, embraced photography; others were nervous of the competition. Chapter 2 explores the wide range of reactions from artists as they grappled with the daguerreotype and learned how to make use of it, some employing it as a copying tool in order to disseminate replications of their work, some using it as a stand-in for traditional sketching, and some using it to make lengthy sittings for portraits unnecessary. Some artists who consistently used the daguerreotype in their work will also be considered. Less explored in the literature and perhaps of more interest to this study, however, is how daguerreotypists positioned themselves in relation to the fine arts. The same tension between democracy and elitism that existed in the sciences and the fine arts was also present in the world of daguerreotyping. Some daguerreotypists consciously borrowed language, lighting, and other conventions from fine artists in order to distinguish themselves from those they regarded as "dabblers." Yet such borrowing existed simultaneously with the development of a distinctly daguerreian aesthetic, one that was separate from fine art, and with a desire on the part of daguerreians to develop an identity that was different from that of fine artists.

The "flip side" of art in early photography (as Sekula calls it) is science, which is the subject of the third chapter. The term "science" encompasses a wide array of disciplines; for the purposes of this study, I am focusing on works that were created in relation to chemistry, biology, or astronomy. Some of those sciences, particularly astronomy, have been treated by art historians, but for the most part scientific photography in the early period of the medium has been unstudied, especially in relation to American photography[43]—perhaps because, along with the rest of the

medium, the identity of the scientific daguerreotype was still in flux during this period. The plate itself *was* a product of science: at least a rudimentary knowledge of chemistry was required in order to create an image. However, very few American experimenters were using daguerreotypes for scientific purposes.

Chapter 3 focuses largely on one daguerreotypist: John William Draper, a professor of chemistry at the University of the City of New York (now New York University), whose work ranged from astronomical photography to portrait photography to using the daguerreotype to attempt to answer scientific questions about the nature of light. Not coincidentally, Draper briefly had been a business partner of his fellow faculty member Morse; the two had operated a daguerreotype studio on the roof of one of the university's buildings. Their partnership in many ways symbolizes the type of connectivity on which this book is focused, and on which the daguerreotype was based. On at least one occasion Draper also created a compositional image remarkably similar to the still-lifes produced by Daguerre, Morse, François Gouraud, and other early practitioners. The few other American early experimenters who used the daguerreotype for scientific purposes are also treated in this chapter.

By 1851, the end date for this study, the idea of a scientific daguerreotype was fairly well known, as the celebration of John Adams Whipple's work with astronomical daguerreotypes attests. In the 1840s, however, there was no central institutional body to support science in America, as there were in the major cities of France, England, and Germany. Though Americans were certainly interested in science, particularly in the natural sciences and geology, technology was even more popular. Americans were deeply invested in their country's identity as driven by technology. Paul Israel, Brooke Hindle, and other scholars have demonstrated that from the Early Republic through the nineteenth century technology and invention were celebrated as particularly American.[44] "That the American people are inventors beyond all others is beyond dispute," the magazine *Scientific American* asserted in 1878. "That the grand results of American inventiveness have been beneficial no one is so foolish as to question."[45] Photography, though not an American invention, was automatically incorporated into this cultural milieu.

Americans immediately began tinkering with the new medium in an effort to improve upon it. Chapter 4 focuses on the daguerreotype's relationship with technology, which, like its relationship with science, was somewhat complicated by the fact that the daguerreotype plate itself was a product of technological innovation. Specific technological improvements to daguerreotype plates, cameras, and related equipment are not the point of this study, though some will be discussed as related to the larger arguments presented. Rather, as with the sciences, this chapter illustrates how the daguerreotype fit into and altered the existing culture of technology in the United States at the time, mainly by examining several early daguerreotypists who came to the medium by way of the mechanical arts. Alexander S. Wolcott of

New York, for example, was a dentist and manufacturer of dental equipment before he invented his refracting camera. Among the other early innovators of the medium were Henry Fitz Jr. of Baltimore (who manufactured telescopes and lenses before briefly entering the daguerreotype business), Joseph Saxton (an instrument maker at the U.S. Mint in Philadelphia), and Robert Cornelius (a metallurgist and a manufacturer of lamps). These men exchanged information with one another and with other early practitioners, including John William Draper. Additionally, daguerreotypes were immediately exhibited at mechanic's fairs and in the annual exhibitions of the Franklin Institute in Philadelphia and the American Institute in New York. The confusion over where to initially place these objects within the exhibitions, and over how they were to be conceptualized in relation to other inventions and to fine art objects, is telling of the contested nature of early photography.[46]

This book considers a historical period during which photography's identity within the United States was being defined. The daguerreotype was the primary photographic medium in the United States until the Civil War. A product of art, science, and technology, it entered into the existing culture of these fields and affected their production, simultaneously creating a new aesthetic and a flourishing commercial product.

1 "REMBRANDT PERFECTED": THE ART, SCIENCE, AND TECHNOLOGY OF SAMUEL F. B. MORSE

In 1846, under the caption "Professor Morse's Great Historical Picture," the magazine *Yankee Doodle* published a simple line drawing of telegraph poles strung across a landscape. (It is reproduced here as figure 1.1.) The text below it read "Yankee Doodle expressed himself much pleased with the unity of design displayed in this great national historical work of art."[1] Appearing two years after the first successful public demonstration of the telegraph, the cartoon probably was meant as a jab at Morse, who had tried and failed to gain a commission to paint a grand historical painting for the rotunda of the capitol building in Washington. The cartoon also can be read, of course, as a celebration of Morse's technological achievement. On that reading, "Yankee Doodle," the quintessential American, declares himself pleased with *this* work of art, as opposed to Morse's work in painting. This narrative fits neatly into the overriding idea of technological progress as a particularly American achievement. Morse himself espoused that sentiment repeatedly and related it to his invention; for example, in 1839 he asserted "There is more of the '*Go-ahead*' character with [Americans], suited to the character of the electro-magnetic telegraph."[2]

It was partially this investment in the concept of America as a nation of technology-minded or "go-ahead" citizens that drew Morse to the daguerreotype. Remembered primarily for his invention of the electromagnetic telegraph, Morse was also a prominent artist. At the height of his artistic success, from around 1825 to 1830, Morse was awarded the most prestigious portrait commission of the decade—for a portrait of the Marquis de Lafayette—by the city of New York. A well-regarded member of the city's cultural and intellectual elite, he painted portraits of such New York luminaries as Governor DeWitt Clinton and the poet William Cullen Bryant. In 1826, Morse co-founded the National Academy of Design, the first arts organization in the United States run by artists, and served as its president for twenty years. He also delivered the first series of lectures devoted to the fine arts in the country.

Professor Morse's Great Historical Picture.

YANKEE DOODLE expressed himself much pleased with the unity of design displayed in this great national historical work of art.

FIGURE 1.1
"Professor Morse's Great Historical Picture," *Yankee Doodle* 1, October 1846.

Indeed, Morse did more to promote and advance the state of fine art in the United States than any other figure in the first half of the nineteenth century.

Morse's long-held interest in both technology and the fine arts and his involvement with the early daguerreotype in the United States make him a perfect figure through which to examine the intersections of art, science, and technology within the new medium. Realizing that science was not his strong suit, Morse teamed up with the chemist and medical doctor John William Draper. Both had experimented with the basic science that is photography before the 1839 announcement of Louis Jacques-Mandé Daguerre's and William Henry Fox Talbot's discoveries (that is, affixing an image to a chemically treated surface via the exposure of light), and upon that announcement both were immediately driven to experiment with the new technology in an attempt to create a permanent photographic impression themselves.[3] They joined forces to open a portrait studio in the spring of 1840—only the second of its kind in New York City. Later they claimed to run their business under a strict division of art and science, with each partner contributing his particular expertise.[4] Though their recollections of the division of labor seem a bit too pat to be true, their partnership can serve as a symbol for the intersection of the disciplines.

The collaboration of Morse and Draper wasn't the only cross-disciplinary alliance engendered by the arrival of the daguerreotype. Several of the figures mentioned in the introduction worked together: Alexander Wolcott (a manufacturer of dental

equipment with experience in optics) and John Johnson (who had worked as a jeweler and as a watchmaker's assistant) opened the first daguerreotype portrait studio in New York. Wolcott is remembered for his invention of a daguerreotype camera with a concave mirror instead of a lens, which made the daguerreotype process much faster. They were assisted by the telescope maker Henry Fitz Jr., who soon went into business on his own in Baltimore. In Philadelphia, the prominent optician John McAllister Jr. supplied lenses to the daguerreotypists Robert Cornelius (a metallurgist and lamp-manufacturer), William Mason (an engraver), Paul Beck Goddard (a chemist), and Joseph Saxton (an instrument maker who worked at the United States Mint). These and other early experimenters formed a vibrant network that exchanged ideas, information, supplies, and images. Morse originally approached Wolcott to be his partner instead of Draper. Saxton ruled a diffraction grating for Draper, so Draper could split a beam of light and create images of the solar spectrum. Goddard and Cornelius joined forces. Wolcott exhibited his plates not in his home town of New York, but in nearby Philadelphia.

Interestingly, among all of these early American innovators, Morse was the only practicing artist. He had engaged in technological experiments for years, including during the 1820s and the early 1830s, his most productive and successful period as a painter. This interest manifested itself chiefly in mimetic reproductive technologies—that is, technologies that copy images and objects exactly, including the daguerreotype and, arguably, the telegraph, in which electricity is used to physically reproduce or mechanically transcribe the mark of a letter or a number in Morse code onto the device's receiving tape. The daguerreotype provides an obvious link between Morse's two careers, art and science, which are typically treated as separate and discrete. The process embodied, in one medium, both the ability to create a visual result and the ability to engage in the sorts of technological and mechanical experiments Morse had long enjoyed. Morse's interest in technology in general and the daguerreotype in particular can serve as a case study regarding the emerging importance of technology during this period of American history. This overriding interest in technology fostered an environment suitable for the explosive success of the daguerreotype when it arrived in 1839. Despite the relative lack of extant plates, the details of Morse's daguerreotype practice offer specific examples of many of the complexities that early photographers had to face and resolve while establishing an identity for themselves and the medium.

THE TECHNOLOGICAL PAST

The basic facts about Morse's interest in both art and technology at an early age have been treated by previous scholars, but I will recount them briefly here in order to establish how they relate to his eventual work with the daguerreotype.

Morse's interest in art, science, and technology, and particularly in mechanical reproduction, began relatively early in his life. As a student at Yale College in the early 1800s, he began to paint miniature portraits of his friends for extra pocket cash; at the same time, he engaged in chemistry lessons and electrical experiments performed in class, particularly under the eminent scientists Benjamin Silliman and Jeremiah Day. In 1811 he traveled to London to study art with the esteemed American painter Washington Allston, and soon he also enrolled at the Royal Academy there. Upon his return to the United States in the fall of 1815, he began to pursue a career in painting and to conduct technological experiments.

Historians of technology have explained how invention came to play an increasingly important role in American culture in the early nineteenth century. In the late eighteenth century, when Morse was born, Americans were ambivalent about technological progress and change. As the nineteenth century progressed, however, the need for economic expansion and changing political and economic forces altered the agrarian society of Morse's youth into a newly formed industrial power, and Americans began to embrace technology as a transformative agent.[5] Morse's repeated inventive efforts before his work with the telegraph indicate his awareness of technology's cultural impact and his desire to be associated with this particularly American brand of modernity.

One of Morse's first efforts in invention was carried out in 1817 and 1818, when he and his younger brother Sidney attempted to create a flexible piston-pump that they hoped to market for use on boats and fire engines. Samuel Morse expressed hope that the pump would be "not only profitable to us, but beneficial to the community." "From its cheapness," he continued, "it will be within the reach of every village."[6] He received the endorsement of his former professors Silliman and Day. Eli Whitney, inventor of the cotton gin, also voiced approval of the machine. Unfortunately, when a demonstration of the pump was mounted, it proved to be a dismal failure, producing no water at all. Despite his frustration, Morse wrote of his intention to continue technological experiments: "The machine business ... yields much vexation, labor, and expense, and no profit. Yet I will not abandon it." However, Morse amended this promise with a caveat: "I will do as well as I can with it, but I will make it subservient to my painting."[7] As early as 1818, Morse declared his intention to somehow combine his interests in art, science, and technology, with an emphasis on the visual. Indeed, from then until 1832, when he began work on the telegraph, all his experiments were related to image-making. Furthermore, they were directly related to the mechanical reproduction of an existing subject.

By 1820, Morse, his wife, and their baby daughter had settled into his parents' house in New Haven. Because the house was quite crowded, Morse had a studio and laboratory built adjacent to it. By chance, Benjamin Silliman was the Morses' next-door neighbor, and during the summers of 1820 and 1821 Morse and Silliman spent

much time together, often engaging in various chemical and electrical experiments. At some point in this period the two conducted proto-photographic experiments, attempting to create an image on a chemically treated surface through the exposure of light. Morse described these experiments in March of 1839, after meeting Louis-Jacques Mandé Daguerre in France and viewing some daguerreotypes. He wrote about the encounter to his brother Sidney:

> You have perhaps heard of the Daguerreotipe, so called from the discoverer, M. Daguerre. It is one of the most beautiful discoveries of the age. I don't know if you recollect some experiments of mine in New Haven, many years ago, when I had my painting room next to Prof. Silliman's, experiments to ascertain if it were possible to fix the image of the Camera Obscura. I was able to produce different degrees of shade on paper, dipped into a solution of nitrate of silver, by means of different degrees of light; but finding that light produced dark, and dark light, I presumed the production of a true image to be impracticable, and gave up the attempt.[8]

Here Morse is basically describing the creation of a negative image, as in the work of his fellow proto-photographers Thomas Wedgwood and Humphrey Davy, whose experiments he and Silliman were undoubtedly following. Neither pair had been able to create a positive image or to fix an image (that is, stop it from continuing to develop).[9]

Another instance of Morse's dedication to mechanical reproduction was his attempt to create a marble-carving machine for the replication of sculpture. He designed such a machine sometime in the winter or the spring of 1823, and by the summer he had hired a local mechanic, Hezekiah Augur, to construct a machine from the design. By December, Morse's machine had produced a successful copy of a bust of Apollo, and triumph appeared imminent. However, Morse abandoned the project after he discovered that a patent for a similar machine had been granted to Thomas Blanchard in 1820.

By 1823, then, there were important precedents for Morse's work with the daguerreotype, and indeed with the telegraph. In both of these instances Morse was attempting to copy an existing subject mechanically. Also, in both instances he was drawing upon the knowledge and skills of a partner with greater expertise than himself in a particular aspect of the invention. In the proto-photographic work, Benjamin Silliman's expertise in chemistry made him an ideal collaborator. In the case of the sculpture-replicating device, Morse paired with a mechanic to physically build his design, a pattern he would repeat later with both his daguerreotype camera and with his prototype for the telegraph. Similar exchanges of knowledge would also figure in the success of the daguerreotype, both for Morse and for other early experimenters, a few years hence.

In a series of Lectures on the Affinity of Painting with the Other Fine Arts, which were written in 1825 and first delivered in 1826, Morse addressed the concept of

mechanical reproduction from an intellectual standpoint as well as from a practical one. By then Morse had reached a degree of artistic success barely rivaled by any of his contemporaries: he had been awarded the commission for the Marquis de Lafayette's portrait in 1824, and in late 1825 and early 1826 he had been instrumental in co-founding the National Academy of Design. He was widely regarded as one of the leading artistic authorities in the United States, and the significance of Lectures on the Affinity of Painting to his artistic thinking cannot be overemphasized.[10] Even though in the lectures Morse discussed the concept of mechanical reproduction intellectually and did not discuss technology or science directly, the importance of these lectures to Morse makes his discussions of reproduction all the more significant and demonstrates how deeply he was invested in the idea of mimetic representation.

In the lectures, Morse outlined his ideas about "mechanical imitation" and "intellectual imitation." According to Morse, one combined these two types of imitation to create the highest class of painting, the historical epic. One copied nature exactly, utilizing "mechanical imitation," and then combined these copies, using "intellectual imitation," to create the final work. "A picture," he added, "then is not merely a copy of any work of Nature, it is constructed on the principles of nature. While its parts are copies of natural objects, the whole work is an artificial arrangement of them." Mechanical imitation, therefore, was essential for achieving intellectual imitation: "Is not Mechanical Imitation in Painting a necessary excellence through every step even to the highest grade of epic? There is no reason why every thing that is selected to be represented should not be imitated exactly ... down to the minutest fold of drapery."[11]

"Imitated exactly": this is precisely what Morse was attempting to do with both the proto-photographic work and with the sculpture-replicating machine—to copy what was before him exactly. Morse put these principles into action in what are arguably his two most important paintings, *The House of Representatives* (1822) (figure 1.2) and *Gallery of the Louvre* (1831–1833) (figure 1.3). In the case of the former, he used a technological device known as a camera obscura to obtain exact views of sections of the interior of the building, which he then assembled to create the final painting. In the case of the latter, he used the camera obscura to copy Old Master paintings culled from various parts of the museum, then re-created these works in his larger canvas. Like a telegraphic message, each of these paintings consists of transcribed or reproduced parts that were assembled into a complete whole.

Morse's use of the camera obscura in painting *The House of Representatives* and *Gallery of the Louvre*, which is rarely placed in the context of his larger interest in the mechanical and in reproductive devices or in the larger context of American technology, combined the democratic impulse of his history of technological experimentation with his elitist desire to educate the public according to his own standards of

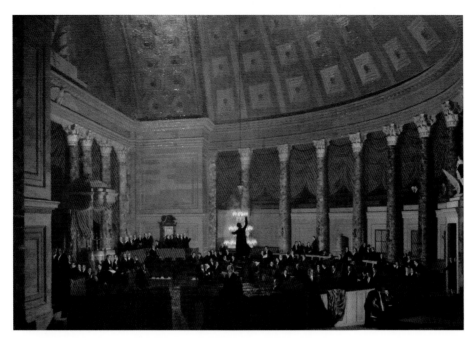

FIGURE 1.2
Samuel F. B. Morse, *The House of Representatives*, oil on canvas, 1822–23. Corcoran Gallery of Art, Washington.

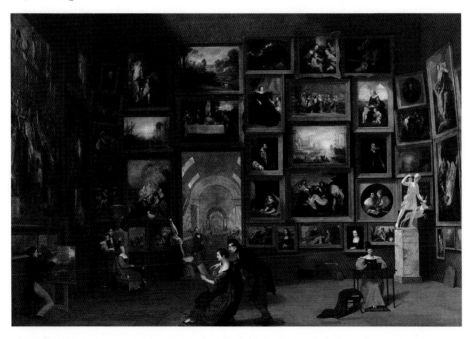

FIGURE 1.3
Samuel F. B. Morse, *Gallery of the Louvre*, oil on canvas, 1831–1833. Daniel J. Terra Collection, 1992.5. Terra Foundation for American Art, Chicago / Art Resource, New York.

taste. Morse held fast to the notion that it was the responsibility of an educated elite to uplift society's standards of taste. In 1833 he wrote: "I believe in the possibility, by diffusion of the highest moral and intellectual cultivation through every class, of raising the lower classes in refinement."[12] *The House of Representatives* and *Gallery of the Louvre* were meant to assist in this refinement, the former by showing the American public where the important work of government was conducted and the latter by hand-picking the most influential and beautiful Old Master works in order to educate the public about good art. It is crucial to note, however, that both works depended on technology.

The American public showed little interest in Morse's brand of edification; both paintings were commercial failures. In January of 1839, when the daguerreotype was first made public, Morse seized upon the new technology as a possible means of bridging his two abiding interests, art and technology, and to continue his combined efforts of creating the visual through mechanical means.

AN INTRODUCTION TO THE DAGUERREOTYPE

Morse may have been the first American to view a daguerreotype in person. By a happy accident, he happened to be in Paris in January of 1839 when the French government announced Daguerre's new invention. Morse probably was not the only American artist in town, but he may have been the only one with a pre-existing interest in reproductive technology. Because of that interest, he actively pursued viewing Daguerre's works in person before they were shown to the public at large.

The story of the meeting of Morse and Daguerre is well known. Morse was in Paris promoting his telegraph. On January 7, having already shown the device to the Académie des Sciences, he was waiting for an invitation to demonstrate it at the French Court when the Académie's secretary, Dominique François Jean Arago, made Daguerre's invention public. The day before that announcement, an article on Daguerre's process based on a press release issued by Arago was published on the front page of *La Gazette*.[13] Thanks to these two carefully orchestrated events and the ensuing flurry of newspaper articles, Morse surely was aware of the daguerreotype almost immediately. He had, after all, been waiting since the previous September for some kind of forward motion on his own invention, and such enthusiasm on the part of the Académie for a new invention would have piqued his concern and interest instantly, particularly in view of his own proto-photographic experiments of the early 1820s.

Despite Morse's interest in capturing a subject by means of chemicals and light in his experiments with Silliman a few years earlier, when he first heard of the new technology he was more concerned with how the daguerreotype might compete with the telegraph in a market constantly inundated with ever more fantastic

inventions. The first mention of the daguerreotype in his correspondence occurred almost a month after Arago's announcement, and Morse's primary concern was how the new technology might compete with the telegraph for government attention and funding.[14] His immediate recognition of the daguerreotype's commercial potential demonstrates that Morse was keenly aware of the daguerreotype as not only an artistic product but also a viable technology ripe to enter the American marketplace. He annotated the aforementioned letter with a definition of the daguerreotype, probably one of the first written by an American, describing it as, "a most singular and beautiful discovery by M. Daguerre, by which the camera obscura imprints, permanently, the objects it reflects, and with such minuteness, that the microscope discovers the minute organization in the print, as in the real object."[15] At this point Morse had not actually seen any daguerreotypes, and probably was describing the process from notices he had read in the press. This soon changed.

Sometime near the end of February 1839, at the suggestion of Robert Walsh, the American consul in Paris, Morse wrote to Daguerre and asked to view some actual daguerreotypes; he offered to show Daguerre his telegraph in return.[16] The meeting took some time to arrange. While Morse was eager to view Daguerre's "most interesting experiments," his primary concern remained that the new invention would compete with his own invention:

I am told every hour that the two great wonders of Paris just now, about which everybody is conversing, are, Daguerre's wonderful results in fixing permanently the image of the *camera obscura* and Morse's Electro-Magnetic Telegraph, and they do not hesitate to add that, beautiful as are the results of Daguerre's experiments, the invention of the Electro-Magnetic Telegraph is that which will surpass, in the greatness of the revolution to be effected, all other inventions.[17]

On the appointed day, March 7, Morse and Daguerre met in Daguerre's residence at No. 5 rue des Marais,[18] which was around the corner from the theater that housed Daguerre's Diorama. The Diorama was a theatrical experience in which patrons would watch a shifting landscape; it was part of a larger trend of interest in optical experiences throughout the early and the middle years of the nineteenth century.[19] Daguerre showed Morse several examples of his work, and Morse was able to examine them under a magnifying glass. It is nearly impossible to ascertain exactly which daguerreotypes Morse viewed while at Daguerre's studio, but a letter he wrote after the meeting reveals that he had viewed a range of plates that demonstrated the medium's abilities. One of them may have been *Boulevard du Temple, eight o'clock in the morning*, a street scene showing the lower half of a ghostly man having his boots polished (figures 1.4 and 1.5). Morse also mentioned an "interior view," probably a still life, and a scientific plate featuring a magnified view of a spider.

The next day, March 8, Daguerre paid a visit to Morse's third-floor rooms at 5 rue Neuve des Mathurins. He arrived at noon, spent more than an hour inspecting

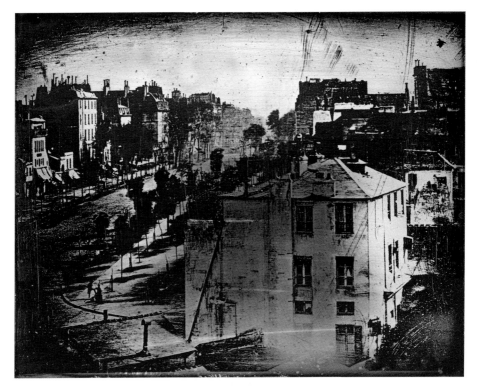

FIGURE 1.4
Louis Jacques Mandé Daguerre, *Boulevard du Temple, Eight o'Clock in the Morning*, daguerreotype, 1838–39. Fotomuseum, Stadtmuseum, Munich.

the telegraph, and "[expressed] himself highly gratified at its operation."[20] While Daguerre was with Morse, his Diorama theater caught fire. The audience was able to escape without harm, and Daguerre's house, which contained his daguerreotype equipment and pictures, was saved, but the Diorama pictures and the theater were completely destroyed. Although Morse and Daguerre continued to correspond, these two days in March of 1839 appear to constitute their only personal interaction.[21]

Morse was immediately taken with Daguerre's technology. Despite his initial fears that the daguerreotype would divert attention from his telegraph, Morse instantly recognized that its marriage of the visual with the technological would be revolutionary, and he embraced its possibilities. Immediately after his final encounter with Daguerre, Morse penned a letter to his brother Sidney in New York describing the plates. The most often-cited passage is one of the most striking, describing the street scene with the headless gentleman having his boots polished:

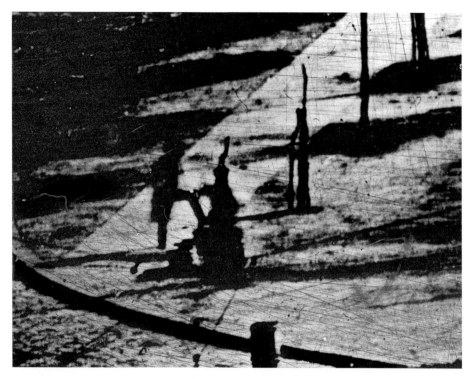

FIGURE 1.5
Detail of *Boulevard du Temple, Eight o'Clock in the Morning.*

Objects moving are not impressed. The Boulevard, so constantly filled with a moving throng of pedestrians and carriages, was perfectly solitary. Except an individual who was having his boots brushed. His feet were compelled, of course, to be stationary for some time, one being on the box of the boot-black, the other on the ground. Consequently, his boots and legs are well defined, but he is without body or head because these were in motion.[22]

Morse sailed home on the same ship that carried his letter, and his brother Sidney published the letter in his newspaper the *New-York Observer* on April 20, 1839, the first in a long series of articles the paper ran on daguerreotyping. Though this publication was not the first report of the daguerreotype to appear in the United States, it was the first *firsthand* account of the new technology published in the country.[23] It also appears to have been the most widely disseminated early account of daguerreotyping in America; within days it was reprinted in several other New York newspapers, in a Philadelphia paper, in a New Orleans paper, and in at least two Boston papers.[24]

This letter verbalizes the shift in Morse's attitude regarding the daguerreotype. Rather than viewing the new medium as a potential threat to his telegraph, as he had in earlier correspondence, Morse began to emphasize the medium's potential, particularly in relation to art and portraiture: "The impressions of interior views are Rembrandt perfected. ... No painting or engraving ever approached it." This reference to an Old Master painter is quite telling. It signals that in addition to his recognition of the new medium's potential to enter the American market as a technological force, Morse is also declaring, in a very public manner, that the daguerreotype is at least on par with (if not superior to) his long-chosen profession and passion, fine art.[25] He also sensed its commercial potential right away. Having been a successful portrait painter for many years, he immediately wondered whether the daguerreotype could be used for that purpose. Though Daguerre assured him that this was unlikely, Morse seemed to land upon the idea of exhibiting photographic portraits almost immediately.[26] In an editorial note accompanying the publication of Morse's letter, Morse's brother Sidney noted the daguerreotype's potential for "perfect representations of the human countenance." "With what interest," he continued, "shall we visit the gallery of portraits of distinguished men of all countries, drawn, not with pencil, but with the power and truth of light from heaven! ... It may not be long before we shall witness in this city the exhibition of such ... portraits."[27]

EARLY EXPERIMENTATION

Morse's account in the *New-York Observer* and various European articles describing Daguerre's process excited great interest in the artistic and scientific communities of the United States. Many, remembering the Great Moon Hoax of 1835, refused to believe them. But Morse's endorsement seemed to reassure many doubters, particularly as he was one of the few Americans who had actually seen examples firsthand.

The daguerreotype was not the only new visual technology in the air in the spring of 1839. In England, William Henry Fox Talbot announced a paper-based photographic process on which he had been working since the mid 1830s. After hearing of Daguerre's invention in early January of 1839, Talbot showed some of his "photogenic" drawings to the Royal Society of London later that month.[29] This process was also described at great length in the American press. Though there were no daguerreotypes circulating in the States until that fall, some examples of Talbot's process were present in New York as early as the spring of 1839. Some of these circulated at a party that was thrown for Morse by the National Academy of Design to celebrate his return from Paris. According to one newspaper account,

Everyone was glad to welcome back [Morse] from Europe, and to congratulate him on the distinction he has won there by his magnetic telegraph. It was a pleasure ... to hear his animated description of the recent wonders brought to light by the curious discovery of Daguerre, which promises such marvelous additions to the existing knowledge of both art and nature. A gentleman present had with him a portfolio of specimens, not of Daguerre's but of Talbot's photogenic contrivance, the method of which we heard discussed with full understanding by an eminent chemist of our city, who deals with paint and pencil almost as skillfully as with retorts, peroxydes and subacids.[30]

Curiously, despite the portfolio's appearance at an Academy party, there is no record that Morse or any other Academician suggested that Talbot be nominated to the National Academy of Design, as Daguerre had been. Indeed, Morse consistently and insistently promoted Daguerre's process, without a word about Talbot's, and even assured Daguerre that in America the daguerreotype would be considered the only acceptable photographic medium.[31] Morse's insistence on identifying Daguerre as the "Lone Inventor" of photography (just as Morse was struggling to be considered the "Lone Inventor" of telegraphy) signals his continued association of the daguerreotype as a technological invention, just as much as it was a visual product related enough to the fine arts that its inventor was worthy of nomination to the National Academy.[32] There has been much speculation among scholars as to why the daguerreotype retained such favor in American culture over Talbot's photogenic drawings (and later over Talbot's calotype process, in which a paper print was made from a negative). Alan Trachtenberg postulates that perhaps the daguerreotype's popularity was due to "the way it held opposites in balance—hand and machine, craft and science, art and technology."[33] For Morse, his absolute conviction in the primacy of the inventor underscored his promotion of Daguerre at the expense of Talbot, whom he seemed to view as an interloper who was encroaching upon Daguerre's territory, just as he feared those encroaching on what he viewed as his sole right to the telegraph. Morse's attitude might well serve as a stand-in for American attitudes as a whole regarding technology and invention, and might partially explain the continued popularity of the medium at the expense of the calotype.[34] Americans were invested in the idea of new technology and invention as an essential building block of their society, and it is possible that the daguerreotype, with its unique, cased image on a hard metal plate, felt more like a product of new technology than did the paper calotype.

Americans were eager for instruction on how to create a daguerreotype. Some copies of Daguerre's manual explaining the process arrived in the United States in September of 1839. Several early experimenters, including Morse, were able to create images within a month after receiving copies. Insofar as it had taken nearly a month for copies of the manual to reach American shores, this is an exceedingly short amount of time.[35]

One of Morse's first images, exhibited in late September, was of the Unitarian Church of the Messiah, which was on Broadway near the University of the City of New York on Washington Square's east side; John William Draper's early image of the same church is shown here as figure 1.6. A local newspaper reported the remarkable event as follows:

Prof. Morse showed us yesterday the first fruits of Daguerre's invention, as put in practice in this country. It was a perfect and beautiful view, on a small scale, of the new Unitarian church, and the buildings in its vicinity.[36]

Morse, always concerned with notions of primacy, wrote to the editor:

In your mention this morning of the specimen of Photographic drawing by the Daguerreotype which I showed you, you use the phrase "first fruits of invention in this country," this may convey the meaning that I am the first to produce these results from the process just revealed by Mr. Daguerre to the Institute of France. If there is any merit in first producing these results in this country, that merit I believe belongs to Mr. D. W. Seager of this city, who for several days has had some results at Mr. Chilton's in Broadway. The specimen I showed you was my first result.[37]

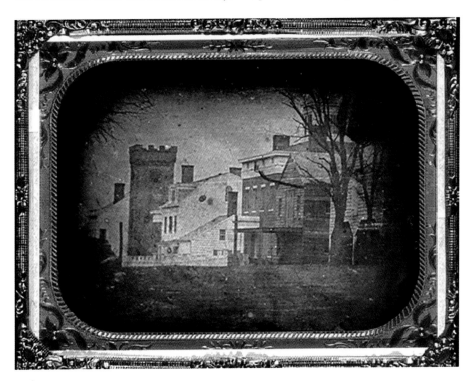

FIGURE 1.6
John William Draper, *View of Broadway featuring the Unitarian Church of the Messiah*, daguerreotype, 1839–40. Photographic History Collection, National Museum of American History, Smithsonian Institution.

One explanation as to why Morse was able to create an image so quickly is that a camera was crafted for him as soon as he received his copy of Daguerre's manual.[38] Morse's immersion in the realm of technology via the telegraph had introduced him to a number of skilled mechanics. Using the same method he employed when creating his machine for replicating sculpture, he hired a local mechanic named George W. Prosch—the same man who had built the prototype for the telegraph—to construct a camera. Prosch had a basement workshop at 142 Nassau Street; Samuel Morse was living in the same building, and it also housed Sidney Morse's *New-York Observer*.[39] Many years later, in an article in the *New York Times*, Charles E. West recalled that in the autumn of 1839 Prosch had been "[Morse's] instrument-maker."[40] In January of 1840, Alfred Vail, one of Morse's more mechanically minded partners in the telegraphic enterprise, wrote to Morse wondering if "Mr. Prosch will make me a first-rate, most perfect [telegraph] machine, and as speedily as possible."[41] Prosch was unable to construct such a telegraphic device speedily, but he did produce a daguerreotype camera in an exceedingly short period of time.[42] West recalls that the camera (show here in figure 1.7) was made "in a few days."[43] The collaboration between the mechanic Prosch and the artist Morse harked back to a pre-existing collaborative culture of inventiveness in American society.

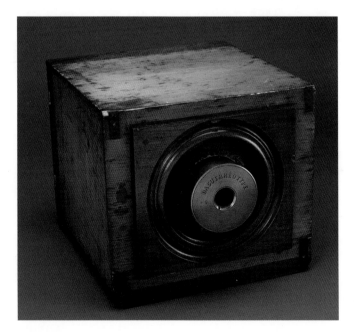

FIGURE 1.7
Samuel F. B. Morse's daguerreotype camera. Photographic History Collection, National Museum of American History, Smithsonian Institution.

Having the camera, though, was only half the battle. As Morse continued to experiment with the new medium, he also continued to balance his training as an artist with his reliance on the worlds of manufacturing and technology in order to produce images. Like many other early experimenters, Morse had to create, find, or buy the remaining equipment the daguerreotype process required: plates, lenses, chemicals, and a developing box. American manufacturers scrambled to produce the necessary materials. The difficulty Morse had finding suitable plates is a perfect example of how an early practitioner had to struggle to find equipment and of how an American manufacturing company attempted to transform itself to answer the needs of the new industry. Morse began by using plates coated with silvered copper bought at a hardware shop. However, the silver was impure. Although he was able to obtain results with the plates, he found them unsatisfactory.[44] Eventually he ordered 38 silvered plates from the Scovill Manufacturing Company in Waterbury, Connecticut, a firm that specialized in rolled metal products such as buttons and door hinges. The Scovill Company jumped at the chance to expand its production. Its owner, J. M. L. Scovill, wrote:

The Daguerreotype is going to be all the go here for a time & they have to use Plated Metal to get the Picture on … . Professor Morse called on me today he had been to Chamberlin [Scovill agent in New York] & ordered 38 plated 6½ × 8½ in. for a trial. … Mr. Morse thought the quantity wanted would be great as soon as it was got in operation.[45]

Scovill rushed to get plates to Morse and other early experimenters. The daguerreotypists, he wrote in a letter to his brother, "want to get the views before the leaves are off the trees."[46] The plates were ready in a few days, but were completely unsuccessful. It took several more months of trial and error on the part of the Scovill Manufacturing Company to produce a plate that was comparable to those being produced in France. J. M. L. Scovill confessed to his brother that the local daguerreotypists were not pleased with the situation, but expressed confidence that the firm would persevere: "Professor Morse & all hands are Chop Fallen about it, but … they shall want 300 lb. per week if it can be made here & the only difficulty is in the plating."[47] By January of 1840 the Scovill Manufacturing Company had solved its plating problem, and by the mid 1840s it was the leading American manufacturer of daguerreotype plates.[48] Morse had moved on by then, however. He complained to George Vail, Alfred Vail's brother and the major financial source of the telegraphic experimentation, about the difficulties in acquiring suitable plates, and about their price:

I have the Daguerreotype apparatus just completed and hope today to try an experiment with it. I am troubled to get proper plates. The silver workers have put on such a price that they have put a damper on the whole matter. This will not last long as we shall have imported plates soon which will make them reasonable. A dollar and a half! And 5 cents for a plate of silvered copper 8½ by 6½ inches is a little too hard upon the *specie currency* just now.[49]

Eventually, Morse came to rely on Corduan, Perkins & Company, a New York firm devoted solely to making daguerreotype plates.[50]

Morse was also having difficulty obtaining an adequate lens for the camera Prosch had constructed. In mid November he wrote to Daguerre complaining that in the course of his experiments he had met with "indifferent success, mostly, I believe, for the want of a proper lens." Morse asked if Daguerre would choose two lenses made by Messrs. Edward & Co. for him, which a M. Lovering would then send to him in the States.[51] There is no indication that Daguerre replied to that letter. A year later, Morse wrote to Lovering to ask what had become of his request, adding "I never heard from you nor had any intimation that my letter was ever received. After waiting some months, I procured both lenses and plates here."[52]

When dealing with the technical aspect of acquiring and learning to use the new daguerreotype equipment, Morse, with his background as a painter, was also concerned with the quality and the content of the images he produced. He experimented with a variety of types of views, pondering what would make the most effective landscapes and still lifes. Although he wanted to travel to Morristown, New Jersey to photograph the Vail family's Speedwell Iron Works ("I hoped to be able to take a Daguerreotype view of Speedwell this season"[53]), he put the trip off, claiming that waiting to make the picture until the leaves would be back on the trees would create a more pleasing result.[54] He also experimented with still-life images similar to those he had viewed in Daguerre's studio and those the French examples that were circulating in New York:

I have taken an interior view, busts, books, rug, etc. From the place where the camera is fixed, I can discern that the books are lettered on the back but cannot read them with the naked eye; the picture has these books, reduced of course to a very diminished scale, with the naked eye the *lines* of letters are perceived but the *letters* themselves cannot be perceived, yet with a magnifier every letter is visible and easily legible.[55]

COLLABORATION

At some point, Morse must have realized that not only did he need a mechanic to create his equipment, he also needed a business partner if he wanted to turn a profit with the daguerreotype. In seeking a suitable partner, Morse followed his established pattern and first sought someone with technological skills. Alexander Wolcott (a New Yorker who had invented and patented a "mirror" camera, which had no lens but instead used mirrors within the camera and outside the studio windows to direct sunlight onto the plate and the sitter) seemed a logical choice.[56] Wolcott had used his "mirror" camera to make portraits, and some of his first sitters had included other early practitioners, including Morse. The "mirror" camera had caused quite a stir among the daguerreotypists in New York, and Morse was

impressed.⁵⁷ But Wolcott declined Morse's invitation to work with him, causing Morse to turn to a scientist: John William Draper, the aforementioned professor of chemistry at the University of the City of New York.

Draper was 28 years old when he was appointed to the university in 1839, and he retained the position for the remainder of his life. His full contributions to the realm of scientific daguerreotyping are the subject of chapter 3, so here he will be considered primarily in relation to his work with Morse. Whether Morse and Draper met through the university or through their shared interest in the daguerreotype is not known, but they probably exchanged advice throughout the fall of 1839, when each was independently experimenting in his room at the university.⁵⁸ Their collaboration is particularly representative of the interdisciplinary nature of the early daguerreotype, and of the kinds of strange bedfellows the new medium created (though perhaps not so strange in this case, owing to Morse's long interest in technology). Their partnership probably began in the spring of 1840, probably in late March or early April. Sometime in that period, they opened a portrait studio on the roof of the university. The studio, described as a "primitive gallery," consisted of "a turret room for a workshop, and a hastily constructed shed, with a glass roof, served for an operating room."⁵⁹ It was one of the earliest commercial portrait studios opened in the city, though not the first—Wolcott had opened one at least a month earlier, and had advertised its availability to sitters in early March.⁶⁰

Undaunted by the potential competition, Morse and Draper commenced taking portraits of their fellow New Yorkers. Though it appears that the joint studio was more a place of experimentation and exploration than a serious commercial venture (though neither Morse nor Draper was averse to making a profit, particularly Morse), each of them made a point of advertising his skill in photographic portraiture. They did so, however, in very different ways.

In late March, Draper sent a notice to the *London and Edinburgh Philosophical Magazine* claiming that he had "succeeded during the winter in procuring portraits by the Daguerreotype."⁶¹ The choice of that magazine is telling: Draper was promoting his abilities to the European scientific community, from which he desired acceptance and legitimacy. Morse, on the other hand, trumpeted his skill in a New York newspaper, his brother's *Observer*:

Prof. Morse has succeeded in taking the miniature of his daughter, by improving upon the discovery of M. Daguerre. The picture is executed quite perfectly too, and as well delineated as the pictures of objects without life. Europeans have not succeeded in taking Daguerreotype likenesses of persons.⁶²

The language of this notice was very deliberate. Morse was already asserting the primacy of American daguerreotyping, carefully noting that he had "improved upon" Daguerre's discovery and reminding his audience that Europeans had not yet been able to create a likeness of a living person. Though daguerreotyping wasn't an

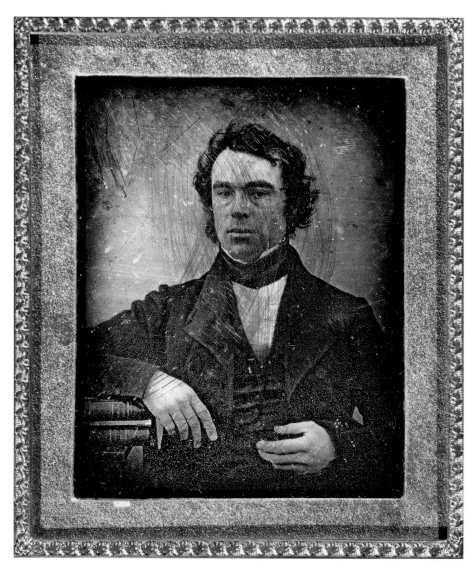

FIGURE 1.8
Artist unknown (possibly Samuel F. B. Morse), *Portrait of John William Draper*, daguerreotype, c. 1840. Division of Medicine and Science, National Museum of American History, Smithsonian Institution.

American invention, Morse was declaring the Americans had, in less than a year, made it better. Morse's insistence on nationalizing his achievement was consistent with contemporary American attitudes regarding invention and technology, which Morse enthusiastically endorsed.

Considerably more information exists about the Morse-Draper studio than about many other early daguerreotype studios. Many of the details Morse and Draper later recalled (for example, "we made a charge to those who sat … as our experiments had put us to considerable expense") seem trivial, but we also learn they charged five dollars per picture, a fairly substantial amount of money in the 1840s.[63] Draper noted that the pair used "a four-inch lens, and then … an achromatic lens and plates, both French, which we imported," confirming the continued scarcity of quality equipment in the States.[64] They also revealed that members of the city's elite, including Theodore Frelinghuysen, chancellor of the university and a future vice-presidential candidate, were fascinated with the process and had flocked to the studio.[65] It seems that the high price initially made the daguerreotype prohibitive for many New Yorkers, for that first summer at least. But such was the fascination with the daguerreotype that the pair had "all the business they could possibly attend to," taking portraits on sunny days and teaching others the practice of daguerreotyping on cloudy days. Morse's cousin Samuel Breese, who was living in the *Observer* building and working with Sidney Morse, chronicled the growing success of the studio in letters to his family. According to Breese, "Cousin Finley" (that is, Samuel Finley Breese Morse) made considerable progress in the summer of 1840. On June 30, 1840, Breese wrote to his father "Finley spends most of his time at the University trying hard to take Daguerreotype Portraits without much success."[66] On July 9, Breese sent his sister Catherine two daguerreotype views, commenting: "The picture of the Astor House is not as good as I wish it was but is the best I can get unless I pay a high price. The view of the City Hall is I think the best picture taken in this country yet."[67] It isn't clear from the July 9 letter whether the views mentioned were taken by Morse or by someone else, but the letter does demonstrate that in those early days the sheer novelty of having a photographed view of something, not necessarily of oneself, was thought to be worth a considerable price. The letter also tells us that that price remained high: Breese could not afford the better view.

By August of 1840, Breese had had his own picture taken: "I have lately had my portrait taken by the Daguerreotype. It is tolerably good as a likeness they say—I am not exactly suited with it and in time having a better one taken. … Cousin Finley has taken quite a number and lately has been quite successful."[68] Since June, then, Morse had become "quite successful," a far cry from Breese's report of two months earlier. It seems reasonable to assume that over time Morse, like many other early daguerreotypists, had become successful both monetarily, in that his business was progressing, and also in skill, in that he was becoming more proficient with the process as he continued his experimentation.

STILL LIFE

Only one plate survives from the Morse-Draper partnership; it is shown here as figure 1.9. Created in 1840, it features images of four prints after works of fine art, a statuette of Venus, a roll of sheet music, a funnel, a graduated beaker, and a chemistry textbook. On its most surface level, this plate offers an overly pedantic display of photography as a marriage of art and science. It also provides a meditation on the Morse-Draper partnership, and on the interdisciplinary nature of the daguerreotype overall. The plate's combined elements of art and science are clearly meant to represent the collaboration. Draper is surely represented by the label on the spine of the chemistry textbook that can be seen resting on a ledge in the lower central portion of the plate. The label reads "Hare's chem.," carefully written backward so it would be legible to the viewer in the finished plate. Dr. Robert Hare had been Draper's chemistry professor at the University of Pennsylvania.[69] Morse's involvement is indicated by

FIGURE 1.9
Samuel F. B. Morse and John William Draper, *Still-Life*, quarter-plate daguerreotype, spring 1840. Photographic History Collection, National Museum of American History, Smithsonian Institution.

the grouping of prints after paintings, particularly those after Old Master paintings, that constitute the primary focus of the work. Morse wrote twice about attempting to photograph a still-life scene, first in a November 1839 letter to his telegraphic partner Alfred Vail ("I have taken an interior view, busts, books, rugs, etc.") and then again in February of 1840, when he recorded in his journal an attempt to capture a group of prints assembled upon cloth: "Arranged objects on the roof in the open air, just without the window. bright sun. … A little wind agitates the drapery and prints after 5 minutes a gust of wind deranged all the prints. No result."[70]

Photographing works of art was not uncommon among early practitioners. Both Daguerre and Hippolyte Bayard (who created a direct-positive photographic method that failed to win the same governmental support as the daguerreotype) produced works that featured assemblages of sculptural pieces. The same is true of François Gouraud, a student of Daguerre's who was in the United States in late 1839 through the early 1840s on behalf of Alphonse Giroux, a manufacturer of daguerreian equipment, and with whom Morse quarreled in the press.[71] Gouraud's only extant plate (figure 1.10), also from 1840, contains only images of sculptures, though apparently he included paintings in some of his plates. Other early French plates by François-Alphonse Fortier and Baron Armand Pierre Séguier are typically also groupings of sculptures with a painting or a print included. William Henry Fox Talbot, the Englishman who introduced a paper photographic method, produced images of single sculptures, most famously his *Bust of Patroclus* (figure 1.11), and multiple images of various prints. As Talbot made clear in his 1844 publication *The Pencil of Nature* (arguably the first photographically illustrated book), sculpture was a highly desirable photographic subject in that its whiteness offered a natural range of tonal contrasts that translated well into the new medium. The same argument could easily be applied to the photographing of graphic works on paper, whose typically black and white tonalities also made for striking photographic subjects. As Talbot pointed out, the photograph also offered the possibility of preservation and duplication, at any desired scale, of an original print or drawing.[72]

The vast majority of photographs of two-dimensional images from this period, such as *Still Life* by François-Alphonse Fortier (1839–40, Société Française de Photographie, Paris), are in essence simple reproductions or groups consisting primarily of sculptures with an occasional print added. Morse surely saw some of these French still lifes, either at Daguerre's studio in Paris or in exhibitions in the United States by Gouraud, and must have been inspired by them. Morse and Draper's *Still Life* differs from other early examples, however, in its direct representation of art and science, and in that it appears to be the earliest known photograph that features an assemblage of *prints* as its primary subject, with sculpture relegated to a secondary position.[73]

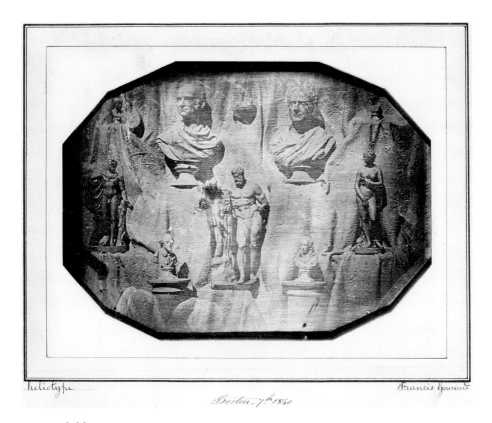

FIGURE 1.10
François Gouraud, *Still Life of Plaster Casts*, daguerreotype, 1840. Museum of Fine Arts, Boston. Gift of Mrs. Joyce Cushing Brandsma in memory of Bradford Cushing Edmands. Photograph © 2015 Museum of Fine Arts, Boston.

FIGURE 1.11
William Henry Fox Talbot, *Bust of Patroclus*, salted paper print from paper negative, August 9, 1843. Metropolitan Museum of Art. Gift of Hans P. Kraus Jr. Image © Metropolitan Museum of Art.

Morse must have been attracted to the particular prints that appear in the plate shown here as figure 1.9 by their formal qualities. Consisting solely of faces, the photographed prints are clear and easily read by the viewer. The two faces on the right side of the plate gaze outward at us, inviting the viewer to contemplate the extraordinary new technology. The top image is a print after the Louvre's *Portrait of a Young Man* (figure 1.12), which has been variously attributed to Raphael, Parmigianino, Correggio, and Perino del Vaga. The bottom right image remains unidentified, but the female figure's short curls, headband, and draped shoulder are similar to neo-classical works dating from the late eighteenth century or the early nineteenth century, such as *Portrait of Pelagia Sapiha* by Elisabeth Vigée-Lebrun (1794,

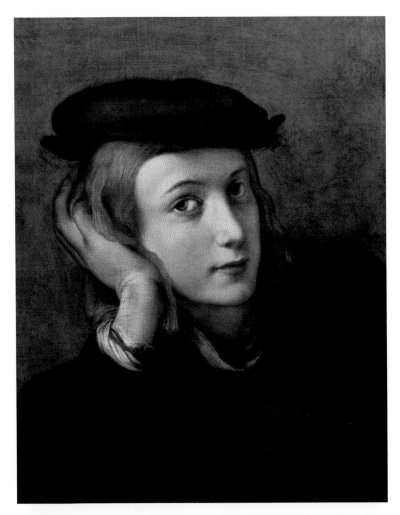

FIGURE 1.12
Parmigianino (Francesco Mazzola), *Portrait of a Young Man (self-portrait?)*, oil on canvas, c. 1524. Musée du Louvre. Erich Lessing / Art Resource, New York.

Royal Castle, Warsaw).[74] The other faces in the daguerreotype contemplate the array of scientific instruments displayed on the shelf below them. The bottom central figure is a print of a detail from Leonardo's *Madonna of the Rocks*, also in the Louvre; this print illustrates the face and shoulders of that painting's angel (figure 1.13).[75] Finally, Morse seems to have humorously positioned the print on the left: head in hand, the helmeted face examines the scientific instruments with a degree of anxiety, as if slightly overwhelmed about the volume of gathered equipment. This print is a detail from François-Pascal-Simon Gérard's 1801 painting *Ossian Evoking Ghosts on the Edge of the Lora* (figure 1.14), and the face shown is Fingal, Ossian's father and a hero in Ossian's poems.[76]

There are several possible visual and iconographic precedents for Morse's arrangement of the prints and other elements in this daguerreotype. One is the tradition of painted deceptions—the form of life known as "trompe l'oeil", which translates to "trick the eye" or "fool the eye." Such pieces have been executed since the Classical era. Although Morse and Draper's *Still Life* is not a proper deception in the most

FIGURE 1.13
Leonardo da Vinci, *Virgin of the Rocks* (detail of the angel), oil on arched wood, c. 1485. Musée du Louvre. Photo: Herve Lewandowski, © RMN-Grand Palais / Art Resource, New York.

FIGURE 1.14
François-Pascal-Simon Gérard, *Ossian Conjures the Spirits on the Banks of the Lora with the Sound of a Harp*, oil on canvas., ca. 1811 Hamburger Kunsthalle, Hamburg, Germany. Photo: Elke Walford / Art Resource, New York.

literal definition of the term—it is not something painted to "trick" the viewer into believing it is real—the daguerreotype contains specific elements that suggest a kinship with painted deceptions. The four faces are formally reminiscent of paintings that act as both portraits and trompe l'oeils—for example, Charles Willson Peale's *Staircase Group: Raphaelle Peale and Titian Ramsay Peale* (1795, Philadelphia Museum of Art), and Louis-Léopold Boilly's *A Collection of Drawings (with Boilly and Elleviou)* (c. 1800, private collection, France). The sitter for the *Portrait of a Young Man* and the unidentified young woman both peep out at the viewer alertly, almost flirtatiously.

Fingal's upward, sweeping gaze from the far left of the plate takes in Leonardo's bashful angel, the scientific instruments, the chemistry textbook, and the vases on the shelf at the lower edge of the plate. The angel gazes at the same assortment of objects in a contemplative manner. One of the most charming elements of the work is also its most deliberate deception: the statuette of Venus, running along the right side of the image, is holding a drape in her outstretched hand, and with it she gently brushes the printed female subject's cheek.

An additional formal similarity to trompe l'oeil paintings of the era is found in the arrangement of the four rectangular works on paper, which strongly resemble the quodlibet (Latin for "what you please") or "letter-rack" form of trompe l'oeil that had been popular since the late fifteenth century. These paintings feature arrangements of objects—typically letters and bills, but also occasionally images tacked or taped to a wall.[77] In America, such works were executed by a number of well-known artists, most notably by various members of the Peale family. Samuel Morse's father had a direct connection to the Philadelphia cartographer and trompe l'oeil painter Samuel Lewis, who worked with Jedidiah Morse as a cartographer on the later editions of *American Geography*.[78]

When *Still-Life* is compared against Samuel Lewis's trompe l'oeil painting *A Deception* (c. 1780, figure 1.15), similarities are instantly apparent. Each image contains diagonal, rectangular shapes of paper suspended on the picture plane, cunningly layered and overlapped to demonstrate pictorial depth. In *A Deception*, as in all other letter-rack paintings, this layering serves to trick the viewer into thinking that the painted space is part of reality; it also showcases the skill of the individual artist. The overlay of the prints in Morse and Draper's still life highlights the pictorial depth of the daguerreotype, but here Morse is showing the actual depth of the space photographed. The arrangement and condition of the prints, and especially of the variously shaped glass containers that line the shelf in front of the prints, not only demonstrates Morse's skill as an artist but also emphasizes photography's capabilities as a medium. Through the composition, Morse reveals the daguerreotype's ability to capture every detail of every complex element displayed, regardless of the pictorial depth, and demonstrates that the medium can capture the transparency of glass, the shadows of solid objects, and the textures of fabrics. Just as Lewis skillfully rendered the torn, curled edges of some of the more well-handled pieces of ephemera in his painting, Morse's daguerreotype faithfully captures tattered and folded edges.

Trompe l'oeil paintings typically feature a "cartellino," a little notecard or piece of paper that bears the artist's signature or other identifying message. Morse and Draper make a nod to the cartellino tradition with their deliberate labeling of "Hare's Chem" on the spine of the book that occupies the central lower position of the plate.

FIGURE 1.15

Samuel Lewis, *A Deception*, pen and black, iron gall, and colored inks with watercolor over graphite on laid paper, c. 1780. Gift of Max and Heidi Berry. Courtesy of National Gallery of Art, Washington.

Another still-life painting that might have provided Morse with some inspiration is Charles Bird King's *The Vanity of the Artist's Dream* (figure 1.16). King and Morse were well acquainted. They had been students together at the Royal Academy in London in the early 1800s. King had been nominated to the National Academy of Design in 1827, while Morse was president. Morse's cousin Thomas R. Walker owned *The Vanity of the Artist's Dream*, and Morse was a frequent visitor to the Walker household in Utica during this time period—on one visit he photographed Thomas's wife, Sarah Breese Walker, and expressed a desire to photograph Thomas in New York City.[79] *The Vanity of the Artist's Dream* depicts, piled high within the illusion of a frame or a cupboard door, some books, a palette, rolls of sheet music, the broken head of a cast of Apollo, a half-eaten chunk of bread, and a painting depicting Plenty discarding the contents of her cornucopia. According to Andrew Cosentino, the painting represents the struggle between the fine arts and society (specifically the rejection of the arts by society) and also has elements of an "attributes" painting of the eighteenth century.[80] Morse and Draper's daguerreotype shares these "attributes" characteristics with the inclusion of the roll of sheet music and the statuette of Venus; however, it offers a more hopeful future for the fine arts than *The Vanity of the Artist's Dream* does—a future in which the arts co-exist harmoniously with the sciences and technology.

Morse's still life also demonstrates compositional and ideological similarities to his painting *Gallery of the Louvre*. In each, Morse acts as the controlling agent, carefully selecting and arranging the works he deems most important for the viewer to encounter. The formal similarity of the still life to *Gallery of the Louvre*, in conjunction with Morse's published statements regarding the daguerreotype, suggests that while he was actively involved in photography Morse regarded the medium as a potential pedagogical tool with which he could continue his lifelong mission to educate the American public and to uplift American standards of taste. *Gallery of the Louvre* was one of Morse's greatest efforts in that mission. The six-by-nine-foot canvas features the Salon Carré of the Louvre hung ceiling to floor not with the contemporary French paintings that probably were displayed there in the early 1830s, but with Old Masters culled from other parts of the museum. *Gallery of the Louvre* showed Americans what good art was and provided examples of how to approach it.[81] Morse believed that a knowledge of good art would lead to good taste, particularly in the general public. He made similar claims about the daguerreotype: when he initially encountered the process, writing to his friend Washington Allston: "Art is to be wonderfully enriched by this discovery. ... Artists will learn how to paint, and amateurs, or rather connoisseurs, how to criticise ... and therefore how to estimate the value of true art."[82] He continued this line of thinking in a speech to the National Academy of Design in which he mused on the relationship between the daguerreotype and public taste: "It is clear that in so far as individuals

FIGURE 1.16
Charles Bird King, *The Vanity of the Artist's Dream*, oil on canvas, 1830. Gift of Grenville L. Winthrop, Class of 1886. Fogg Art Museum. © Harvard Art Museum / Art Resource, New York.

are interested in observing [the daguerreotype's] wonderful production, their taste must be improved."[83] Morse's still life offers a promise that the daguerreotype has the potential to revolutionize art's relationship with the sciences and technology. By showing the clarity with which the daguerreotype was able to capture the details of the diverse elements within the plate, Morse was supporting his argument that the daguerreotype would be a great aid to artists. In the aforementioned speech on daguerreotyping to members of the National Academy of Design, he encouraged the assembled academicians to envision how art could be improved by the new medium:

Think how perspective, aerial as well as linear, is illustrated and established by [the daguerreotype's] results, and, as a consequence, proportion also. How the problems of optics are confirmed and sealed for the first time by Nature's own stamp! See, also, what lessons of light and shade in all their fascinating varieties, are fixed and brought under the contemplation and closest scrutiny of the artist!

The precision of photography would also help guide the public. Viewers' taste would be improved, Morse contended, by their studying portions of nature, which would enable them to learn the value of a good painting. Morse mused that an observer who had been educated by the lessons of the daguerreotype's accuracy would exclaim "I used to think [artists] exaggerated in their light or shade, but here I see that their effects correspond with those of nature's drawing."[84]

SOLO PRACTICE

Morse and Draper's emphasis on experimentation rather than serious profit is typical of many early American daguerreians. Almost all of those who were in the vanguard of early photography abandoned the medium within a few years of its introduction. They experimented, they explored, and they improved upon the medium, but few of them took part in the enormous surge of commercial activity that characterized the American daguerreotype through the remainder of the 1840s and continued into the 1850s. Draper left the partnership in the fall of 1840, later stating he had done so in order to resume his teaching duties at the university.[85] Morse continued alone, taking a brief stab at the daguerreotype as a strictly commercial venture before he too quit photography for good.

Morse did not appear to have much luck. The shift from experimentation to commercial venture proved to be quite challenging, particularly without a partner to help shoulder the burden. "I am tied hand and foot during the day endeavoring to realize something from the Daguerreotype portraits," he wrote to Alfred Vail, adding "I am under the necessity of attending to duties which will give me the means of living."[86] By November, Morse had moved out of the university studio

and had opened a new one on the roof of his brother's *New-York Observer* building at the corner of Nassau and Beekman streets in lower Manhattan.[87] He claimed that an enormous skylight he had had installed in the new studio enabled him to reduce in exposure times drastically:

> It is true that I have taken portraits in diffused light in ten seconds, and one not so strongly marked in *five seconds*. I feel confident that I can make an arrangement by which I can take a portrait in two seconds if not in one. ... [The new studio] is entirely of glass, so that I have nearly the effect of outdoor light. ... I have also used the sun which gives a more pleasing result on the face, and in ten seconds gave a beautifully sharp and well defined delineation of all the features.[88]

Morse's cousin Samuel Breese also wrote about the new studio to his family in upstate New York, again emphasizing Morse's continuing development of the medium:

> Finley is very busy fixing up his glass palace on the roof of the house and in a few days will be able to receive his visitors. He has a fine parlour in the third story for the purpose of receiving ladies, and a woman to wait upon them thus—I am afraid that you did not receive a very favorable impression of Daguerreotype portraits from the specimens I showed you, they are not all as bad as mine.[89]

Sidney described the studio to the third Morse brother, Richard, in similar terms, adding that "the workshop over the room where I sleep has been fitted up for the purpose [of daguerreotyping], the roof having been removed [and a] skylight built over the whole."[90]

Morse probably took one of his only known extant portraits, *Portrait of a Young Man* (figure 1.17), in the aforementioned studio. Nelson eventually became a well-regarded Methodist minister; at the time this portrait was taken, however, he was about 22 years old and newly ordained. Though the image conveys a certain amount of stiffness, it is a compelling portrait nonetheless. Perhaps most striking is the intensity of Nelson's stare. Nelson exhibits a solemn, almost stern countenance. It is almost certain that he never had been photographed before. ("Many daguerreotypes," the contemporary writer T. S. Arthur noted, "have a strange, surprised look, or an air as if the original was ill at ease in his or her mind. Of course, these various impressions are all the result of an effort to sit perfectly still and look composed. Forced ease is actual constraint, and must appear so. In Daguerreotype portraits this is particularly apparent."[91]) Surely Nelson was attempting to appear relaxed, and the effort caused him to appear even more constrained and nervous than he would have otherwise.

Another striking characteristic of the portrait of Reuben Nelson is the off-center placement of the sitter, which has been attributed to Morse's relative lack of daguerreian skill and the work's early date.[92] Morse's portrait of Nelson, however, actually displays the artist's dexterity in arranging his subject: in his early teen years, Nelson had lost his right arm in a factory accident.[93] Morse carefully positioned his sitter so

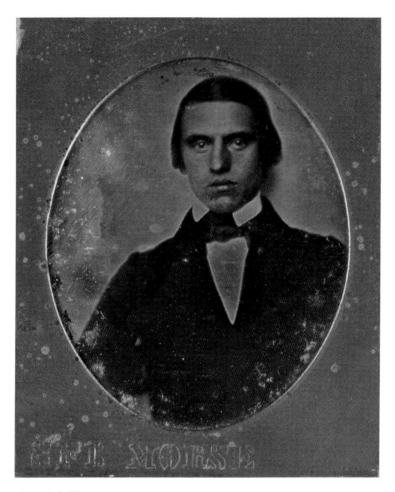

FIGURE 1.17
Samuel F. B. Morse, *Portrait of a Young Man* [Reverend Reuben Nelson], daguerreotype, November 1840–August 1841. Gilman Collection, Metropolitan Museum of Art. Gift of the Howard Gilman Foundation, 2005. Image © Metropolitan Museum of Art.

he was slightly off center, leaving Nelson's left arm and shoulder in full view, and carefully cropped his right arm out of the frame. The same technique is evident in a portrait of Nelson painted about thirty years later by Thomas Buchanan Read (1870, Wyoming Seminary, Kingston, Pennsylvania). Read also cropped out the majority of Nelson's right arm, yet, like Morse's daguerreotype, the composition is elegant.

Sidney Morse had spent $500 on outfitting his brother's new "palace of the sun" (as he called it), and had hoped to be repaid quickly. Unfortunately, Samuel Morse remained commercially unsuccessful. Sidney remained optimistic about the enterprise, writing to their brother Richard "I cannot but think that [Samuel] will earn soon $20 or $30 a day by Daguerreotype portraits." Sidney did offer an explanation, though, as to why Samuel was not making any money: "He has taken some beautiful groupes; but as yet none for which he has received pay."[94]

By the winter of 1840–41, daguerreotype studios were becoming more common. Whereas most of the very early experimenters had been interested in science or technology, people from a diverse array of backgrounds were now beginning to take up the profession because it had the potential to be quite lucrative.[95] Most of the new practitioners were seeking to make money from portraiture. It appears that Samuel Morse, on the other hand, was using his studio to create compositions for potential paintings, which is probably why he received "no pay" for any of the "beautiful groups" he photographed. Morse's cousin, Reverend Edward S. Salisbury, commissioned a painting from Morse and forwarded him $300 as advance payment. Morse feared he was rusty after not painting for several years, but he promised his cousin he would try to complete the painting with help from the daguerreotype:

I am at present engaged in taking portraits by the Daguerreotype. I have been at considerable expense in perfecting the apparatus and the necessary fixtures, and am just reaping a little profit from it. My ultimate aim is the application of the Daguerreotype to accumulate for my studio models for my canvas. Its first application will be to the study of your picture.[96]

Morse's "beautiful groups" were unusual enough to warrant notice from the press on at least one occasion:

Mr. Morse has executed lately some Daguerreotype likenesses, which have extraordinary beauty in their way. We have just seen a family group of three persons taken by him, which, differently from most Daguerreotype likenesses, is really a beautiful picture. The arrangement of the group, and the attitudes, under the direction of the artist, are exceedingly elegant and agreeable. The expression of the countenances is also free from constraint and harshness which is often seen in things of this kind. The specimen we have seen was executed in the space of fifty seconds, not in the sunshine, but in what is called diffused light—the ordinary light of a well lighted apartment. Mr. Morse, in addition to his merits as an artist, possesses extraordinary mechanical skill, and has spent a great deal of time in endeavoring to perfect the Daguerreotype for the taking of likenesses of the human face and figure.[97]

It is possible Morse was not seeing any profits from his daguerreotype work because, rather than charging sitters for portraits, he may have been paying models for their time while also covering the expenses of plates and other equipment.

Perhaps because he was not making money from his photography, Morse began what amounted to an advertising campaign for the studio. He placed advertisements in at least four separate newspapers and journals. As other practitioners also did, he tried to word his advertisements so they would appeal to potential sitters. A notice that appeared in *Niles' National Register* (originally printed in the *Journal of Commerce*) may have been meant to appeal to those who were scientifically minded, as it was titled "Daguerreotype Discovery" and promoted the rapidity with which Morse was able to take portraits:

> By a peculiar preparation of the plate, discovered by Mr. Geo. Prosche of this city, daguerreotype likenesses are taken at the studio of professor Morse, with the most perfect correctness, in a second of time—as quick, indeed, as the aperture of the lens can be opened and shut again.[98]

In that notice, Morse was still acknowledging the contributions of his mechanic, George Prosch, who had manufactured his daguerreotype equipment. He must have thought that including Prosch's name and acknowledging their collaboration would appeal to clients. In other advertisements, he coolly asserted his abilities to work in poor weather. For example:

> DAGUERREOTYPE PORTRAITS, Taken from 10 o'clock A.M. until dark, at Professor Morse's studio, No. 136 Nassau street, opposite Brick Church, by S. BROADBENT. Professor Morse will generally be in attendance. N. B. Cloudy and even stormy weather present no obstacles to a successful result of the process.[99]

Here Morse was beginning to branch into another area of the daguerreotype business that soon would become commonplace: name branding. A few years later, Mathew Brady launched an empire of storefront studios up and down the East Coast. All the studios bore Brady's name, but rarely was he present at any of them. It was Brady's name that attracted clients, whether or not he was taking the photographs. Morse was hoping to use his reputation to draw sitters into his studio, even though he made it clear that sitters' pictures probably would be taken by his former student Samuel Broadbent.[100] A similar advertisement, placed in the *New York Mechanic*, was first published on April 17, 1841 and continued to run through the summer:

> Daguerreotype Portraits Taken with or Without Sunlight, from ten o'clock, A.M. until dark, every day at the studio of Professor Morse, no. 136 Nassau Street, Opposite the Brick Church, by S. BROADBENT. Professor Morse will generally be in attendance. N. B. —Portraits are taken equally well in *cloudy* and even in *stormy* weather. More recently likenesses are taken in the sunlight, in one second of time; without the sun in twenty seconds.[101]

Other advertisements also appeared in the *New York Mechanic*. On April 24, 1841, readers were informed of "*Daguerreotype Miniature Portraits in Perfection*—at Professor Morse's Saloon, corner of Beekman and Nassau Streets—detention one second—terms $6 including cases. Groups of three or four $8."[102] Another advertisement appeared the following week: "*The instantaneous painting of Apollo in perfection.*—We should hope that no friend of 'improvement in the arts and sciences,' would neglect to procure his *fac similie*, at Professor Morse's saloon, corner of Nassau and Beekman streets."[103] In the latter, Morse took a different tactic, attempting to appeal to the friends of "improvement in the arts and sciences" by comparing the daguerreotype to "instantaneous painting," thus aligning the daguerreotype with the fine arts and simultaneously acknowledging its status as a technological improvement within the sciences.

Toward the end of the summer of 1841, Broadbent left New York hoping to establish his own studio, and word must have gotten out that Morse needed a new assistant. Thomas Smiley of Philadelphia wrote to Morse inquiring after the job, but Morse had already hired someone, a Mr. N. V. Young.[104] Young apparently worked for Morse only for a few months; by late November he had opened his own shop in Baltimore with a Mr. Parker.[105] That Young took leave of Morse sometime that autumn suggests that Morse's interest in the daguerreotype was waning. Sarah Breese Walker, Morse's cousin, recalled that in the summer of 1841 Morse had attempted to take daguerreotypes of various members of the family in Utica, but that he also had spent much time discussing his electromagnetic telegraph.[106]

Throughout the fall of 1841, Morse distanced himself from the daguerreotype and re-focused his energies on his invention. That summer he had received a letter from Isaac Coffin, a Washington lobbyist, who had offered to assist Morse in petitioning Congress for funds to test the device.[107] The unexpected offer of help revived Morse's interest in the telegraph, and he spent a large bulk of that autumn making contact with his partners in the enterprise, Alfred Vail and Francis O. J. Smith.[108] Alfred and his brother George Vail, who had financed Morse's telegraph operation, were displeased that Morse had neglected the telegraph for so long in favor of the daguerreotype.[109] Insofar as the Vail brothers held the purse strings to the telegraph's finances until Morse received some money from Congress, it must have seemed prudent to Morse to devote himself fully to electromagnetism. In February of 1842, a congressman from Connecticut, William W. Boardman, agreed to sponsor Morse's petition later that year. Boardman recommended that Morse continue to advertise his invention until then, adding "It may be worth while to keep the matter before the public eye, and excite an interest in it."[110] In part because of that promise, in part because of the Vail brothers' annoyance with his photographic activity, and in part because of Isaac Coffin's reminder that "a claim ... needs the most constant, unceasing and untiring and vigilant attention to see that it is not

neglected [in Congress]," Morse reduced his daguerreotyping activities in order to pay more attention to telegraphy.[111]

There is very little mention of the studio, or of daguerreotyping at all, in Morse's correspondence after the autumn of 1841. One is left to wonder what became of the studio. Did N. V. Young continue to pose sitters in the "palace of the sun" from September to November while Morse negotiated with his telegraphic partners and the lobbyists in Washington? The studio itself remained on the roof of the *Observer* building until 1849, when the other Morse brothers asked if it could be dismantled. "You may ascertain the cost of restoring the roof of the Daguerreotype room, and let me know," Samuel Morse replied. "If the glass can be preserved in whole panes by a little pains in unputting, I can make use of it to great advantage. The larger plate glass I specially wish preserved."[112]

THE TURN TO TECHNOLOGY

Art, science, and technology: the important link between many aspects of Morse's production (his most significant paintings, *The House of Representatives* and the *Gallery of the Louvre*, the daguerreotype, and the telegraph) is that they are all forms of communicative representation through transcription of a subject via mechanical means. The camera obscura transcribed the scene in front of Morse so he could trace it for use in his larger composition, the photographic camera's optics and chemicals caused the subjects of his daguerreotypes to adhere to the plate, and the electromagnetic telegraph used electricity to physically transcribe the mark of the letter or number in Morse code onto the device's receiving tape. The types of communication are visual and written or coded, but they are all communication nonetheless. Morse's shift in focus from the fine arts to the technological did not, in fact, represent an enormous change in his thinking. It was just that: a shift.

Additionally, Morse's decision to drop daguerreotyping in favor of telegraphy was not, in fact, terribly abrupt, but can be situated within a larger cultural trend toward professionalization of all of the fields in which he was involved. Morse had always been keenly invested in technological innovation, even during his career as an artist. In some ways he had attempted to model his life after another early American artist, Charles Willson Peale, who was both a fine artist and a respected as a man of science. Peale, who founded a museum that contained specimens of natural history, including the first North American display of mastodon bones, was also an accomplished and well-respected painter. Peale was able to straddle the worlds of art, science, and technology admirably well; Morse, however, was not. The art world was frustrated by Morse's turn to technology and science, and because of his past as an artist the scientific community was mistrustful of his abilities.

One of the main differences between the reception of Peale and that of Morse is simply one of time. Peale was primarily active in the late eighteenth century. By the middle of the nineteenth century, when Morse was working, art and science had become increasingly specialized, and the "Renaissance Man" model embodied by Peale was no longer applicable. As the 1840s progressed, Morse found it impossible to be accepted as both a man of science and a man of art. Fellow artists and some members of the National Academy of Design (of which he was president) complained that he was spending too much time on telegraphy and not enough on his duties as president of the Academy:

[Morse] has been all winter at Washington ... trying hard to push his 'dunder & blixen' Telegraph thru Congres. ... I am afraid however that Uncle Sam will be found lightning proof in this case & that his unlucky Godson will return as he went with the exception of having exhausted the $700 salary from the N.A.D., with small benefit to the Fine Arts.[113]

Two years later, at least one publication called for his resignation as president of the National Academy of Design:

Mr. Morse has probably been doing more to confer renown upon himself, and benefit upon his nation, by his scientific labors the past five years, than he ever did before; but when he seeks for reputation in any other field of employment than that of art, he should resign his post. ... No true artist ever abandoned his profession.[114]

Morse did not accept re-nomination as the Academy's president that year.

But Morse was also increasingly aware that his past as an artist was hindering his reputation as a serious scientist and technologist. After he was awarded $30,000 by Congress to realize his proposed Baltimore-to-Washington telegraph line, Morse made what Kenneth Silverman has called "a bid for scientific respectability": he published an article titled "Experiments Made with One Hundred Pairs of Grove's Battery, Passing through One Hundred Sixty Miles of Insulated Wire" in his former professor's journal, *Silliman's American Journal of Science*.[115] Morse asked John William Draper to provide an addendum showing mathematically that his 160-mile experiment would also work over greater distances.

Perhaps because it was becoming clear that telegraphy was a viable and potentially lucrative technology, Morse was subjected to a series of lawsuits over patent rights. The cycle of lawsuits is too lengthy and complicated to detail in full, but the legal actions concerning telegraphy went on for six years (1848–1854).[116] The attackers included Morse's former business partners and associates Henry O'Reilly and Francis O. J. Smith. Morse's abilities as a scientist were brought under serious scrutiny. The most damning testimony came from Joseph Henry, possibly America's best-known scientist in the middle of the nineteenth century. In September 1849, in his deposition in the first of the lawsuits, Henry stated:

> I am not aware that Mr. Morse ever made a single original discovery in electricity, magnetism, or electro-magnetism, applicable to the invention of the telegraph. I have always considered his merit to consist in combining and applying the discoveries of others in the invention of a particular instrument and process for telegraphic purposes. ... [When I met Morse in 1837, he had] very little knowledge of the general principles of electricity, magnetism, or electro-magnetism. He made no claims ... to any scientific discovery.[117]

Of course, Henry felt he had been treated unfairly by Morse, in part because his important work on electromagnetism had been left out of the book on the telegraph that Morse's partner Alfred Vail had published. Also, Henry prioritized what he termed "abstract" science (what is now called basic or pure science), and made a conscientious distinction between theoretical science and the mechanical work of technologists or inventors. Henry believed in the importance of applying science to invention, but protested the belittling of theorists and their academic accomplishments and the adulation of inventors and machines.[118] Although the Supreme Court eventually granted Morse almost complete control of the patents on the electromagnetic telegraph (save the claim that Morse had exclusive use of electromagnetism for recording, which the Court felt was too broad), throughout the litigation Morse had been keenly aware of and defensive about his lack of formal scientific training.

Significantly, after Henry's deposition Morse made forceful statements rejecting his artistic past. In October of 1849, he ignored a plea from the artist Charles Ingham for financial help with the National Academy of Design's rent and other financial obligations.[119] The following month, he wrote of his break with his former profession to his old friend James Fenimore Cooper:

> My dear sir, the very name of pictures produces a sadness of heart I cannot describe. Painting has been a smiling mistress to many, but she has been a cruel jilt to me. I did not abandon her, she abandoned me. I have taken scarcely any interest in painting for many years. Will you believe it when last in Paris in 1845, I did not go into the Louvre, nor did I visit a single picture gallery. ... Except for some family portraits, valuable to me for their likenesses only, I could wish that every painting I ever painted was destroyed. I have no wish to be remembered as a painter, for I never was a painter.[120]

Coming so close on the heels of Joseph Henry's denigration of his scientific abilities (which so affected Morse that he began a years-long battle with Henry during which each of them published tracts defending himself against real or perceived accusations by the other[121]), Morse's complete denial of his artistic past cannot be separated from his desire to be accepted as a serious scientist and inventor.

Perhaps Morse's abandonment of the daguerreotype also had to do with the changing nature of the medium. As early as 1841 the daguerreotype was evolving into discursive spaces of "art," "science," and "technology." The hybrid quality of the medium was becoming compartmentalized as more and more enthusiasts

entered the profession and changed it from experimentation to an industry. Morse was a part of that shift, but chose not to remain in that world once the change was firmly underway. He had briefly believed the daguerreotype might augment his quest for the elevation of public taste; however, daguerreotyping did not evolve as he had hoped. Though artists made use of the new medium, it did not become the pedagogical tool Morse desired. Indeed, the widespread democratization of photography and its eventual reputation as a skill anyone could pick up in a matter of days (which in 1851 led to calls for increased professionalism in the field),would have been extremely distasteful to Morse. As the daguerreotype evolved, though, Morse's celebrity from telegraphy extended to his early work with photography. He was invited to judge photographic competitions and to weigh in as an expert in a debate having to do with Levi H. Hill 's claim to have made color daguerreotypes. Later in the nineteenth century, despite his short involvement with the medium, Morse would active promote himself as the "The Father of American Photography."[122]

2 "ALL NATURE SHALL BE HENCEFORTH ITS OWN PAINTER": THE INTERSECTION OF ART AND DAGUERREOTYPING

One of the greatest effects the daguerreotype had on American culture was on the visual arts; it was, after all, a new visual medium entering a realm of existing visual media. This statement is simultaneously patently obvious yet also underexplored. Reproducibility in imagery had, of course, long been in existence due to the circulation of prints. New technologies such as lithography, which had become commercially possible in the 1820s, helped print culture rise and flourish in the United States.[1] Most middle-class and upper-class homes contained prints, often views of landscapes, portraits of celebrities or other public or historical figures, or copies of Old Master paintings. Sporting events, cartoons, prints with religious, temperance, or moral scenes and messages, and images of ships all enjoyed wide circulation in the middle of the nineteenth century. Thanks in large part to the Apollo Association and its successor, the American Art-Union, that period also witnessed an increased circulation in the number of prints after fine art by American artists. The Apollo Association was founded in 1839, and in 1840 it began offering its members a print after a painting by an American artist. Members in New York City were also issued tickets to an annual lottery in which a painting from the association's collection was the prize. By 1851, when it disbanded, the American Art-Union was responsible for greatly increasing the American public's appreciation of native art, and for introducing reproductions of art into a much wider swath of middle-class homes than had previously existed.[2]

The daguerreotype, then, was entering a market that was well accustomed to the circulation of imagery and that, as the success of the American Art-Union demonstrates, was increasingly hungry for imagery. Prints and daguerreotypes were both reproductive visual technologies, yet the causal relationship of the daguerreotype to its subject was new. Daguerreotypes, though, could not be reproduced endlessly, as prints could; a daguerreotype was a unique image on its metal plate, with no preliminary drawing.

Also, the daguerreotype required a machine—the camera—to create its image, unlike the preliminary drawing often from hand used to create a print.

This chapter explores the question of how artists and the general public related to a new form of visual production that was as much a product of technology as it was of fine art. The relationship of the daguerreotype to the existing fine arts, including prints, painting, and sculpture, had to be created. How were these new images to be displayed and exhibited? How did artists perceive and utilize the daguerreotype? How did daguerreians position themselves in relation to the fine arts?

ARTISTS ON THE DAGUERREOTYPE

The public reaction to the daguerreotype was striking and immediate, and many wondered about the new technology's potential effect on the fine arts. Artists reacted in a variety of ways, and spent the 1840s adapting and adjusting to the presence of a new medium, developing a complex and often contradictory relationship with the daguerreotype that in many ways mirrored the concerns of American society as a whole toward proliferating technologies. Some expressed fears that the ability for anyone to create a daguerreotype image would be the ruin of some existing media, particularly printmaking and miniature painting. For example, *The New-Yorker* worried that "painters of views" would be "superseded," with "many worthy and industrious men out of employment": "for who, that really values views, will not prefer the real representation to the less to be depended upon?"[3] These speculations often used a grim sort of humor to mask their concerns, such as that expressed in one of the first widely published reactions to the daguerreotype: "Steel engravers, copper engravers, and etchers, drink up your aquafortis and die! There is an end to your black art. ... All nature ... shall be henceforth its own painter, engraver, printer and publisher."[4] Similarly, *Godey's Lady's Book*, discussing the plates of Philadelphia daguerreotypist Robert Cornelius, slyly observed: "A few more [daguerreian] experiments in this way, and we shall do without engravers—those very expensive gentlemen."[5] Yet these somewhat humorous comments masked an underlying anxiety that was not altogether displaced: at least one artistic practice and industry—miniature painting—was virtually decimated by the arrival of the daguerreotype.[6]

Other reactions included outright disbelief. A Philadelphia engraver named John Sartain, for example, succumbed to the idea that the daguerreotype was a hoax. Sartain and some other prominent Philadelphia artists were gathered at the home of a local architect for an Artists Fund Society reception when Morse's letter from Paris describing the new process was read aloud. The letter, according to a later recollection, "was received with considerable ridicule by most present. After the discussion the consensus of the meeting was that they could believe Herschel's moon story, but this one—never."[7] Morse himself, however, followed his letter with continued

public support of the medium once he returned to the United States. He was one of the first Americans to comment publicly on the potential relationship of photography with the fine arts, and because he was president of the National Academy of Design his influence appears to have been considerable. He was overwhelmingly positive about the new medium. His remark upon first viewing Daguerre's works—"The impressions of interior views are Rembrandt perfected"—was an enthusiastic endorsement of daguerreotyping to the American artistic community.[8] He continued this public support by nominating Daguerre to the National Academy of Design, and Daguerre was accepted by the artists with a unanimous vote.[9] The National Academy of Design was, in 1839, the most prestigious arts organization in the country. It had been founded by Morse and several other artists in 1825 on the principle that an arts organization ought to be run by artists. Morse had been serving as president since its inception. It is important to recall that when Morse nominated Daguerre for membership, in May of 1839, he probably was the only member of the Academy to have actually seen a daguerreotype. Daguerre was elected to the Academy more because of the Academicians' faith in Morse than their faith in the unknown process.

By the spring of 1840, examples of daguerreotypes were circulating throughout New York City. Academicians requested that Morse directly address the new medium and its relation to the fine arts in a talk to be given at their annual supper.[10] The original document is now lost, but within a few days it was reprinted in several local newspapers. In his address, Morse clearly promoted photography as beneficial to art, artists, and public taste:

The daguerreotype is undoubtedly destined to produce a great *revolution* in art, and we, as artists, should be aware of it and rightly understand its influence. This influence, both on ourselves and the public generally, I am of opinion, will be in the highest degree *favorable* to the character of art.

He went on to assert that it was photography's ability to record "Nature" that would prove valuable to art and to artists:

By a simple apparatus, easily portable, [the artist] now has it in his power to furnish his studio with *fac-simile* sketches of nature, landscapes, buildings, groups of figures, &c., scenes selected in accordance with his own peculiarities of his own taste ... painted by Nature's self with minuteness of detail, which the pencil of light in her hands alone can trace, and with a rapidity, too, which will enable him to enrich his collection with a superabundance of *materials* and not *copies*;—they cannot be called copies of nature, but portions of nature herself.[11]

Morse told his fellow artists that such "portions of nature" must surely "modify ... the artist's productions." Daguerreotypes, he insisted, could assist with problems of optics, perspective, proportion, and teach precious lessons of light and shade. He concluded that the daguerreotype, in reproducing nature, must aid the average

person's appreciation of nature, and therefore of any art based on that nature—which, of course, is the form of art superior to all others. Therefore, the daguerreotype would certainly assist in elevating levels of public taste:

> I have but a moment to speak of the effect of the Daguerreotype on the *public taste*. It is clear that in so far as individuals are interested in observing its wonderful productions, their taste must be improved. Already have I witnessed its influence on many persons, who notice with surprise effects of light and shade and perspective, long familiar to artists. ... Can these lessons of *Nature's Art*, if I may be allowed the seeming paradox, read every day by thousands charmed with their beauty, fail of producing a more just estimate of the studies and labors of the artist, with a better and sounder criticism of his works? Will not the artist, who has been educated in Nature's school of Truth, now stand forth pre-eminent, while he, who has sought his models of style among fleeting fashions and corrupted tastes, will be left to merited neglect?

Morse finished his address by calling upon the assembled Academicians to recall the inventor responsible for photography, and by associating photography with the arts in no uncertain terms:

> Gentlemen, Daguerre is a painter; he is a member of this Academy. I, therefore, propose to you the following sentiment:—Honor to Daguerre, who has first introduced Nature to us, in the character of *Painter*.[12]

As was discussed in chapter 1, Morse also privately expressed his excitement to his mentor, the artist Washington Allston: "Art is to be wonderfully enriched by this discovery. How narrow and foolish the idea which some express that it will be the ruin of art, or rather artists, for everyone will be his own painter."[13] The daguerreotype perfectly fit Morse's interest in the beneficial effects of mechanical imitation, and he encouraged his fellow artists to share his enthusiasm for all the medium could do for the fine arts.

Morse's continued support of photography's relationship to art, particularly as president of the leading arts institution in the United States, gave the medium a certain validity in the US that it lacked elsewhere, even in its home country, France. Rather than grant Daguerre membership, the Académie des Beaux-Arts politely declined to meet with him, making it clear that the daguerreotype was not considered art.[14] The very things for which Morse praised the daguerreotype—its fidelity to detail, its ability to capture nature exactly—were those for which the majority of the French artistic community scorned it.[15] The Académie preferred the quiet, calotype-like results of the direct-positive process of Hippolyte Bayard.[16] The French, then, in contrast with the Americans, favored the "artistic" product over the "inventive" one.

Despite daguerreotyping's effect on miniature painting, many members of the American artistic community seems to have followed Morse's thinking. Perhaps hiding their fear, American artists insisted that the daguerreotype was not a threat to their profession. The chief argument for this stance was that the daguerreotype

was too thorough, too exacting, and too *mechanical* to be a threat to painters, particularly portrait painters. Thomas Cole, who was, in essence, the father of American landscape painting, wrote in 1840: "You would be led to suppose the poor craft of painting was knocked in the head by this new machinery [but] the art of painting is creative, as well as an imitative art, and is in no danger of being superseded by any mechanical contrivance."[17] After viewing an early exhibition of daguerreotypes, the editor of *The Knickerbocker* declared: "The daguerreotype will never do for portrait painting. Its pictures are quite *too* natural, to please any other than very beautiful sitters."[18] Morse himself assured the assembled members of the National Academy of Design that painting would merely be augmented by the photograph:

I hear it asked, "will not the Photographic portrait unfavorably affect portrait painting?" Not at all. Be not alarmed. Nature's pencil is too true to be popular. She does not flatter. Who wishes to see or hear the truth of themselves? The Daguerreotype will be called to bring into existence the infant truth, but the painter will yet be needed to clothe it in more popular dress and "give a grace beyond the reach," *not of art* but of "nature."[19]

Samuel Irenaeus Prime, as editor of the *New-York Observer*, later recalled Morse expressing similar sentiments: "I was among the first whose portraits were taken by [the daguerreotype] on this side of the sea. [Morse] said that it would not hurt the business of portrait-painter, for *it would not flatter.*"[20] These associations continued through the 1840s and were still in place at the time of the Crystal Palace Exhibition. According to John Tallis's sumptuous guidebook to that exhibition, "Artists, especially miniature painters, are naturally opposed to daguerreotypes. The *artist* can soften down defects, and present the sitter under the most favorable aspect. The *sun*, however, is no flatterer, and gives the lineaments as they exist, with the most inexorable fidelity, and the most cruel precision."[21]

As the century progressed and the daguerreotype continued to flourish and to become increasingly professionalized, the artistic community became increasingly vocal about the superiority of the hand-crafted picture to the mechanical photograph. This sentiment appears over and over again in the periodicals of the day, particularly in art journals, such as the *Bulletin of the American Art Union*. Sometimes the mechanical quality of the plates is blamed on the photographer rather than on the process—for example: "It is true, that as yet these miniature resemblances struck by rays of light are far less flattering than those penciled by the artist; but this defect we conceive arises principally from a want of management in the adjustment of the light on the face of the sitter."[22] More often, however, the nature of photography itself is blamed; for example: "There is ... a radical difference between [the daguerreotype's] productions and true works of Art. The first are simple reflections of Nature, glimpses through a new medium; the last present a mingling of the individuality of the artist ... with natural appearances."[23] The *Bulletin of the American Art Union*, like

many other publications, attributed the daguerreotype's inferiority to the fact that it captured a person's ever-changing countenance only at a single moment:

Not even in the department of portraiture, will the Daguerreotype ever supersede the Art of Painting. ... When we think ... that the Daguerreotype can only give us the aspect of a face as it appears during a mere moment of time, and that our ideas of that face are formed from a combination of a great number of its appearances at various times, and that its characteristic expression comes and goes with the rapidity of thought—we shall cease to wonder that a photograph is so often unsatisfactory, and the artist's portrait is so much more life-like.[24]

Some articles on the daguerreotype were drawn from foreign sources. For example, an article by a M. Figuier from the French journal *Illustration* was published in translation in the *Bulletin of the American Art Union*; it asserted that "a more serious fault of the daguerreotype is that it does not *compose*, but *copies* with too much exactness."[25] Commentators giving public addresses also noted the difference. Speaking at the dedication of the Baltimore Athenaeum in 1848, Brantz Mayer, a politician from Maryland, asserted: "Art is the vehicle of idea by form and color. The mere servile limner of features has a talent which is not superior to the monkey, the looking glass, or the mechanical daguerreotype. It is that of imitation or reflection, alone."[26] The idea that the mechanical daguerreotype was inferior to hand-crafted imagery was applied not only to painting and drawing but also to engraving. Mattias Weaver, a lithographer based in Philadelphia, wrote: "You ask whether the 'Daguerretype' will interfere with Engraving: it will not—for several reasons—there is no certainty in producing one of these plates, and again, they have not the pleasing effect of the contrasts, in high light and deep shade, in Engravings ... [the daguerreotype] is an inanimate, cold, mechanical picture. It can never interfere with the fine arts—it is only interesting to the curious."[27]

This emphasis by artists and other commentators on photography's mechanical nature and its inferiority to painting can be read as part of a larger anxiety in mid-nineteenth-century American culture over technology in general. The idea that too much technological progress and resultant wealth might corrupt the nation's moral and political fiber was deeply rooted in America's federalist traditions, and had been commented upon by Thomas Jefferson. As the historian of technology Merritt Roe Smith has pointed out, when Jeffersonians and other Americans spoke of progress they "gave human betterment (intellectual, moral, spiritual) equal weight with material prosperity. Without betterment, prosperity was meaningless."[28] Though by the early 1830s American society had more fully embraced a "business-oriented emphasis on profit, order, and prosperity," there remained some resistance to the idea that technological progress automatically equaled social betterment, particularly among intellectuals. Henry Thoreau, Nathaniel Hawthorne, Herman Melville, and (eventually) Ralph Waldo Emerson often wondered whether technology would

be the downfall of society; indeed, in 1843 Hawthorne wrote a short story, titled "The Celestial Railroad," in which passengers on a steam locomotive become aware that their destination is Hell.[29]

The historian Leo Marx characterizes the tension within American culture between the celebration of technological achievements and the simultaneous fear of their corruption, which, in turn, creates a longing for a pastoral ideal, as "the machine in the garden."[30] The historian Alan Trachtenberg also refers to this tension when he describes American society's difficulties in acclimatizing to the new medium of photography. Drawing upon period literature and popular fiction (particularly the novels of Hawthorne), Trachtenberg notes that many writings refer to a sense of dislocation that photography caused in sitters and viewers by making things that once were familiar seem startling and new.[31] The daguerreotype's association with other new technologies of the day, particularly Morse's telegraph, was noted by a number of observers. Some commented that, much as the telegraph harnessed an invisible, natural substance (electricity) to generate coded numbers or letters, the daguerreotype harnessed light to create a mark or impression on a receiving surface. As was discussed in the introduction, these two technologies were often described as the "annihilation of space and time." Writers of the time noted the similarities almost immediately and commented upon it often; for example, when the Atlantic telegraphic cable was laid in 1858, Jeremiah Gurney's photographic studio projected a transparency that read, in part, "Daguerre and Morse/One harnessed the Light, and the other the Light-ning."[32] An anonymous poem from 1852 also celebrated the connection:

FRANKLIN brought down the lightning from the clouds,
MORSE bade it act along the trembling wire,
The trump of Fame their praises gave aloud,
And others with the same high thoughts inspire.
DAGUERRE arose—his visionary scheme
Was viewed at first with jeers, derision, scorn,
Conquered at last by the grand power supreme
Of god-like mind—another art was born.[33]

Though lithography, another reproductive visual technology, was also being introduced in the middle of the nineteenth century, it belonged to a long tradition of printmaking whose identity was already established in American society. Printmaking also had a component of the handcrafted, whereas the daguerreotype was perceived as purely mechanical. An early quotation characterizing the daguerreotype as one more invention in a long succession of inventions bears repeating here:

There is no breathing space —all is one great movement. Where are we going? Who can tell? The phantasmagoria of inventions passes rapidly before us—are we to see them no more?[34]

ARTISTS' USES OF THE DAGUERREOTYPE

Though deriding the daguerreotype's soullessness, artists made liberal use of the technology's most salient feature: its ability to copy exactly. Indeed, some commentators suggested that this very quality made the daguerreotype superior to painting: "If there is one thing more than another that the magic power of the Daguerreotype is valuable for, it is this, of limning the fleeting expression on the human face; for here the painter, however great his skill, is most at fault."[35]

One of the most prominent uses to which artists put the daguerreotype was as an aid for portraiture. By late 1840, some painters were actively advertising such use. For example, a Madame Guillet advertised that she was using the daguerreotype to create painted miniatures, and that therefore long sittings were no longer necessary. According to a notice in the *New-York Mirror*, "a single [daguerreotype] sitting produces a perfect facsimile of the features, from which a most accurate miniature is painted. Sitting for one's portrait, by this method, is no longer the Herculean task that Sheridan gravely pronounced it."[36] By the mid 1840s, it was common practice for artists to use the daguerreotype in order to create paintings, in both portraits and genre subjects.[37] These artists ranged from naïve itinerants, such as Erastus Salisbury Field, to sophisticated members of the National Academy of Design, such as Charles Loring Elliott. Other mid-century artists known to have used the daguerreotype or other photographic methods as an aid to their work include William Page, Thomas Sully, William Sidney Mount, Worthington Whittridge, George Peter Alexander Healy, William Morris Hunt, Alonzo Chappel, and the limner Horace Bundy. By 1851, the year of the Crystal Palace Exhibition, the use of daguerreotyping by artists was accepted to a degree. John Tallis's guidebook to the Crystal Palace Exhibition noted:

> It is known that some of the most eminent portrait-painters, those whose productions have raised them above petty feelings, do avail themselves of the aid of daguerreotypes, where well-executed representations of that kind are attainable, and they see in this no more degradation of their art, than a sculptor finds in using a cast of the subject which his chisel is about to reproduce.[38]

The painter Charles Loring Elliott exhibited a particular enthusiasm for the daguerreotype, and his experience with photography provides an example of how one artist used the medium. Though Elliott had a brief sojourn in New York City in 1829, he began his career there in earnest in 1839, when he showed his first paintings at the National Academy of Design. Of course, that was the year the daguerreotype was introduced in the United States, first in New York. As Elliott's painting career ascended through the 1840s and the 1850s, so did the new technology. By the late 1850s, Elliott was unquestionably the most highly regarded portraitist in the city, if not in the entire country, and daguerreotyping had become a booming

industry, with 200 commercial studios in New York City alone. When Elliott first returned to New York in 1839, however, he was an ambitious and talented young painter hoping to make his mark, and the city was abuzz with talk about the new invention from France. Elliott would have been aware of the nascent technology almost immediately.

As his career progressed, Elliott began to use the daguerreotype as a tool for portraiture, and to interact with daguerreotypists. He respected the medium as an art form, and publicly endorsed Gabriel Harrison and other daguerreotypists whom he considered to be superior and "artistic." In a series of advertisements, he said of Harrison: "Having frequently compared the best specimens of Daguerreotypes, I cannot resist the desire to express my opinion, that those produced by yourself combine in the greatest degree all the excellencies of the Photographic Art, in clearness, tone, and color; also, in the artistic arrangement of positions, accessories, &c., they stand pre-eminent in this country."[39] Elliott's friend Thomas B. Thorpe recalled his keen appreciation of the medium:

He observed that he never saw a picture made by the process that did not have something about it to admire. He liked Rembrandt better, if such a thing were possible, after he had studied daguerreotypes, for they justified his extreme effects of light and shade, for he had seen pictures taken by the sun that literally resembled many of Rembrandt's etchings of the human face.[40]

The comparison of daguerreotypes to Rembrandt here is reminiscent of Morse's assertion, upon first viewing daguerreotype plates, that they were "Rembrandt perfected." Elliott also painted a portrait of the famed daguerreian Mathew Brady, and in turn had his daguerreotype made by Brady (figures 2.1 and 2.2). This exchange of portraits was typical of mid-century artists as a sign of respect for other's work— Elliott enacted similar exchanges with fellow painters, among them William Sidney Mount. The portraits of Elliott and Brady are almost mirror images of each other. In each, the bearded sitter is shown in bust length, in a three-quarter view, against a neutral background. Both have somber expressions, but whereas Brady has painted Elliott gazing out of the picture plane to the right, Elliott has Brady looking directly at the viewer. Elliott utilized a subdued palette for Brady's portrait; as in a daguerreotype, the dark coat, vest, and patterned necktie stand out sharply against the bright white of the collar. Also as in a daguerreotype, Elliott has captured the gleam of light that falls on each painstakingly realized curl on Brady's head.

Not only did Elliott publicly and enthusiastically endorse the daguerreotype and daguerreotypists; he seems to have been quite frank about which pictures he painted with the aid of a daguerreotype. His friend Thorpe also recalled Elliott using a daguerreotype to paint a portrait of James Fenimore Cooper: "I sat beside Mr. Elliott much of the time he was engaged in painting his portrait of Fenimore Cooper. ... He was copying it from a small daguerreotype."[41] Elliott's painting appears to closely

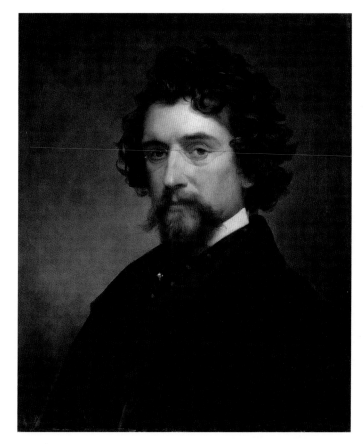

FIGURE 2.1
Charles Loring Elliott, *Mathew B. Brady*, oil on canvas, 1857. Gift of the Friends of Mathew Brady, 1896. Image copyright Metropolitan Museum of Art. Source: Art Resource, New York.

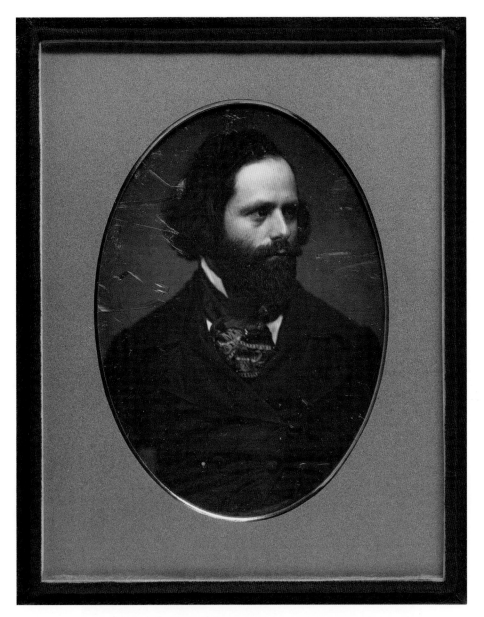

FIGURE 2.2
Mathew B. Brady, *Charles Loring Elliott*, daguerreotype, c. 1850. Courtesy of National Portrait Gallery, Smithsonian Institution, Washington.

follow a daguerreotype of Brady's, another link between the two men.[42] It is assumed that some other works of Elliott's also were made from daguerreotypes, among them the 1847–48 portrait of Henry Inman reproduced here as figure 2.3. Elliott and Inman met in 1846, after Inman had heard much about Elliott's work. At the time of that meeting, Inman was generally regarded as the premiere American portrait painter. He was so impressed with Elliott's works that he suggested an exchange of portraits, to which Elliott happily agreed. Inman died a few weeks later, and Elliott completed his portrait over the next two years, probably using a daguerreotype. The painted

FIGURE 2.3
Charles Loring Elliott, *Henry Inman,* oil on canvas, 1847–48. Century Association, New York.

portrait closely resembles Brady's daguerreotype of Inman (figure 2.4).⁴³ In the Brady daguerreotype, Inman is looking over his shoulder in a slight turn to the right, rather than facing the camera directly. The daguerreotype has captured the circles under his eyes, but also his slight smile. Elliott's painting retains the slight smile, softens some of the less flattering elements in the daguerreotype, and tames Inman's hair. The painting is practically a mirror image of the daguerreotype, showing Inman looking over his shoulder to the left in the same bust-length view. In each, the sitter wears a bold and distinct plaid vest and a matching cravat.

FIGURE 2.4
Mathew B. Brady, *Henry Inman*, half-plate daguerreotype, c. 1845. Prints and Photographs Division, Library of Congress, Washington.

Mathew Brady in particular seems to have been one of the daguerreotypists appreciated by the fine-arts community. A long article in the *Bulletin of the American Art-Union*, reprinted from the *New York Tribune*, celebrates Brady's work as being of particularly high caliber: "The specimens we have seen of this new process combine in an eminent degree the beauty of a fine painting with the fidelity of the Daguerreotype."[44] The article notes Brady's premiere status among daguerreians in the city, and goes on to mention a new method of taking daguerreotypes on ivory. Though the article was originally published in a local newspaper, the fact that the *Bulletin* (then the only major journal devoted exclusively to the fine arts) chose to reprint it for its readership of working fine artists suggests an acknowledgment of the possibility of artistic expression within the medium.

COPIES AND REPRODUCTIONS

Not all artists were as forthcoming about using the daguerreotype for their portraiture as Elliott was. Instead, many found the medium most useful for copying their own works of art, and using the copies as tools to circulate images of large or bulky works—particularly sculptures. Much has been written about photographic copies of works of art, but typically with a focus on paper copies of European art, or on the relative quality of printed or photographed nineteenth-century reproductions, and on the subsequent market for these images.[45] Rarely has the use of photographic copies been discussed in relation to American art and the daguerreotype.

At the time of the daguerreotype's introduction, replicating existing works of fine art, either by copying an existing painting (particularly one by an Old Master) in paint or by reproducing an existing works as an engraving, was already a well-established practice. Both of these forms of copying were previously existing industries in their own right: the prevalence of prints after fine art in American homes has already been discussed, and many American artists, including Morse, funded educational tours of Europe by accepting commissions for copies of the Old Masters they planned to view. How the daguerreotype would affect not only this industry of copying, but also artists engaging in copying as a part of their training, was part of the larger concern initially raised upon the medium's introduction. In early 1839, *The New-Yorker* worried that artists would lose their "genius" if the practice of drawing sculpture was supplanted by the daguerreotype: "If the artist can lay up a store of objects without the (at first very tedious) process of correct drawing, both his mind and his hand will fail him. … Who will make elaborate drawings from statues or from life, if he can be supplied a more perfect, a more true manner, in the space of a few minutes?" The article went on to ponder how the new medium might affect the appreciation of and the market for engraved copies of Old Masters: "When one thinks of the possible power of copying pictures—in having fac-similies, in all but

color, of Raphael and Correggio, one cannot but dread, in the midst of hope of the rich possession, the diminution of so admirable an art [of engraving]."[46] Yet as the 1840s progressed, these fears proved unfounded. Engraving, the copying of paintings, and the drawing of sculptures for training continued to thrive, even as many artists also began to utilize and experiment with the daguerreotype for needs other than portraiture. The hesitations expressed by *The New-Yorker*, however, can again be read as part and parcel of American society's larger, complex relationship with ideas related to technology and with the daguerreotype's mechanical nature.

By 1850, the benefits of daguerreotyping art had been established. The *Bulletin of the American Art-Union* published a long article assessing the daguerreotype's effect on the fine arts eleven years after its introduction. The *Bulletin*'s frequent discussion of daguerreotyping signifies the American artistic community's continued efforts to grapple with their often-contradictory reactions to the medium. In an article titled "The Daguerreotype," the *Bulletin* proclaimed: "There is one use of this discovery, which strikes us as being exceedingly valuable … its power of representing great objects of art, particularly in sculpture. The metallic plate seems to take reflections from white marble with more clearness and beauty than from other substances." The article went on to mention a particular plate of a sculpture by the American artist Erastus Dow Palmer, *Infant Ceres*, calling the sculpture "one of the most admirable productions of American Art … [possessing] a grace and delicacy worthy of the chisel of an ancient Greek." According to the article, "These qualities were all represented in the Daguerreotype [of *Infant Ceres*], which seemed to us to be only less valuable than the original object itself, and infinitely more so than all the etchings or drawings that could be made of it." After this rather extraordinary and unusual assertion—that the daguerreotype of an object exceeds the value of a print or drawing of it—the *Bulletin* pondered the "inestimable worth of a collection of Daguerreotype views of the principle statues of the world— those, for instance, in the Vatican. … They would afford the next best pleasure to that derived from seeing the originals."[47] Palmer was an up-and-coming sculptor in 1850, and *Infant Ceres* was his first fully three-dimensional work (in contrast with a bas-relief). It garnered him a great deal of attention and promoted his career.[48] The daguerreotype mentioned by the *Bulletin* may have helped launch the piece's reputation, and by extension Palmer's.

The knowledge that photography was particularly well suited to capture sculpture was not new. As was discussed in chapter 1, William Henry Fox Talbot had made the connection between photography and sculpture clear in his 1844 book *The Pencil of Nature*, noting how the white hues of marble sculptures represented well in photographic processes.[49] The daguerreotype, with its silvered, mirrored surface, captured those tones even better than Talbot's paper-based process. American artists and daguerreotypists took advantage of the medium's ability, and the daguerreotype was frequently utilized to circulate images of sculptural works, particularly marbles.[50]

Using the daguerreotype for this type of circulation was certainly a practical decision, as the works were often large and bulky and could not be transported easily; however, it may also have been an aesthetic decision—white marble captured in silver has a pleasing look. Indeed, of the extant daguerreotypes of mid-nineteenth-century American sculptors, far more seem to be of marble works than of bronzes.[51]

Palmer continued to use the medium to circulate copies of his sculpture, which helped him gain commissions. "It will be remembered, the *Bulletin* noted, "that the beautiful bas-relief of *Morning* ... is to be executed by Mr. Palmer. The order was given upon a daguerreotype of the plaster model, which was submitted to the committee several weeks hence."[52] The following year, the *Bulletin* again mentioned a daguerreotype of a work by Palmer: "Our readers may remember the beautiful bas-relief of *Morning*, which was included in the last distribution. We have seen a daguerreotype of the model of a pendant to it, *Evening*, which has been commissioned by a distinguished member of the Legislature."[53] Another daguerreotype of a later Palmer work, *The Spirit's Flight*, is in the collection of the Library of Congress. Shown here as figure 2.5, it was a gift from Palmer to another prominent American sculptor, Henry Kirke Brown.[54] Brown, in turn, both had his work daguerreotyped (such as the daguerreotype of his large, currently unlocated 1850 bronze *Indian and Panther*) and, like many portrait painters, sometimes used the daguerreotype to create portrait busts. Other large works, such as the architectural monuments that often housed sculptures *in situ*, were sometimes daguerreotyped for greater exposure. For example, when a temple designed by architect E. B. White was proposed to house Hiram Power's sculpture of John Calhoun in Charleston, a daguerreotype copy of White's design was displayed at the Art-Union Gallery for the curious to view.[55]

Daguerreotyping sculpture not only helped artists gain commissions, it was also a way for the general public to either see works they might not be able to in person, or to own an image of a popular large marble. One of the most widely photographed sculpted marble works of this period was Hiram Powers's enormously successful *The Greek Slave* (figure 2.6). Powers, a well-known American sculptor living in Florence, created six versions of the piece by 1843. The first, exhibited in New York in 1847, proved wildly popular, and copies were exhibited in dozens of other American cities in the ensuing decade. Also indicative of the works' popularity are the numerous poems, prints, and daguerreotypes made about or after the sculpture. Smaller versions and busts became common in private collections and homes. Here the daguerreotype was working in concert with other forms of written and visual representation to further the visibility of a particular piece. In at least one instance, a daguerreotype of a painting titled *The Greek Slave* was created. (See figure 2.7.) The circulation of all these visual addenda increased the visibility of the sculpture and helped whet the public's appetite for the piece.[56]

FIGURE 2.5

Unknown photographer, view of sculpture relief *The Spirit's Flight* by Erastus Dow Palmer, half-plate daguerreotype. Prints and Photographs Division, Library of Congress, Washington.

FIGURE 2.6
Southworth and Hawes Photography Studio (Albert Sands Southworth and Josiah Johnson Hawes), *Hiram Powers's Sculpture of the Greek Slave*, 1848. Gilman Collection, Purchase, Ann Tenenbaum and Thomas H. Lee Gift, 2005, Metropolitan Museum of Art. Image copyright Metropolitan Museum of Art. Source: Art Resource, New York.

FIGURE 2.7
Unknown photographer, *Painting of 'The Greek Slave' with Figures in Oriental Dress,* quarter-plate daguerreotype, c. 1847. Collection of W. Bruce Lundberg.

Daguerreotypes of *The Greek Slave* by several different daguerreians, most notably the Boston team of Albert Sands Southworth and Josiah Hawes, are found in no fewer than five museum collections.[57] The *Boston Daily Evening Transcript* reported that one of these daguerreotypes exhibited "three separate representations of the statue on one plate—the back, front and side view—each conveying a very perfect idea of the original" and that it would "furnish all lovers of true art with a very faithful copy at an essentially low price, and which will show at once how materially art is capable of multiplying objects of beauty." The aforementioned team of daguerreians apparently also projected this daguerreotype by means of a megascope, or opaque projector, which gave a slight illusion of depth to the projected image.[58] Through the daguerreotype, any member of the public could own a "faithful copy" of *The Greek Slave*. The Boston article belabored this point of financial accessibility: "In these days of business depression, it is refreshing to be enabled to direct the attention to matters of science and taste, and to feel that the mind may call up objects of beauty and divinity amidst the maze of politics and the deep anxieties of the money market."[59]

The daguerreotype, then, was an inexpensive way for artists, particularly sculptors, to multiply their works and have images of those works placed in private homes. As the daguerreotype of the painting of *The Greek Slave* reminds us, the medium also was commonly used to reproduce two-dimensional graphic works as well as sculpture. Reproducing works of art was a skill in enough demand that daguerreotypists often advertised their proficiency and skill in doing so. The *Daguerreian Journal* ran articles with practical tips on how to copy works of art, and Mathew Brady and other daguerreotypists explicitly promoted this ability.[60] Brady ran a repeating advertisement in the *Bulletin* reading: "In the Department arranged for Copying Engravings, Painting, Statuary &c., the light and instruments have been expressly designed for this purpose."[61] Both professional artists and private owners of paintings availed themselves of the services of Brady and of other daguerreotypists, creating copies of works they created or owned. Naturally, there were pros and cons to using the daguerreotype as a copying tool rather than engraving or some other method. Certainly the lack of color was a factor. The lack of reproducibility of the daguerreotype also was a consideration. Because a daguerreotype is a unique image, the only way to create a copy of one is to make another daguerreotype of the existing plate.

Many of these factors came into play with the reproduction of a group of sketches and outlines by Washington Allston found in his studio after his death. Stephen H. Perkins, a nephew of one of Allston's wealthy Boston patrons, Thomas Handasyd Perkins, decided to publish these engravings. He asked the daguerreians Southworth and Hawes and the engravers John and Seth Wells Cheney to copy them. The introduction to the resultant 1850 book explained: "Where it was necessary to reduce [the sizes of the sketches] for engraving, the daguerreotype was used, by which the

image was conveyed to the engraver's plates, prepared for that purpose, and there fixed by tracing the line through the silver."[62] Daguerreotypes were made by Southworth and Hawes; then the Cheney brothers created engravings by working directly on the daguerreotype plates, from which impressions were subsequently made.[63]

The Cheney brothers were no strangers to copying. Seth Cheney worked from the collection of images and plaster casts at the Boston Athenaeum, with his earliest extant engravings dating from 1830. The Cheneys, whose family also ran a silkworm business, became well established among Boston artists. Seth engraved Allston's now destroyed *Mother and Child* in 1832.[64] They were avid collectors of prints and casts as well. Seth was in London around the time the daguerreotype was introduced in early 1839, and as a working artist (he executed portraits in crayon and paintings as well) he naturally expressed interest in the new medium, writing to John: "Some time ago there was a good deal said about the new art of making pictures by the camera obscura, but I have never seen any of the effects produced by it, and lately have heard nothing of it."[65] Soon enough the Cheney brothers did hear more of the daguerreotype, as their brother Frank Cheney briefly went into the business around 1841.[66] There is no record of either Seth or John Cheney actively using the daguerreotype; however, the collection of the Smithsonian Institution's Archives of American Art contains eighteen daguerreotypes and one ambrotype of what are presumably either Seth or John Cheney's engravings or drawings. It isn't clear whether one of the Cheney brothers—Seth, John, or Frank—took these images, or what their function might have been; they may have been taken simply as examples or copies of their work.

The book of Allston's sketches provides an interesting example of the intersection of drawing with the reproductive modes of engraving and daguerreotyping, and of the interconnectivity of painters, engravers, and daguerreotypists in America in this period. In an effort to honor the memory of Allston, one of America's great artists, and to disseminate his work, both methods of copying were used, but at least one critic found fault with the mechanical nature of the translation: "No engravings, however well they may be executed, can give all the effect of drawings in chalk upon canvas. This is not said from any desire to disparage these engravings in comparison with others, but as a remark which ought to be made in this connexion. No mechanical process can perfectly imitate the work of the *human hand*."[67] Although this assertion of the superiority of the handcrafted was quite common among American artists at this time, one wonders if the critic would have been quite so vocal in his displeasure had it not been for the concurrent use of the daguerreotype in the creation of these engravings. The review continues:

In original outline drawings there is something which makes us feel more vividly the intention of the artist and his skill ... Especially this is true of outlines reduced and thus copied.

The Daguerreotype, which has here been employed, and which it is gratifying to find is at last doing some service to art in return for the staring and grinning caricatures of the human face it has been for several years spreading all over the country, can copy accurately, if rightly adjusted; but it cannot transmit the entire spirit of the original. There is a certain inequality and indefiniteness in actual drawings which can no more be copied than the lines of nature.[68]

Clearly this particular reviewer found it problematic not only that the works had been copied but also that they had been reduced mechanically. As there would have been no other way to disseminate Allston's sketches, it seems to be the technical and mechanical nature of the copying, rather than the fact that the works were copied at all, that the reviewer found offensive. Such a reaction is indicative of how much of American society seems to have felt about endlessly copied originals. And many of the final versions of Allston's drawings were, indeed, several times removed from the originals. First they had been daguerreotyped and reduced in size; then the daguerreotype had been transferred to the engraver's plate. The viewer was confronted with an image that, in the end, did not resemble the original closely. The reviewer's frustration is reminiscent of the responses some sitters had to seeing their daguerreotyped portraits: that the mechanically transcribed image did not resemble them at all.[69]

Despite reactions such as those mentioned above, artists continued to utilize the daguerreotype to copy their works, as proven by extant daguerreotypes of mid-nineteenth-century American paintings. One example is the 1847 painting *A Solitary Indian, Seated on the Edge of a Bold Precipice* by Charles Deas (Autry National Center, Los Angeles), photographed by Thomas Easterly (figure 2.8). Easterly also daguerreotyped Seth Eastman's 1847 painting *Indian Burial*. Easterly was based in St. Louis, and both of the aforementioned paintings were only briefly on view there. Easterly probably continued to display the daguerreotypes of the paintings, however, affording the local citizenry the opportunity to continue to enjoy the paintings and also demonstrating his talent as a copyist.[70] Southworth and Hawes were particularly prolific in this department, creating multiple copies of engravings after Old Masters, such as a daguerreotype of an engraving after Raphael's *Transfiguration* (figure 2.9); they also made copies of works by American artists, including Washington Allston's painting *Beatrice*.[71]

FIGURE 2.8
Thomas Easterly, *'A Solitary Indian, Seated on the Edge of a Bold Precipice' by Charles Deas*, daguerreotype, c. 1847. Photographic History Collection, National Museum of American History, Smithsonian Institution, Washington.

FIGURE 2.9
Albert Sands Southworth and Josiah Johnson Hawes, *Engraving after Raphael's 'Transfiguration'*, whole-plate daguerreotype, c. 1847. Department of Printing and Graphic Arts, Houghton Library, Harvard University.

THE INTERSECTION OF DAGUERREIAN AND PAINTED PORTRAITS

The vast majority of daguerreotypes of two-dimensional works are copies of painted portraits. These daguerreotypes represent a wide swath of paintings in terms of date and style. Public figures, celebrities, and politicians had both painted and daguerreotyped portraits made of themselves. The senator and statesman Daniel Webster was daguerreotyped several times by Southworth and Hawes, many paintings were created after those daguerreotypes, and a daguerreotype of at least one of the paintings was made. (See figure 2.10.) As with the book on Allston's sketches and outlines,

FIGURE 2.10
Unknown photographer, *Daniel Webster from a Painting at the Boston Athenaeum*, half-plate daguerreotype, c. 1845–1850. Long-term deposit of Dr. Gregory Alan and Bernadette Mary Zemenick. Courtesy of American Antiquarian Society.

FIGURE 2.11
Unknown photographer, *Dr. Samuel B. Woodward from life*, sixth-plate daguerreotype, c. 1848. Woodward Collection. Courtesy of American Antiquarian Society.

and as with the daguerreotype of the painting of the sculpture *The Greek Slave*, these images constitute a curious layering of media and representation. A daguerreotyped portrait from life was used to create a painting, which was then daguerreotyped. This kind of representation, in which the final image is removed several degrees from the original, harkens back to another set of early fears around the medium, in which a person might encounter his own visage endlessly: "Every thing and every body may have to encounter his double every where, most inconveniently."[72] Americans were encountering their initial insecurities about the medium: though many complained that they could not recognize themselves in their daguerreotyped portraits, they continued to reproduce themselves from life and from paintings. This kind of double replication was not limited to politicians and other public figures; private citizens were often represented in multiple media. Dr. Samuel B. Woodward, for example, a pioneer in psychiatric care and mental illness, had a daguerreotype made from life and also had one made of his painted portrait. (See figures 2.11 and 2.12.)

SSR

• Buy Aesthetic Ideology

t as an ideal
herent traits of art — Platonic
ntrast between liberal thought
gvmt.
ymbolism
he City
cience Ian McEwan

ussia — Symbolic narrative
apan — tradition, family
 good way Nationalism — objectification of
 to contrast women
 these?
 Violence & chaos
atm ⌈ Atheism/Corruption ⌉
triarchy The chaos
 of Modernity

inema is aetheistic
inema is philosophical

Japan — Endless Desire
⇒ the difficulty/irony of the image

FIGURE 2.12

Unknown photographer, *Dr. Samuel B. Woodward from a painting*, sixth-plate daguerreotype, c. 1848. Woodward Collection. Courtesy of American Antiquarian Society.

Curiously, many daguerreotypes of paintings feature portraits of individuals who passed away well before the daguerreotype was invented. One such daguerreotype features a painted portrait of Maine Governor Enoch Lincoln, who died in 1829 (figure 2.13). Plates that feature the deceased call to mind the practice of daguerreotyping the recently dead and the well-discussed link between daguerreian portraiture and remembrance. The portrait photograph's alleged ties to memory and nostalgia are almost as old as the technology itself, and are related to ties already established during portraiture's long history, regardless of medium. "The portrait," the art historian Richard Brilliant noted, is "the creation of a visible identity sign by which someone can be known, possibly for ever. This sign constitutes the admission that there is 'someone' out there worthy of identification and preservation."[73] The daguerreotype portrait, particularly because of its mechanical nature, appeared to reinforce that visible identity sign. As early as 1841, photographers were promoting daguerreotype likenesses as a way to remember the deceased: "Who does not consider accurate likenesses of those they love, invaluable? How many times do we hear the expressions of grief from survivors that they have no likenesses of friends who have left them—and what grief like that which is unavailing?"[74] Geoffrey Batchen has written that almost all of photography's most astute theorists believe that photography does not aid memory, but rather hinders it.[75] Nineteenth-century Americans, however, seem not to have thought that was the case. Indeed, the great popularity of portrait photography (particularly of the post-mortem sort) suggests that many nineteenth-century Americans believed that, in some way, photographs could operate as sites of memory.[76] They flocked to have their portraits and portraits of loved ones taken. The daguerreotypist Nathan G. Burgess made this connection explicit in an 1855 article titled "The Value of Daguerreotype Likenesses":

When those we love and cherish leave us forever; when their spirit passes away from this frail tenement of earth, to another sphere—who would not give all they possess for a likeness of that face, or a slight resemblance of those they once loved. The Daguerreotype possesses the sublime power to transmit the almost living image of our loved ones; to call up their memories vividly to our mind, and to preserve not only the sparkling eye and winning smile, but to catch the living forms and features of those that are so fondly endeared to us, and to hold them indelibly fixed upon the tablet for years after they have passed away.[77]

Timothy Shay Arthur's 1849 article "American Characteristics—The Daguerreotype" also clearly elucidates the relationship of the daguerreotype to memory, particularly in relation to post-mortem photography. Arthur relays two stories of parents in mourning. In the first, a mother finds a portrait of her recently deceased adult daughter on display in a daguerreian studio. Arthur reports that she "gazed once more into the almost-speaking face of her child." In the second story, a cautionary tale to those who did not "secure the shadow," Arthur writes of a young couple who

FIGURE 2.13

Unknown photographer, *Enoch Lincoln from a Painting*, quarter-plate daguerreotype, c. 1845–1850. Gift of Mrs. Frances M. Lincoln. Courtesy of American Antiquarian Society.

delayed having their small child's portrait taken. After the child died, "the only image of the child that remained for the mother was on the tablet of her memory."[78]

The ties of the daguerreotype to remembrance and nostalgia extend beyond post-mortem portraiture, and are transposed onto the living as well. Arguing for the importance of the photograph, Marcus Aurelius Root wrote: "With these literal transcriptions of features and forms, once dear to us, ever at hand, we are scarcely more likely to forget, or grow cold to their originals, than we should in their corporeal presence."[79] Similarly, an article in the *Photographic Art Journal* observed that before the daguerreotype "friends at a distance could not send to each other their likenesses, as memorials of affection except under peculiar circumstances." "Now," the article continued. "the poorest man can have the portraits of his children taken, and they become invaluable the moment they are dead. Friends, at their parting, to go on distant and perilous expeditions, can, in an hour, and at a trifling expense, multiply their portraits, and leave them to be gazed on by those whom they have left behind."[80] In the rapidly expanding United States, the daguerreotype was a way to remember not only those who had died but also those who had relocated many miles from their original homes.

The proliferation of daguerreotypes of painted portraits furthered ideas of daguerreotyping and remembrance. So deeply ingrained in the American collective psyche was the idea that one should commemorate a loved one or oneself with a daguerreotype portrait that even people who had died before the process was invented were commemorated with a daguerreotype of a painted portrait. That practice was later extended to taking daguerreotypes of living sitters *with* painted portraits.[81] Sometimes a single sitter was posed next to a painted portrait; sometimes a family group was posed with a painting positioned as if the painted subject were there. This phenomenon is rarely seen in paintings (portrait paintings within portrait paintings), so it is clear that the particular qualities of the daguerreotype—its causality with a living referent, its relationship to memory and nostalgia—were driving these pairings. In most cases, it is safe to assume that the painted portrait was of a deceased member of the family with whom the living sitter wished to have a final image made. In rarer instances, the living sitter was posed with a painted portrait of himself or herself—an example of this is Josiah Hawes's daguerreotype of his wife Nancy Hawes with her painted portrait (figure 2.14).[82] Is one meant to compare the daguerreotyped likeness with the painted one? Is the combination meant to be a comment on the two differing modes of portraiture? It does not appear that Hawes was emphasizing the superiority of the daguerreotype; rather, in view of Southworth and Hawes's emphasis on artistry in their works, and in view of Hawes's own private painting practice, Hawes probably was asserting that the daguerreotyped portrait was on an equal footing with the painted one. The plate is not closed in a case, but is set in a frame as if it were a painting. The image reproduced here in figure 2.14 can

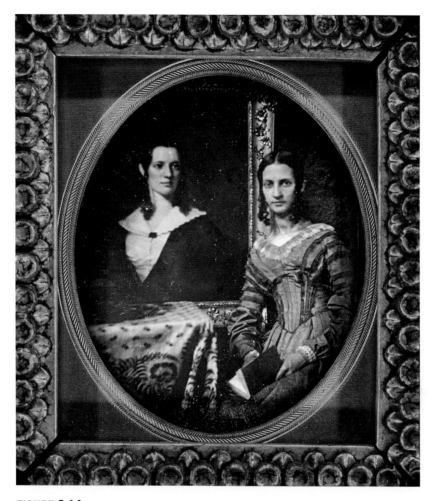

FIGURE 2.14
Albert Sands Southworth and Josiah Johnson Hawes, *Nancy Southworth Hawes and her Painted Portrait*, sixth-plate daguerreotype, c. 1842–43. Archive of Modern Conflict, Toronto.

serve as a meditation on new and old forms of representation, with Nancy Hawes's daguerreotyped image mirrored by her painted one, just as her own face would have been mirrored in the daguerreotype's surface as she gazed at the plate.

DAGUERREOTYPES AND THE PRINTED PORTRAIT

Another of Southworth and Hawes's images of a sitter posed with a painted portrait (figure 2.15) features a young girl gazing over her shoulder at one of Gilbert Stuart's portraits of George Washington.[83] This daguerreotype reminds us that images of celebrities and public figures, alive or deceased, were hugely popular in the middle of the nineteenth century. Before the introduction of the daguerreotype, the need for images of celebrities was fulfilled solely by prints, particularly lithographs. Indeed, printmakers, lithographers, and publishers often struggled to keep up with public demand for images of well-known figures.[84] Upon its introduction, the daguerreotype acted in concert with the print market to help feed public demand for images of famous figures. Because a daguerreotype is a unique image, with no negative from which to create endless positives, portraits of well-known figures had to be circulated by other means. The mass production of prints from daguerreotypes was anticipated soon after the medium's introduction. "The practice of producing prints from daguerreotypes," one journal predicted in 1842, " is [not] so general as it is likely to become."[85] That prediction was correct—both engravings and lithographs after daguerreotypes soon proliferated in the market. The fields of printmaking and photography became increasingly interconnected as the 1840s progressed; indeed, the 1840s saw a veritable explosion in printmaking, particularly lithography. In making prints after daguerreotypes, photographers and graphic artists were able to join forces for the mutual benefit and expansion of both professions.[86]

Portrait prints of public figures created after daguerreotypes became extremely popular and commonplace. During the 1840s and the 1850s, Wendy Wick Reaves and Sally Pierce have explained, "the relationship between photography and printmaking was not so much competitive as interdependent and symbiotic."[87] Such images were an extension of a bustling trade for inexpensive portraits of public figures that was already in place. The daguerreotype added a new and desirable element to that trade, offering a veracity that extended to the prints themselves. The fidelity that caused portrait painters to believe the daguerreotype would not be a threat ("it does not flatter," as Morse said) was highly valued in printed portraits of public figures. "Plain style" was a positive term applied to the works of some American portraitists, among them Charles Willson Peale, to refer to direct, unembellished, unidealized images of leaders and statesmen.[88] "Plain style" images brought to mind republican ideals of civic duty and high moral character, traits Americans wanted to see in their elected officials. That tradition extended to the

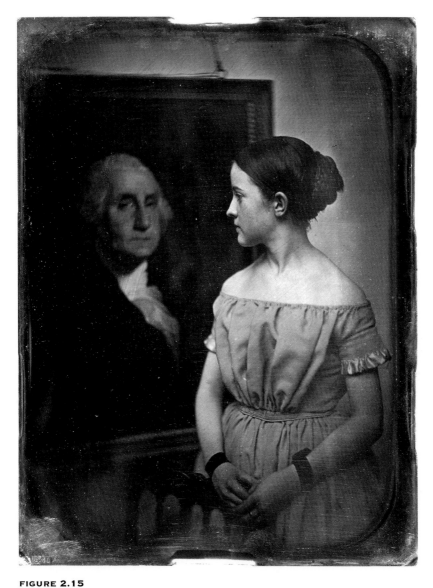

FIGURE 2.15

Albert Sands Southworth and Josiah Johnson Hawes, *Girl with Portrait of George Washington*, daguerreotype, c. 1850. Gift of I. N. Phelps Stokes, Edward S. Hawes, Alice Mary Hawes, and Marion Augusta Hawes, 1937. Metropolitan Museum of Art. Image copyright Metropolitan Museum of Art. Source: Art Resource, New York.

often-unflattering verisimilitude of the daguerreotype portrait, and by extension to prints that were created after daguerreotypes.[89]

Soon series of prints after daguerreotypes of public figures were being created. Mathew Brady's *Gallery of Illustrious Americans* was, in the words of Alan Trachtenberg, "the first ambitious photographic project to take America itself as subject and theme."[90] It consisted of twelve portraits, engraved as lithographs after daguerreotypes, of well-known individuals, including presidents, senators, and generals. One image was sent to a subscriber every month, and the option to have the images bound at the end of the year was offered. Another series was proposed by John Plumbe, the proprietor of a national chain of daguerreian studios. An 1846 broadside advertised the National Plumbeotype Gallery"[91]:

The portraits will comprise Presidents of the United States, Vice Presidents, Heads of Departments, Members of Congress, Statesmen, Judges, Lawyers, Divines, Officers of the Army and Navy, Actors, Authors, Editors, Physicians, Poets, Artists, Musicians, Distinguished Strangers, &c., &c. At the end of each half year, a splendid title page and Index will be supplied to subscribers, gratis, to enable them to have the work bound.[92]

Series such as these whetted the public's appetite for images of public figures, and had the added value of being disseminated via the new technological medium of the daguerreotype. Through the daguerreotype and the lithograph, one could own an image of a president or a celebrity and could know with certainty that the photograph had captured the sitter's face truthfully. Indeed, the daguerreotype's reputation for fidelity so aided the already booming market for portrait prints of public figures that it became commonplace to note both the daguerreotypist's and the engraver's name on the final print, emphasizing the image's photographic origins. Examples of prints including the daguerreotypist's name abound in current-day print collections. In an 1848 engraving of Zachary Taylor by John Sartain (figure 2.16), only Taylor's face that is taken from a daguerreotype; the background is imaginary—Taylor is shown standing beside his horse on a battlefield, with troops silhouetted in the background and cannonballs stacked on the left side of the image. Yet the publisher, or perhaps Sartain, wants viewers to know that Taylor's likeness was taken from the sitter himself: the print reads ""From an Original Daguerreotype." Other prints after daguerreotypes resemble their photographic predecessors more closely, showing the sitters in simple half length. One such lithograph featuring Sam Houston, from 1848, labels the engraver Francis d'Avignon, and also reads "From Daguerreotype by Bartlett & Fuller, Hartford, Conn" (figure 2.17). Many such prints also include a facsimile version of the sitter's signature beneath the image. These signatures serve as a kind of reinforcement of the indexicality of the image, as they had to originate from the person photographed, even though, like the daguerreotyped image itself, the final result is several times removed from its original referent.[93]

FIGURE 2.16

John Sartain, *Major-General Zachary Taylor*, engraving from an original daguerreotype, 1848. Library Company of Philadelphia.

FIGURE 2.17
Francis d'Avignon, *Samuel Houston*, lithograph after a daguerreotype by Bartlett & Fuller, 1848. Courtesy of National Portrait Gallery, Smithsonian Institution, Washington.

As with images of works of art, there are many examples of layered media in portrait prints after daguerreotypes—for example, a print after a painting that was made from a daguerreotype. Like the earlier discussed daguerreotypes of paintings of long-deceased individuals, these prints were often made well after the sitter's death. For example, an 1874 engraving of Thomas Chalmers, the leader of the Free Church of Scotland (figure 2.18), was made after a painting by Alonzo Chappel,

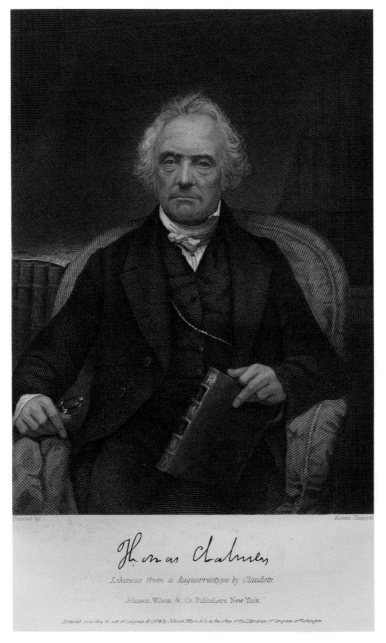

FIGURE 2.18
Unknown artist, *Thomas Chalmers, Painted by Alonzo Chappel, Likeness from a Daguerreotype by Claudet*, engraving, 1874. Library Company of Philadelphia.

which itself was made after a daguerreotype by Antoine Claudet. Again, though the image was several degrees removed from the original sitter, the publishers of the print clearly felt it important to note that it originated with a daguerreotype.

DAGUERREIANS ON ART

As the 1840s progressed, daguerreotyping grew into a profession and struggled to develop standards, policies, and concerns. As was discussed in the introduction, by 1851 there were two professional journals devoted to the medium—the *Daguerreian Journal*, which began in 1850, and the *Photographic Art Journal* (later renamed the *Photographic and Fine Art Journal*) founded in 1851—a fact that did not go unnoticed by the *Bulletin of the American Art-Union*: "All classes and crafts have their particular 'organs' now-a-days, and therefore we ought not be surprised that the daguerreotypists possess two."[94] The medium's professional growth raises the question of how daguerreians positioned themselves in relation to the fine arts. Artists had a complex and often contradictory relationship with the daguerreotype; daguerreians had a similar relationship with the fine arts. Many prominent daguerreotypists seemed to struggle to define themselves in relation to existing visual media. The *Photographic Art Journal* and the *Daguerreian Journal* attempted to bridge a perceived gap between the two partially by fashioning themselves as vehicles that could reasonably discuss both professions and a variety of media, not just photography. Both journals included articles relating to fine art. The *Daguerreian Journal* ran a series of articles on recent art exhibitions, particularly that of the American Art-Union, and the *Photographic Art Journal* criticized the practices of the American Art-Union.[95]

Many daguerreians were sensitive to the complaints about the quality and nature of their images that had been leveled against them: that daguerreotypes were too mechanical, too exacting, that they were caricatures and not true portraits. There was much discussion in the journals about the lack of professionalism within the daguerreian field, and a heightened consciousness of the amount of inferiority among their ranks. The *Photographic Art Journal* complained about daguerreians who lacked proper training:

> They are lured into this pursuit by a prospect of an easy and rapid accumulation of money. Instantly they repair to some cheap Daguerrean establishment, or perhaps apply to an itinerant professor and … are regularly manufactured in the short space from three to six days, into full-bred professors of the photographic art. Is it then to be wondered at that we find so many awful, ghost-like looking shadows poured into the world by a host of ignorant pretenders? Not at all![96]

Similar articles abound in both the *Daguerreian Journal* and the *Photographic Art Journal*. They reveal a deep concern among daguerreotypists for the reputation of their

livelihood. In an effort to distinguish between its relatively untrained amateurs and its more established professionals, the profession created societies and hold conferences to support the goals and aims of daguerreotyping. For example, in an early issue of the *Photographic Art Journal* the editor, Henry Hunt Snelling, used the proliferation of pornographic images created by the "mere mechanics, dabsters" as an occasion to urge his fellow daguerreotypists to adopt higher professional standards.[97] Snelling mused about the differences between how painting and sculpture created images of the human form and how photography did so. "Why," he wondered, "is the daguerreotypist more culpable [of pornography] than the painter, who frequently resorts to nude life models in the practice of his art?" Snelling concluded that, whereas painters and sculptors had study the human form in order to replicate it, daguerreians did not have to do the same, and also that their motives were "widely different": "The painter has a noble, glorious object in view; he aims at the elevation of his art, and the improvement of public taste; while the class of Daguerreotypists to whom we allude are actuated by the desire to pander to a vitiated and gross appetite, to accomplish which the most positions are required from the degraded characters obtained for the purpose." Snelling went on to state that the public nature of the daguerreian studio, in contrast with the privacy of the painter's studio, provided an incentive against activities that might damage the reputation of the daguerreian profession. He concluded by calling for the formation of a National Photographic Society.[98]

This kind of comparative self-rumination by the editor of one of the two journals on daguerreotyping was a continuation of the kinds of identity formation of the profession that took place throughout the 1840s. Very early in the medium's history, a conscious distinction developed between "artistic" daguerreians and daguerreotypes and those who were considered rudimentary and unpolished. As was discussed in chapter 1, in 1841 a reviewer had distinguished between some of Morse's daguerreotypes and those commonly produced: "We have just seen a family group of three persons taken by [Morse], which, differently from most Daguerreotype likenesses, is really a beautiful picture. The arrangement of the group, and the attitudes, under the direction of the artist, are exceedingly elegant and agreeable. The expression of the countenances is also free from constraint and harshness which is often seen in things of this kind."[99]

Throughout the 1840s, many daguerreians sought to distinguish themselves from the "amateurs" who had proliferated in the field by self-consciously establishing themselves as "artistic." One of the best-known daguerreians to have promoted himself in that way was Mathew Brady. As has been noted, Brady was greatly esteemed by the fine-arts community. Its acceptance of him was partially due to Brady's having deliberately positioned himself as being a higher caliber than those daguerreotypists who were itinerants or untrained. Brady accomplished this in a

variety of ways. First, he emphasized his artistic pedigree, claiming to have received artistic training from painter William Page and daguerreotype training from Samuel Morse. There is no hard evidence that Morse ever worked with Brady, yet having been trained by the well-known and well-established older artist was something Brady touted, particularly in his later years. Brady also deliberately differentiated himself from other daguerreotypists in his advertisements. In one broadside from 1849, he asserted: "the objections previously connected with the art [of daguerreotyping] hav[e] been obviated by the improvements [made by Brady]."[100] Here Brady is distancing himself from "objections to the art," which in 1849 typically consisted of stiff and unnatural-looking sitters. Brady posed his subjects in a manner more reminiscent of miniature or portrait painting, employing methods such as a three-quarter view and careful lighting, as can be seen in the previously discussed plate of Henry Inman (figure 2.3) and in Brady's portrait of Daniel Webster (figure 2.19). In the latter, Webster is seen partially turned toward the right, rather than facing the camera head-on, and Brady has lit him so that his features are illuminated clearly but not harshly. Light gleams off the folds of his necktie. Similarly, in Brady's daguerreotype of the artist George Peter Alexander Healy (figure 2.20), the subject is shown pensively gazing off to the left, eyes tilted upward. These plates are reminiscent of painted portraits by mid-century artists.

Other daguerreians who promoted themselves in this manner were the Bostonians Southworth and Hawes, who had an association with Morse. Albert Sands Southworth and his first business partner, Joseph Pennell, studied the daguerreotype with Morse in the spring of 1840, when Morse and Draper were opening their roof-top studio.[101] Like Brady, they actively advertised themselves as artists. One advertisement, referring to Josiah Hawes's background as a painter, proclaimed "One of the partners is a practical Artist." Even the location of their studio—at 5½ Tremont Row, in an area known as an artists' neighborhood—was a part of this self-promotion.[102] The illustration that typically accompanied their advertisements also referenced the partners' relationship to art, featuring a sun holding a painter's palette and brush, standing before a canvas, and painting the entire globe posed before him. And, like Brady, Southworth and Hawes consciously emulated poses from fine art in their daguerreotypes. An example of this can be seen in the daguerreotype of an unidentified woman reproduced here as figure 2.21. Southworth and Hawes have positioned their sitter at a slight angle from the camera, turning her head in the opposite direction from her body. A shawl is wrapped and nestled in the crook of the sitter's arm, and she gathers it up in one hand at her waist while the other hand rests on her lap. Similar positions can be seen in other nineteenth-century paintings of female sitters, such as Morse's portrait of *Mrs. Daniel DeSaussure Bacot* (1820, The Metropolitan Museum of Art). Morse also paints his sitter as gazing off to one side, with a shawl wrapped in the crook of her arm and her hand resting on

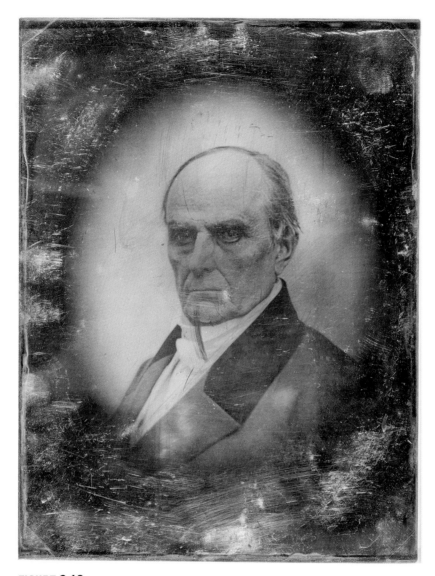

FIGURE 2.19
Mathew B. Brady, *Daniel Webster, Possibly After Southworth & Hawes*, whole-plate daguerreotype, c. 1855. Prints and Photographs Division, Library of Congress, Washington.

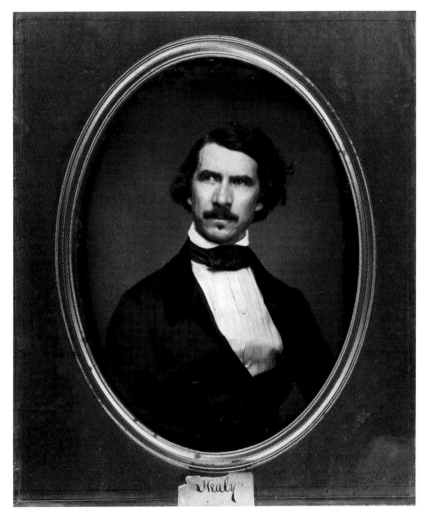

FIGURE 2.20
Mathew B. Brady, *George Peter Alexander Healy*, half-plate daguerreotype, c. 1850, Prints and Photographs Division, Library of Congress, Washington.

FIGURE 2.21
Albert Sands Southworth and Josiah Johnson Hawes, *Unidentified Woman*, whole-plate daguerreotype, c. 1850. Courtesy of George Eastman House, International Museum of Photography and Film.

her waist. Such poses were fairly common in painting but less so in daguerreotypes of the period, which more often featured sitters facing the camera straight-on, with few props.

Through essays in the *Boston Daily Evening Transcript*, Southworth sought to use the daguerreotype not to democratize art but instead to educate the general public in the ideals of fine art.[103] These actions are similar to Morse's attempts with the medium: Morse also emulated fine-art poses in his daguerreian work, and also urged the public and the fine-arts community, through spoken or public statements, to use the daguerreotype as a tool to learn about and appreciate fine art.

Despite the conscious emulation of fine art by several of the period's leading photographers, these daguerreians also celebrated their medium's technological capabilities. In trying to find a new language to describe the mechanical *and* the visual, many described their work as more accomplished than traditional modes of representation. Advertisements for the Langenheim brothers of Philadelphia boasted "No limner's brush, no engraver's steel, no lithographer's ink is able to produce a likeness so striking, pleasing and lifelike as the Daguerreotype, which is not done by the hand of the artist, but by the Pencil of nature."[104] Many daguerreians were actively celebrating the very mechanical nature for which the daguerreotype was often derided. For example: "[The daguerreotype] is slowly accomplishing a great revolution in the morals of portrait painting. The flattery of countenance delineators, is notorious. No artist of eminence ever painted an ugly face. ... Everybody who pays must look handsome, intellectual, or interesting at least—on canvass. These abuses of the brush the photographic art is happily designed to correct."[105]

A SPACE FOR DISPLAY

The poses and postures of sitters were not the only aspect of fine art that daguerreians often emulated. Many also set up their studios in spaces that traditionally had served as artists' studios. This served a dual purpose: it made practical sense, as the rooms typically had enough light and space to create a painting or a daguerreotype, but by transforming artists' studios into daguerreotype studios daguerreians could also capitalize on the cultural validity an artist's studio already contained. One such space was the Granite Building on the northwest corner of Broadway and Chambers streets in New York (figure 2.22), constructed around 1839 and demolished in 1877. It was later converted into the Irving Hotel, and by the late 1850s it housed the restaurant Delmonico's, but originally it was specifically built as a space for artists' studios—"fitted up in the most approved manner with sky-lights, gas fixtures, etc," as one newspaper notice promised. "No pains nor expense has been spared to render this gallery unobjectionable in this respect, artists of eminence having been consulted ... the manner and arranging of admitting the light is copied after

FIGURE 2.22
Henry Bricher, *Panoramic View of Broadway, New York City, Commencing at the Astor House,* detail: *Northwest corner of Broadway and Chambers, showing the Granite Building [Irving House],* wood engraving. Published in *Gleason's Pictorial Drawing Room Companion* (March 18, 1854,, volume 6, no. 11). Department of Prints and Photographs, New York Historical Society.

the Grand Gallery of Paintings at Munich."[106] The Apollo Association (precursor to the American Art-Union) held its 1841 exhibition there, and the auctioneer James Bleeker held sales of Old Master paintings there in the early 1840s.[107] Many individual painters and sculptors kept studio spaces in the building throughout the 1840s, among them the genre painter Albertus Browere, the Hudson River School painter Jasper Cropsey, and the portraitists Daniel Huntington and Charles Loring Elliott. The sculptor Edward Augustus Brackett briefly exhibited works there, and the sculptor Harris Kneeland worked there. Countless other artists, lithographers, engravers, and frame makers set up shop in the vast four-story building, which also housed a druggist, a hat maker, and a bookshop.[108] Though constructed specifically for artists, the building was perfect for the exhibition and production of the emerging medium

of daguerreotypes. Some of the earliest daguerreian activity in the country took place in the building. The first exhibition of daguerreotype plates from France was held there almost as soon as it was finished, in December of 1839. François Gouraud lectured there on the daguerreotype throughout the winter of 1840, and exhibited several daguerreotypes by Daguerre himself.[109] *The Knickerbocker* declared: "We have seen the views taken in Paris by the 'Daguerreotype' and have no hesitation in avowing, that they are the most remarkable objects of curiosity and admiration, in the arts, that we ever beheld."[110] *The New-Yorker* followed suit: "The Daguerreotype is only another method of causing Nature herself to multiply her own works,—and although yet in its infancy the productions effected by means of it bear the impress of a perfection never before attained by human ingenuity."[111]

With such precedents, the Granite Building may have seemed a natural choice for Alexander Wolcott and John Johnson when they opened the doors of their portrait studio there in February or March of 1840. It was arguably the first daguerreian studio in New York (and perhaps the first in the United States). It was in the rooms of that studio that Wolcott and Johnson devised the process of mounting mirrors to the windows to focus enough light, through the reflecting camera, onto the sitter to create a portrait (figure 2.23).[112] The reflecting camera, patented by Wolcott, became standard in early daguerreotype practice. The Granite Building is an excellent example of technological innovation (the reflecting camera hanging out of a window) and fine art (exhibitions of painting and sculpture) residing in the same physical location.

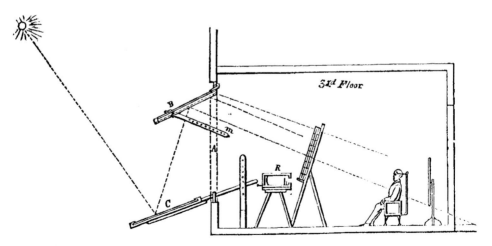

FIGURE 2.23
Diagram of the Wolcott reflecting camera.

In those very early days of the medium, daguerreotyping was an intellectual and exciting pursuit. As there was no set space for the exhibition of art in New York, daguerreotypes often mingled with the fine arts in spaces like the Granite Building. The medium had not yet received the reputation of being merely mechanical that it would shortly, and exactly what a photographer's studio consisted of and where daguerreotypes should be displayed were still in flux. Other early plates, including Morse's view of Broadway, were shown in James R. Chilton's drugstore, also located on Broadway, just one block away from the Granite Building. Chilton experimented with the medium as well as supplying many early practitioners with chemicals, and his shop became something of a meeting place for early experimenters. Mechanical fairs were also a space where daguerreotypes were frequently shown, as will be discussed in chapter 4. Although some institutions that were wholly devoted to the fine arts, such as the National Academy of Design, declined to show photography in any of their exhibitions, the Pennsylvania Academy of Fine Arts in Philadelphia did show daguerreotypes in the medium's nascent years. It seems rather curious that the National Academy, of which Morse was still president, decided not to incorporate daguerreotyping as part of its mission, even though they had voted to include Daguerre in their membership. The exhibitions at the Pennsylvania Academy of Fine Arts were sponsored by the Artist's Fund Society, and it appears that daguerreotypes were shown in these exhibitions in 1840, 1842, and 1843, before exhibitions were suspended after a fire in 1845.[113] When the exhibitions resumed, the Pennsylvania Academy continued to show various types of photographs throughout the nineteenth century.

The interconnectedness of the arts and scientific communities in New York and Philadelphia is evident in the fact that the first daguerreotype the Pennsylvania Academy chose to exhibit was not a portrait of a Philadelphian or even a scene by a Philadelphia-based photographer, but instead a daguerreotype by Wolcott of New Yorker James J. Mapes (figure 2.24).[114] Mapes, who had been a professor of chemistry at the National Academy of Design, may have been one of the first Americans to have a portrait made, as he was one of Wolcott's first sitters. Mapes was in Philadelphia in the spring of 1840, showing Wolcott's daguerreotypes to the Franklin Institute, a prestigious society that studied science and technology.[115] Why the members of the Pennsylvania Academy chose to exhibit the daguerreotype of a visiting New Yorker over an image created by one of that institution's own daguerreotypists (for example, Robert Cornelius, who had also created portraits by the spring of 1840) isn't clear. Perhaps they chose Mapes's image because of its priority, or perhaps Cornelius (a metallurgist working with Paul Beck Goddard, a chemist) did not feel daguerreotypes should be displayed as fine art. That Wolcott's images were simply superior seems unlikely, though Wolcott had been working in the medium a few months longer than Cornelius. So few daguerreotypes by Wolcott are extant that

FIGURE 2.24
Studio of Mathew B. Brady, *James J. Mapes*, half-plate daguerreotype, c. 1844–1856. Prints and Photographs Division, Library of Congress, Washington.

FIGURE 2.25
John Sartain, *Reverend Edwin N. Kirk A. M., after a Daguerreotype by A. S. Wolcott,* mezzotint, c. 1845. Library Company of Philadelphia.

a fair comparison doesn't seem possible. There is, however, a mezzotint by John Sartain after a daguerreotype by Wolcott, showing Edwin N. Kirk (figure 2.25). In it the bust-length figure is seated, gesturing at the book in front of him. It is unlikely that the original daguerreotype contained the neoclassical attributes of curtained background and pillar, or the careful positioning of the hands or the book in the foreground. Sartain probably used only the face from the daguerreotype. What is clear about the choice made by the members of the Pennsylvania Academy is that they didn't seem to care that the image was mechanical, or chemical, or that it had been brought to Philadelphia to be shown at the technology-based Franklin Institute. They still felt as though the daguerreotype deserved a place on their exhibition walls along with the paintings of Thomas Sully, Washington Allston, and other contemporary American artists.[116]

As the 1840s progressed, daguerreians created a specific space for their works to be shown in: that of the daguerreotype studio itself. Mathew Brady's "Daguerreian Miniature Gallery," which opened just up the street from the Granite Building on Broadway in 1844, probably set the standard and the tone for a high-end daguerreotype studio. Consistent with his aspirations to establish himself as "artistic" and therefore different from his compatriots, Brady emulated and surpassed artists' studio spaces. By 1853, when Brady had moved to larger and more luxurious accommodations, his gallery was a tourist attraction. Its large, impressive rooms were filled with fashionable furniture, carpets, and interior fixtures.[117]

Brady may have been inspired by John Plumbe's extensive network of studios. Plumbe began an "open arms" practice, allowing the daguerreotype studio to become a space in which members of the public were welcome to visit even if they were not having their photograph made. In an advertisement, Plumbe described his New York space this way: "The gallery and lounge is free, frequented by the elite of the city who find it an agreeable resting place."[118] Both Plumbe and Brady also exhibited daguerreotypes of their sitters, particularly those who were well known. Eventually, higher-end daguerreotype galleries such as Brady's and Plumbe's became gathering spots where one could see and be seen, and could view the portraits and daguerreotypes of the famous or the beautiful that lined the walls.[119] It was in Plumbe's gallery that Walt Whitman stood transfixed, in 1846, gazing at the assembled faces of all those captured by silver—the experience that prompted him to remark that the daguerreotype annihilated time and space. The poet also commented on the crowds of spectators in the gallery: "You will see more *life* there ... than in any spot I know of. The crowds continually coming and going—the fashionable belle, the many distinguished men, the idler, the children—these alone are enough to occupy a curious train of attention."[120] In 1846 a reviewer commented on the general practice of displaying public figures in daguerreotype studios: "Already the daguerreotypes of the most important public characters adorn the saloons of

noted artists. You have only to enter and you find yourself in a miniature President's levee."[121] Displaying daguerreotypes in studios became a common practice. Many galleries or "saloons" had areas devoted to portraits of famous personages.[122] In addition to celebrities, however, these studios would also display images of sitters who were simply interesting or particularly beautiful. The literature of the period is full of stories of people falling in love with or otherwise interacting with a portrait displayed on a daguerreotypist's wall.[123]

Studios such as Brady's were a far cry from the experimental workshop-*cum*-studios on the roofs of buildings or with reflecting mirrors hanging out the windows, as exemplified by the early efforts of Morse and Draper or of Wolcott and Johnson. Though there are few descriptions of the interiors of daguerreotype studios of the 1840s, it is possible the actual shift from experimental laboratory toward commercial studio began, again, with Morse. When he opened his second studio (the "Palace of the Sun") in the *New-York Observer* building in 1840, it had a "fine parlour in the third story for the purpose of receiving ladies, and a woman to wait upon them."[124] A simple action such as creating a separate waiting room for women eventually led to extravagances such as Brady's, with its elaborate furniture and large mirrors for grooming. These public spaces, separate from the artist's studio, "addressed the theater of having one's picture made."[125]

As the nineteenth century progressed, artists' studios eventually also became spaces for public meeting and display, full of opulent and exotic furnishings, more on a par with what photography studios had created.[126] By the 1870s, William Merritt Chase and some other American artists had set up studios that had an outer room for receptions and gathering and an inner studio for painting, again mimicking, possibly unconsciously, the set-up of daguerreian studios of the 1850s. Throughout the 1840s, though, while artists were adjusting themselves to the presence of a new medium, and some daguerreians were struggling to define that medium as art, practitioners in the worlds of science and technology were also working to carve out a space for the daguerreotype in their respective, shifting fields.

3 "WE WILL NOT BORE OUR READERS WITH ANY MORE CHEMISTRY": SCIENCE AND THE DAGUERREOTYPE

On July 3, 1839, the French scientist and politician François Arago gave a speech to the Commission of the Chamber of Deputies, encouraging them to grant Daguerre and Isidore Niépce lifetime government pensions for their invention of the daguerreotype.[1] Arago informed the Deputies that his speech would address four questions: Was the invention original? Would it render a service to archeology and the fine arts? Was it practically useful? Could the sciences derive any advantages from it? Arago (a scientist interested in astronomy, optics, magnetism, and light) was, perhaps, most interested in the last of these questions. He thoroughly answered his own question regarding the daguerreotype's potential usefulness to science, laying out for the Deputies the various scientific uses to which the daguerreotype might be put, including its possible benefits for astronomy, physics, and microscopy.[2]

As Arago's speech makes clear, the intertwining of media within the daguerreotype that this book explores (fine art, "practical uses" or technology, and the sciences) had been apparent to commentators ever since the daguerreotype's inception. This chapter examines the early American daguerreotype's relationship to the sciences, and how scientific daguerreotypes related to and differed from daguerreotypes associated with technology and with the fine arts.

As I noted in the introduction, in this book I am focusing on certain disciplines with science, particularly chemistry, biology and astronomy. During the 1840s, exactly what constituted a "scientific" daguerreotype was being defined. Of course, the daguerreotype itself was a product of science, consisting of a potent chemical mixture that, if prepared improperly, could severely damage or ruin the plate or even the daguerreotypist's health. As Arago's speech demonstrates, there was immediate recognition that this scientific object also contained the potential to advance scientific knowledge.

As with fine art, the daguerreotype was entering a realm in which scientific imagery already circulated. Scientific prints, particularly botanical prints, enjoyed wide circulation among both professionals and amateurs. Scholars have discussed the introduction of photographic imagery into this territory, particularly as it affected British scientific culture, focusing primarily on Talbot's photogenic drawings and on the use of calotypes.[3] The daguerreotype was, of course, a wholly different photographic process, resulting in an image that visually has little to do with photogenic drawing or the calotype. Rarely is the introduction of the daguerreotype into scientific discourse discussed, and even more rarely is it discussed in the context of a specifically American scientific discourse.

SCIENCE IN MID-NINETEENTH-CENTURY AMERICA

The first American to echo Arago's call was, not surprisingly, Morse. In his written account of his meeting with Daguerre, Morse used scientific metaphors to describe the new technology and advocated scientific uses for it. In a letter dated March 9 and published in the April 20, 1839 edition of the *New-York Observer*, Morse described the effect of the daguerreotype as "that of a telescope in nature." He also noted that one of Daguerre's plates featured a magnified "impression of a spider," and marveled: "You perceive how this discovery is, therefore, about to open a new field of research in the depths of microscopic nature. We are soon to see if the minute has discoverable limits."[4] Morse, not a hard scientist, relied on others to heed the call and use the daguerreotype for extensive scientific inquiry.

It appears, however, that in the 1840s very few American men of science explored the daguerreotype's experimental potential as thoroughly as their European counterparts did. This is borne out by an examination of what was published in contemporary American scientific journals: almost all the articles on the daguerreotype in the *Journal of the Franklin Institute* from this period, for example, are reprinted from European journals; very few are products of original American research. Benjamin Silliman's *American Journal of Science* didn't do much better; during the 1840s, it ran only three articles detailing research being conducted in the United States with the daguerreotype.[5]

The British scientific community, exemplified by figures such as William Henry Fox Talbot, Sir John Herschel, Sir David Brewster, and Robert Hunt, was extremely interested in photography. Talbot introduced a different kind of photographic process—photogenic drawing—at the same time that Daguerre's single-plate process was announced. Talbot used his process to explore microscopic photography and made photogenic drawings of botanical specimens. A Fellow of the Royal Society of London, he presented his process to that society soon after Daguerre's findings were announced. Herschel was Britain's leading man of science.[6] His contributions

to photography included the discovery of the fixing agent for the development of a photographic image (hyposulfite of soda or "hypo"), the invention of the cyanotype, and the establishment of some of the most commonly used photographic terms: "photography," "positive," "negative," "snapshot."[7] Herschel and Talbot met in 1824, and Herschel probably influenced Talbot's decision to research light—a decision that led to Talbot's discovery of photogenic drawing. In addition, Herschel introduced Talbot to Brewster, a Scottish scientist who was one of the editors of the *London and Edinburgh Philosophical Magazine* and a leading researcher on physical optics and the nature of light and who consistently promoted photography-related topics in his journal.[8] Hunt, a scientist based in Cornwall and later in London, developed an interest in photography after Daguerre's announcement and began researching the physical qualities of light. He published two important early texts: *A Popular Treatise on the Art of Photography* (1841) and *Researches on Light* (1844), the latter of which began as a series of articles in the *Philosophical Magazine*.

In France there were a number of experimenters who used the daguerreotype or other forms of photography for scientific means. Daguerre did so almost immediately, photographing a magnified spider and a partial eclipse of the sun. As Stephen Pinson has argued, Daguerre's well-known early arrangement of fossils and shells must also be considered scientific in light of the burgeoning disciplines of paleontology and stratigraphy.[9] Jean-Baptiste Biot, a physicist, championed Talbot's method and other paper-based processes of photography, using them to investigate the nature of light.[10] In 1845, the physician Alfred Donné and his assistant Jean Bernard Léon Foucault produced a text for medical students, *Cours de microscopie complémentaire des études médicales*, which was illustrated with engravings of daguerreotypes made through the microscope. In his introduction, Donné asserted that daguerreotype images were superior to scientific drawings in that they could include the entire microscopic image.[11] In 1844, under Arago's direction, Foucault joined forces with another of Arago's former students, Hippolyte Fizeau. Like Biot, Foucault and Fizeau used photography to try to measure different intensities of light, but rather than a paper-based process they used the daguerreotype. They made daguerreian images of the solar spectrum, eventually (under Arago's guidance) utilizing a guillotine shutter to create a daguerreotype of the sun that was then published in Arago's textbook on astronomy.[12] Meanwhile, Biot's student Edmond Becquerel used daguerreotype plates and paper photography in an extensive study of spectra on various light-sensitive materials, employing photographic technology to help solve scientific questions, including those concerning the potential for photographic color.[13]

In view of the daguerreotype's extraordinary capabilities and potential, why did American men of science shy away from using it to answer experimental questions? The answer is multivalent and layered. Although there are notable exceptions,

which will be discussed in detail below, one reason why American scientists did not seem to utilize the daguerreotype had to do with the state of the sciences in the United States during this time period. The historian George Daniels has labeled the middle of the nineteenth century American science's "emergent period," a time of transformation from amateurism to professionalism.[14] At the beginning of the nineteenth century, the "arts and sciences" model of the preceding century still predominated, embodied by institutions such as Benjamin Franklin's American Philosophical Society (founded in 1743) and the American Academy of Arts and Sciences (founded in 1780). Both organizations espoused the study and promotion of a broad range of topics, including "natural philosophy, moral science, history, politics ... investigations in botany; in medicine, in mineralogy and mining; in mathematics; in chemistry; in mechanics; in arts, trades, and manufactures; in geography and topography; in agriculture."[15] There also was a connection between the fine arts and the sciences during the early years of the Republic. By 1786 Charles Willson Peale's museum had exhibited both Peale's own oil paintings and an array of natural history displays. By the 1830s, however, the "arts and sciences" model that had made institutions such as Peale's museum possible was slowly dissolving in favor of specialized fields within both the sciences and the humanities. A wealth of discoveries within the various disciplines necessitated narrower interests and a rising degree of professionalization within each field.[16] As the historian Russel B. Nye has noted,

[In America] there was so much to do and so much to know in every field of science that the old-fashioned scientist who took all knowledge as his province, or the 'natural philosopher' who studied 'nature,' could no longer grasp it all. ... The new scientist narrowed his interests, limited his objectives, concentrated on smaller segments of knowledge; better to specialize in one field and share information with others, he believed, than to attempt mastery of several at once.[17]

The popularization of science in America was occurring without a centralized, government-supported institution devoted to scientific research, such as those in France and Great Britain. In America there was no one comparable to Arago to support and promote the scientific potential of a new medium such as the daguerreotype on a national level. Rather, as the nineteenth century progressed, America continued to rely upon the multiple smaller institutions that had been founded in the eighteenth century, among them the American Philosophical Society, the Franklin Institute, and the New York Lyceum of Natural History. This lack of centralization and government support and patronage, a major hindrance to the advancement of the sciences in the United States in the early years of the nineteenth century, may have affected how the daguerreotype was used scientifically.

Another may have been the reputation of American science abroad, which was often quite poor. Alexander Dallas Bache (a great-grandson of Benjamin Franklin)

and Joseph Henry (who later would serve as director of the Smithsonian Institution) complained bitterly about this reputation, and worried over the prevalence of "charlatans" or "quacks" in American science, referring to those promoting theories or conducting experiments without proper scientific qualifications and without empirically substantiated evidence.[18] Bache and Henry felt the sting of being snubbed by prominent European scientists when visiting the Continent, and they blamed the insult on the United States' reputation for scientific quackery. This suspicion of lack of rigor in the sciences, and the division of "real" scientists versus "amateur" scientists, foreshadowed American daguerreotypists' later concerns regarding professionalism in their own community. As has already been mentioned, many Americans, scientists and non-scientists, first believed the daguerreotype to be a hoax. By 1851, daguerreotyping had a reputation as something "men enter into because they can get nothing else to do," and an aura of sham often surrounded the daguerreotypist too.[19] The relatively unstructured state of American science in the first half of the nineteenth century, coupled with this fear of the taint of charlatanism, may have contributed to resistance to using the daguerreotype to explore scientific questions.

Yet another consideration is the relative popularity of the types of science the daguerreotype was suited to explore, particularly chemistry and the physics of light. Within scientific communities, there was equal emphasis on studies of the physical sciences and on studies of natural history. Among the general public, however, there seemed to be an overwhelming preference for natural history and geology over chemistry or physics.[20] A very early article detailing the new invention began by recounting the steps of the daguerreotype process, but then quickly reassured "we will not bore our readers with any more chemistry."[21] Geology, on the other hand, was trumpeted as the "fashionable science of the day"—a science that "may be said to form a necessary part of practical and ornamental education."[22] As the sciences were becoming more professionalized, those who had engaged in amateur scientific activities often complained that scientific knowledge was becoming too esoteric and advanced for the layperson to understand. By the 1840s, there was high demand for lectures and articles that approached scientific topics from a "popular," or less professionalized, angle.[23] Additionally, there was a desire among scientists for their work to appear functional, useful to society, and thus worthy of further public support. According to the historian George Daniels, "even scientists whose private statements and research interests were wholly unconnected with immediate utility were nevertheless anxious to publicly represent themselves as utilitarians."[24] We can infer that "utilitarian" referred to the practical application of theoretical principles, or technology, and it does seem that those who worked with the daguerreotype in the United States generally experimented with the aims of advancing the process itself, rather than using the medium to explore scientific questions such as the

nature of light. This community of experimenters, centered primarily in New York and Philadelphia, is discussed in full in the following chapter.

JOHN WILLIAM DRAPER

A notable exception among those who worked with the scientific daguerreotype in the United States was John William Draper. As was discussed in chapter 1, Draper was a professor of chemistry at the University of the City of New York (now New York University) and briefly had a daguerreotype studio, one of the first in the city, with Morse. Draper first became interested in the chemical reactions of and caused by light as a student at University College London under Professor Edward Turner. The nature of light had become an increasingly urgent question of scientific inquiry in the early nineteenth century. In May of 1801 Thomas Young began a series of experiments, most famously with a double slit, to prove that light was a wave, rather than a particle as had long been proposed by Sir Isaac Newton.[25] Upon presenting his findings to the Royal Society of London in November of 1801, Young was met with severe doubt expressed by those who were wary of overturning any of Newton's theories. Young's contention was still being debated when Draper attended school in London.

Draper immigrated to the United States in 1832 at the age of 21. In 1835 he enrolled in the University of Pennsylvania's medical school, where he worked in the laboratory of Dr. Robert Hare. Draper's fascination with light and its properties led him to produce scientific photography that covered several fields within the sciences, including chemistry, astronomy, and biology. Draper's photography made visible what could not be seen with the eye: details of the surface of the moon, the inner workings of plants and animals, and the wavelengths of light. The diverse and often fantastic body of images Draper left behind, however, was a mere by-product of Draper's interest in the means of photography, particularly the daguerreotype, and what it could reveal about the chemical and physical nature of light.[26]

Unlike the work of most daguerreotypists of the day, particularly in the United States, the majority of Draper's work was oriented toward process rather than results; he was interested in *what* appeared on a plate only insofar as it was able to tell him about *how* it had appeared there. Often, as in his work with portraiture, this resulted in technical improvements, but the motivations behind those improvements were quite different from those of many of Draper's colleagues, including Morse. Some of the other early experimenters with whom Draper associated focused more on technology. For example, the New Yorkers Alexander S. Wolcott (who invented a daguerreotype camera with a concave reflector) and John Johnson (Wolcott's partner) briefly worked with Henry Fitz Jr., a telescope and lens maker and early daguerreotypist who eventually settled in Baltimore. Similarly, Philadelphia, Robert Cornelius, Paul Beck Goddard, and Joseph Saxton worked primarily on the

technological advancement of the medium, rather than on philosophical and scientific questions such as those Draper was asking.

EARLY EXPERIMENTATION

Draper's long interest in how certain chemicals reacted when exposed to light had led him to publish a series of articles in the *Journal of the Franklin Institute* over several months in 1837, two years before the announcement of Daguerre's process.[27] Those articles were strictly concerned with how various chemicals and solutions reacted to solar light. For example, in June of 1837 Draper followed the basic principles of Young's experiments by passing light through a slit. Draper, however, also used several of the basic principles of photography. In a darkened chamber (a literal camera obscura), he allowed a beam of light to pass through an aperture with a lens in a shuttered window. The angled beam of light passed through a slit cut into a thin metallic plate. Half of the beam then passed through a glass trough containing liquid, and the other half fell next to the trough. Each half of the beam then passed through a prism, and two spectra were projected onto a pasteboard screen. Draper could then compare the spectrum of the light that had passed through the trough with that of the light that had not done so, and he repeated this experiment by adding different chemicals and liquids to the trough, observing how each affected the spectra.[28] Unlike many other early experimenters who can be classified as "proto-photographers" (those who were working with the basic concept of photography before the "official" onset of the medium in 1839), Draper expressed no desire to "fix" an image on a surface.[29] He was content to examine the results of how light reacted, to see what kinds of spectra were created, but he did not try to capture those spectra permanently. In these early experiments, then, Draper was more like his predecessors who investigated the nature of light itself, rather than the proto-photographers who were trying to capture a permanent image.

Once Daguerre's process became known, Draper seized upon this new means of scientific inquiry immediately and began experimenting on his own. Like other early experimenters in New York, including Morse, Draper was able to take views of nearby buildings almost immediately, he also tried his hand at portraiture.[30] In the early spring of 1840, he joined forces with Morse, continuing his work to improve portraiture. Around that time, he penned his earliest public commentary on the new medium in the July 1840 issue of *The American Repertory of Arts, Science and Manufactures.*, titled "Remarks on the Daguerreotype." In it, Draper discussed various experiments he had made over the preceding year using the daguerreotype, including making daguerreotypes by artificial light, creating duplicates of existing daguerreotypes, taking lunar daguerreotypes, and determining which rays of light reacted with the silver iodide coating a plate to produce a photochemical reaction.[31]

DRAPER'S LUNAR DAGUERREOTYPES

Draper's article appears to have gotten very little reaction in the scientific community. One wonders about the distinct lack of excitement generated by Draper's report on daguerreotyping the moon. Creating "photographic maps of our satellite" was one of the first applications of the new medium proposed by Arago when he introduced the daguerreotype to the French Academy of Sciences.[32] Apparently Daguerre, at Arago's suggestion, did indeed attempt to record the moon, and by all accounts was able to capture an indistinct yet recognizable image.[33] Alexander von Humboldt saw Daguerre's plate and, though he wished it had more clarity, was quite impressed. "Even the face of the moon," Humboldt marveled to a friend, "leaves her portrait in Daguerre's mysterious substance."[34] But there appears to have been no commentary about Draper's accomplishment in the scientific community. He presented his findings to the Lyceum of Natural History in New York in March and perhaps in April of 1840. (He had been elected a member in January.) The Lyceum reported the event in their minutes for the meeting, but those minutes would have remained the private domain of its members, not accessible to members of the public unless they chose to visit the Lyceum.[35] For public purposes, however, the Lyceum published a brief account of the event in its annual report for 1840, which appeared in *The American Repertory of Arts, Sciences and Manufactures*: "Dr. Draper announced that he had succeeded in getting a representation of the Moon's surface by the daguerreotype, but owing to the Moon's motion, the figure was confused in some places."[36] Perhaps because the public account of the experiment had been fairly stark, Draper published his own account a few months later. After noting that he had over-exposed a plate and lost the image, he described a more triumphant result:

> The moon being seventeen days old, by means of two lenses I obtained an image of her nearly an inch in its longest diameter; and to this, for three quarters of an hour, an iodized plate was exposed. The mercury bath evolved a chart, which was however deficient in sharpness partly owing to defects in the optical arrangement, but chiefly on account of the difficulty of making the heliostat follow the course of the moon with accuracy. The position of the darker spots on the surface of the luminary was distinct.[37]

Draper had used the mirror of a heliostat—a device normally used to track the movement of the sun—to reflect the moon's rays through two lenses within his camera. To capture an image of the moon onto a sensitized plate, he had left the plate exposed for 45 minutes. Coordinating tracking of the moon's progress would have been extremely difficult over that long an exposure, as the clockworks in the telescopes of the era were too rudimentary to keep the image of the moon stable on the plate; indeed, not until John Adams Whipple joined forces with William Cranch Bond at the Harvard Observatory nine or ten years later was the problem of tracking solved. This problem may have been what Draper meant when he noted

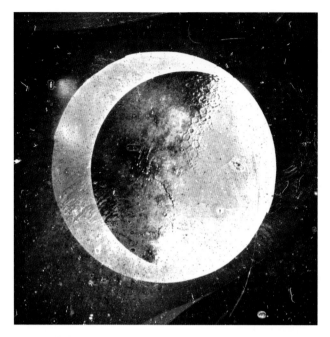

FIGURE 3.1
John William Draper, *Moon*, daguerreotype probably made on March 26 1840. Courtesy of New York University Archives.

that the "defects in the optical arrangement" caused some blurriness in the final result. Regardless, Draper's image (figure 3.1) was by far the most successful lunar daguerreotype yet created.

In an era when reprinting salient articles from other journals was standard practice for disseminating information, it is curious that other scientific journals did not seem to trumpet Draper's successful result. This could be a result of both where Draper chose to publicize the accomplishment and the unsettled state of science in America during this time period. Draper, who had studied under Robert Hare at the University of Pennsylvania, may have inherited some of Hare's apprehension of being criticized for being too esoteric and opted to limit publicity of his accomplishments to scientific journals rather than the popular press. In addition, Draper surely was aware of the reputation of American science abroad. British by birth, he longed for legitimacy from the more established scientific community; indeed, Draper's biographer has suggested that he felt "in exile" from European intellectual life.[38] "Remarks on the Daguerreotype" was the last article on daguerreotyping that Draper published in an American journal, though several of his European-published articles were later reprinted in American journals, as was standard practice. Perhaps

he believed that by publishing in European journals, particularly the *London and Edinburgh Philosophical Magazine,* he could advance his reputation within the European intellectual community.

PORTRAITURE

Although Draper made several contributions to the advancement of daguerreian portraiture, thereby increasing the market for such images, his approach to portraiture was strictly scientific. As with his lunar photographs, and indeed as with all his scientific photography, Draper focused on the process rather than the results. He was interested in making a successful portrait as a scientific problem: success would demonstrate that he had calculated the scientific possibilities successfully. He was not particularly interested in portraiture as a commercial venture. He left the studio he had founded with Morse at the end of the summer of 1840, after he had solved the scientific problems he had identified.

Of course, the verisimilitude of the daguerreotype portrait was much vaunted in the popular press, particularly in advertisements placed by studios seeking clients. These calls for clarity and the perfection of likenesses come closest to how Draper discussed the photographic portrait; after all, a scientifically sound result was, at its core, an accurate representation of the sitter. Draper was not the only early experimenter who was interested in photographic portraiture as an intellectual challenge, but he was one of the few in the United States who sought to gain scientific credibility from his experimentation by publishing the results of his work in one of Europe's leading scientific journals. Seeking to join the conversation happening there, in 1840 he published a paper titled "On the Process of the Daguerreotype, and Its Application to Taking Portraits from the Life" in the *London and Edinburgh Philosophical Magazine and Journal of Science,* a publication he seems likely to have chosen because Sir David Brewster was its editor.[39] In that article, which began with a detailed discussion of the chemistry involved, Draper discussed the most effective ways to create a successful portrait. He referred often to Daguerre's manual and to the theories of the Swedish chemist Jöns Jacob Berzelius. He went on to explain his experiments and proposed his recommendations to other researchers, offering direct scientific justifications for his actions. For example, in choosing a background, Draper advised using a drape of "drab color"—"White, reflecting too much light, would solarize upon the proof before the face had had time to come out, and owing to its reflecting all the different rays, a blur or irradiation would appear on all the edges, due to chromatic aberration."[40] He applied these same principles of the absorption of solar rays to the types of dress a sitter should wear, and went on to recommend the use of blue glass or a blue liquid in a trough to diffuse brilliant sunlight, which was distressing to the sitter's eyes but was needed to obtain the image.

Draper's approach to photographic portraiture differed greatly from that of his colleague and business partner Morse. Morse wanted to use photographic portraiture as a means to an end; he was hoping to obtain results that he could apply to his paintings.[41] Draper, however, was seeking a different reaction, from a different audience. When he submitted his article to the *London and Edinburgh Philosophical Magazine and Journal of Science*, he included one of his most successful plates: a daguerreotype of his sister (figure 3.2). That image is often erroneously labeled the first successful portrait of a living subject, though it was probably produced in the late spring or early summer of 1840.[42] Draper offered the plate to the European scientific community as proof of his endeavors, and hoped that the editor would include "an editorial note giving a brief statement of the appearance of these portraits." He also asked the editor to forward the plate and an accompanying note to Sir John Herschel.[43] In his letter to Herschel, whom he admired greatly, Draper labeled the plate a "proof," identifying it not as a representation of his sister but as a scientific object, and offered the plate as a tribute to the British scientist. Draper also sent the plate in reaction to Herschel's recently published claims regarding the necessity of an achromatic lens in photography. Draper hoped his plate of Dorothy Catherine would prove the viability of a non-achromatic lens—that is, a lens that did not correct for different wavelengths of lights. Herschel was deeply impressed with the image, calling it "beautiful and exquisite," but did not believe it proved Draper's claims regarding the non-achromatic lens. The image's flaws, he commented, could have been corrected if an achromatic lens had been employed: "For instance the bright speck in each eye [of the portrait] ought, if the figure were rigid and the camera perfect, to exhibit a picture of the external landscape as seen through the window of the apartment."[44] Note the underscoring of "ought": Herschel knows what the lens should do in theory, but has not seen a photograph actually accomplish this task, as he admits his test might be too severe for a living subject. In 1840, only a year into photography's existence, constant experimentation was pushing the known boundaries of the medium, but many theories regarding the new technology were as yet unproven. Here, Draper used the plate as a scientific object through which to engage in a discussion with another scientist skilled in the principles of optics, chemistry, and the nature of light. Herschel was eager to engage in the debate as well, in a way that Draper's American colleagues were not. The article accomplished Draper's goal: it allowed him access to the philosophical discussion taking place in Europe. Not only did Herschel address Draper's points both publicly and privately, but Robert Hunt reprinted most of Draper's article in his 1841 text *A Popular Treatise on the Art of Photography, Including Daguerreotype*. Hunt also included Draper in a list of leading experimenters in the field, all of whom were European save Draper.[45]

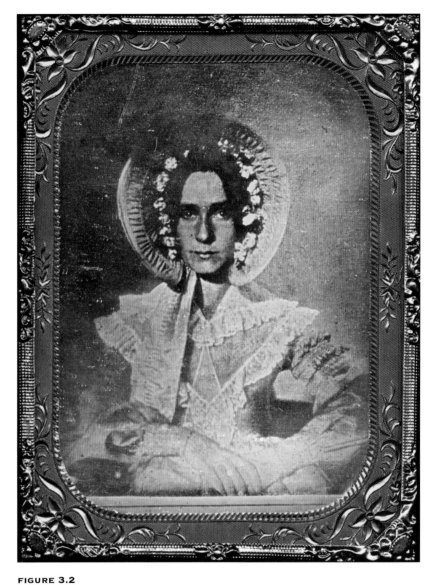

FIGURE 3.2
John William Draper, *Portrait of Dorothy Catherine Draper*, daguerreotype made before July 1840. Photographic History Collection, National Museum of American History, Smithsonian Institution, Washington.

SPECTRA DAGUERREOTYPES

Draper's biggest bid for scientific recognition via the daguerreotype was through his images of the solar spectrum. The reception of this body of work in particular illustrates the complexity of photography's relationship with scientific findings in its nascent years, and how Draper's work in particular may have been too esoteric, and the medium too new, for him to gain widespread recognition for his accomplishments with the daguerreotype.

The knowledge that light passing through a prism creates a rainbow of colors had been observed since Roman times. Solar spectra were represented in some of Newton's publications, and in 1802 W. H. Wollaston had observed that the visible spectrum of the sun had dark lines in it. Solar spectra first began to appear in visual imagery with regularity around 1814–15, when the optician and instrument maker Joseph von Fraunhofer published a map of the spectrum in which the dark absorption lines Wollaston had noticed were labeled with an identifying system of letters. These lines, which represent where certain wavelengths of sunlight that are absorbed by atoms and ions and are therefore invisible in the spectrum, would eventually be named for him.[46] Fraunhofer's work was translated into English and French in 1823, and researchers began to expand upon his discovery and attempt to capture the dark lines in the solar spectrum through a variety of means. Once introduced, the daguerreotype became an ideal vehicle for this experimentation. The light-sensitive chemicals of the daguerreotype process were able to record lines that weren't visible to the eye. A debate arose, however, as to what and how the photograph was able to record. Through his experimentation, Draper was able to shine light on the daguerreotype's capabilities, particularly on what the daguerreotype could capture.

In July of 1842, Draper made a series of plates featuring the solar spectrum, utilizing differently shaped apertures—a circle, a triangle, a fissure—to achieve differing results. Having begun a conversation with Herschel, Draper sought to continue it by forwarding the result made with a circular aperture to the European scientist. Draper had recently promoted a complex theory of what is now called latent image fading, and he was attempting to enlist Herschel's support for his ideas. Though Herschel supported Draper's priority in discovering what were then called "vapor images," he seemed wary of Draper's theory of how such images were created.[47] Draper postulated that photographs were created not by light but by a previously undiscovered imponderable. At the time, imponderables were thought to be a class of weightless substances, such as different types of rays such as light, heat, and electricity. Draper proposed that photographs were created by chemical rays, rather than light, reacting to the sensitive material on the photograph's surface. He labeled the new imponderable "tithonicity," after the story in Greek mythology of

Tithonus, who was granted immortality but not eternal youth. He compared the loss of mythological Tithonus's fading strength to the loss of photographic effect, or latent image fading. Draper suggested changing terms that had the prefix "photo" to new ones with the prefix "titho"—"tithonoscope, tithonometer, tithonography," and so on—which he deemed "musical in an English ear."[48]

Draper hoped that his image of the photographic spectrum would help sway Herschel to accept his theory of tithonicity, and that Herschel, in turn, would support his theory in front of the larger European and American scientific communities. Herschel, however, was circumspect regarding this new imponderable, and published a response in which he warned against "the adoption of a new name (and a most fanciful one), for an old idea."[49] Herschel once again chided Draper for using a non-achromatic lens, which he felt elongated the spectrum to such a degree that it became distorted. Herschel had recently made his own daguerreotypes of the solar spectrum—his first attempts at daguerreotyping anything—and informed Draper in a personal letter that Draper's were far superior in terms of artistic effect.[50] However, he disputed Draper's claim that a "different class of rays … under a brilliant sun" was necessary to produce a plate of the solar spectrum; Herschel accepted the disparity between their results, but asserted that it was "not from any difference in the quality of sunshine in Virginia and England, *but from a difference in the law of photographic dispersion in the prisms used.*"[51]

Despite Herschel's (and eventually others') rejection of his theory of tithonicity, Draper continued to experiment with images of the solar spectrum.[52] In May of 1843, he obtained a diffraction grating with which he hoped to produce spectrum images of greater precision. Many physicists had been using diffraction gratings, which caused wavelengths or frequencies to break down more evenly, since the early 1820s. The mechanic and daguerreotypist Joseph Saxton of the United States Mint in Philadelphia ruled the grating, which was made of glass and which measured ⅝ inch by ⅓ inch. Draper improved upon it by silvering its surface with tin amalgam, thereby increasing the brilliance of the spectra produced.[53] Draper was the first photographer to produce an image of the diffraction spectrum. With this tool, he was able to identify lines in the infrared section of the spectrum—lines that could not be observed with the eye, but only photographically. He also recorded ultraviolet lines that could not be seen with the eye. French experimenter Edmond Becquerel discovered these lines simultaneously, but wasn't able to record them.

The photographic capture of the diffraction spectrum was a major scientific accomplishment. As with Draper's images of the interference spectrum, however, the daguerreotype wasn't able to fully manifest the magnitude of the achievement. The daguerreotype plate could not record the solar spectrum's most distinguishing characteristic: its brilliant array of colors. These colors did not appear in the black-and-white medium of the daguerreotype, or in any other mid-nineteenth-century

medium. To circumvent this lack, Draper added paper labels to two of the plates from his experiments in July of 1842, one created with a triangular aperture and one with a circular aperture. The image made with the triangular aperture bears a paper label placed over the plate itself and secured on the edges by the plate's metal frame (figure 3.3). The label, which was then fixed atop the plate until the frame was removed, marks the location of the various colors that indicate the different wavelengths along the spectrum, according to the Newtonian system, and contains a series of dashes where the colors change, each with an accompanying letter: "V" for violet, "I" for indigo, "B" for blue, and so on to "R" for red. Above these markings is this notation, "Spectrum of a triangular aperture / ¼ inch on base and ⅜ on each side, Time 15' / Same conditions as other." The label on the plate created with a circular aperture—the one Draper sent to Herschel (figure 3.4)—is more elaborate; the plate is oriented vertically, and is flanked by paper labels. The label to the left of the image is an expanded version the one shown here in figure 3.3; it bears the same series of dashes indicating where the colors along the spectrum change. But rather than use letters, here Draper spells out the colors fully: "Green," "Yellow," "Orange," and so on. The label on the right offers the date, the temperature, and the latitude at which the piece was produced, and notes "Time occupied in exposure 15 minutes." Draper also marked the plate itself, using letters to note the rays' locations and indicating ray corresponds to which letter in the label on the right of the image: "A. upper neg. ray," "B. white ray," "C. daguerreotype ray," and so forth.[54]

The need for augmentation also held true for Draper's image of the diffraction spectrum. The daguerreotype could record the three additional absorption lines of the spectrum and the ultraviolet rays, but without the guide of the colors the only way to accurately assess the difference between a prismatic spectrum and an interference spectrum would have been to measure the Fraunhofer lines—an intensive and time-consuming process.[55] Thus, without augmentation the image was fairly useless as a scientific object.[56] Draper was aware of this limitation. In order to fully illustrate his findings, he published a hand-colored engraving comparing the two spectra—one prismatic, one interference—as the frontispiece of his *Treatise of the Forces Which Produce the Organization of Plants* (1844), and he discussed the differences in the text. Of course, the hand-colored engraving (figure 3.5) showed the colors the daguerreotype lacked.

These results, as a whole, appear to have excited very little interest in the scientific community and remained unknown to several other researchers who later thought they had been the first to reach the same findings. Herschel was excited by the images themselves, but disagreed with almost everything Draper was attempting to prove scientifically with these plates. Rather, the British scientist seemed to focus on the aesthetic virtues of the plate of the spectrum Draper sent to him, calling it "a joint work of nature and art … extremely remarkable and beautiful" and

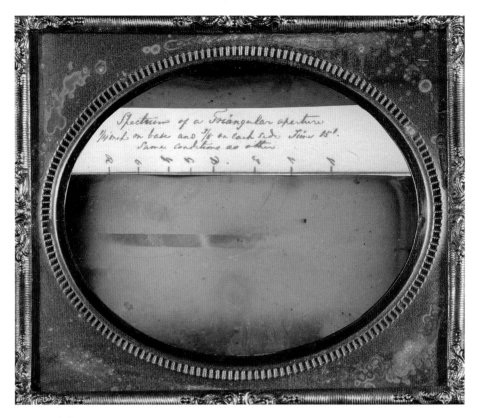

FIGURE 3.3

John William Draper, *Solar Spectrum of a Triangular Aperture*, daguerreotype made in July of 1842. Photographic History Collection, National Museum of American History, Smithsonian Institution, Washington.

noting the image's "perfection … of artistic effect."[57] As for the image made by the diffraction spectrum that Draper published in his 1844 text, that very real achievement seems to have gone almost completely unnoticed. The French experimenters Léon Foucault and Hipplolyte Fizeau also photographically recorded ultraviolet lines a few years after Draper. Believing they had been the first to do so, the pair delivered a sealed envelope to the Académie des Sciences documenting their work.[58] Even later in 1856, M. Eisenhoher published results similar to Draper's regarding the diffraction spectrum, also having been unaware of Draper's work.[59]

Perhaps some of this disconnect was simply due to the relative difficulty of transmitting information to a large community in an era when the transatlantic telegraph was just coming into existence. Perhaps it was also due to Draper's decision to publish the findings in his book rather than in an article in a scholarly journal.

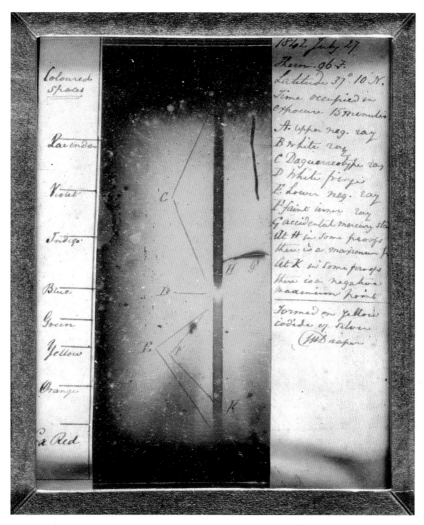

FIGURE 3.4
John William Draper, *Experimental Spectrum*, daguerreotype made on July 27, 1842. National Museum of Photography, Film and Television, Bradford, England.

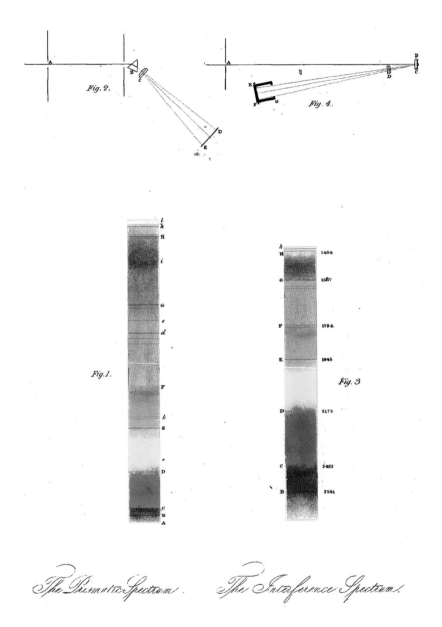

FIGURE 3.5

The Prismatic Spectrum and the Interference Spectrum, hand-colored engraving by unknown artist. Reproduced as the frontispiece of John William Draper's *Treatise on the Forces Which Produce the Organization of Plants* (New York: Harper, 1844).

Indeed, *A Treatise of the Forces Which Produce the Organization of Plants* received at least one negative review for attempting to be all-encompassing and for covering territory that had little or nothing to do with "vegetable physiology"; one can assume that a discussion of the diffraction spectrum might have been viewed as part of that outside territory.[60] However, as the science historian Klaus Hentschel has shown, exploration of the solar spectrum and its absorption rays often led researchers to results they were ill-equipped to understand, simply because they were unsure of the forces creating the spectrum. Although the infrared region of the solar spectrum was initially discovered by Friedrich William Herschel (John Herschel's father) in 1800, and the ultraviolet region by J. W. Ritter in 1801, scientists were still debating the nature of light and how those spectra were formed. This uncertainty led to theories such as tithonicity, when Draper tried to explain what substance created photographs. The lack of scientific knowledge affected Draper's understanding of his recording of the ultraviolet rays beyond the visible violet end of the spectrum, shown through his colored engraving of the diffraction spectrum. Other researchers were able to find the same results by non-photographic means. For example, in 1852, in a series of experiments involving first a spectroscope and then quartz optics, Sir George Gabriel Stokes, a professor of mathematics at Cambridge University, also observed the solar spectrum beyond its violet end. But because Stokes came to the same results as Draper by a different method, he wasn't sure that they were indeed the same results. As Hentschel has written: "Who could guarantee that the rays detectable with [Stokes's] visual techniques were really the same as those Draper had found with his photochemical method? As long as interpretation of these different types of rays remained unclear, there was no proof that the two types of spectra ought to be identical."[61] Because researchers were still uncertain about what they were finding and how they were finding it, the daguerreotype's status as evidentiary was rendered unstable and ultimately unreliable. Even though Draper translated his findings into the more common and perhaps more acceptable format of the engraving, the discovery's basis in the photographic made it perplexing and untenable.

Draper, frustrated by the lack of support from the scientific community during the 1840s, wrote numerous, querulous letters to the editors of the *London and Edinburgh Philosophical Journal* trying to right real or imagined slights against his work and to establish the priority of his findings over those of other scientists.[62] The early history of photography began to be told and created almost in tandem with the development of the medium, and the desire to institute precedence in experimentation was part and parcel of this retelling, particularly during the nineteenth century. Marcus Aurelius Root, one of the first Americans to write a history of photography (*The Camera and the Pencil: or, The Heliographic Art*), described Draper as an "eminent savant" and a pioneer who delved deeply into many aspects of the medium.[63] That reputation persisted well after Draper's death and indeed has persisted to

the present day. Because of his own bias and the American scientific community's apparent lack of interest in utilizing the daguerreotype for scientific research, Draper actively sought a European audience for his work. Despite this, and despite his reputation as a researcher of the chemical properties of light, several of Draper's very real accomplishments with the daguerreotype remained unknown. This may be attributable to the difficulties of disseminating information in the 1840s, or to the lack in the United States of a central scientific body through which he might have registered his work. Draper's lackluster reception may also be due to the very means of his experimentation—that is, photography. Draper was more interested in the process of daguerreotyping—how it worked, what made the images appear on the plate, what the image could tell us about the chemical and physical properties of light—than in the finished product. As a result, many of his images are perplexing and difficult to understand. It seems no accident that the accomplishments for which Draper was best known are those concerning portraiture, with results that were the most recognizable. The very newness of the daguerreotype medium, with its silvered, mirrored surface, made Draper's other scientific images—particularly those of the solar spectrum, but also his blurred images of the moon—more challenging to comprehend than the engraved or drawn reproductions most scientists (not to mention the general public) were used to encountering. Draper's images on their own, without the labels, cannot prove anything beyond their ability to make a record.[64] The spectra daguerreotypes as scientific specimens thus become paradoxical: only the photograph can prove that certain wavelengths in the spectrum exist, yet because of the photograph's limitations, the daguerreotype cannot illustrate the subject's most defining quality: color. Without explanatory text, the images are so abstract they almost appear to be photographic mistakes, and their significance as scientific objects are undermined almost to the point of negation.

COMPOSITION

In the midst of this contested territory, Draper did not limit himself to purely scientific inquiry with the daguerreotype (though of course, in the early part of the 1840s, photographing anything was a scientific endeavor, simply by virtue of the newness of the process.) On at least one occasion, he created an arrangement of sculpture and prints quite similar to that created with Morse (figure 3.6), including a small piece of paper tucked into the frame's corner that reads "Composition / Dag /J W Draper." It is not known when the plate was produced, though its physical similarity to the one produced with Morse suggests an early date.[65] The plate is dominated by a centrally placed framed drawing or lithograph of a bust-length figure of Christ carrying the cross. Above and to the right of this large image are at least four additional prints or drawings; like the images in *Still-Life*, they are hung or

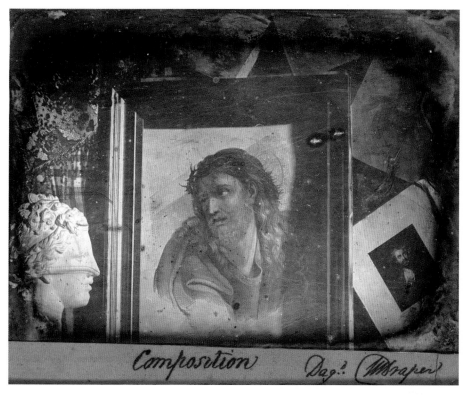

FIGURE 3.6
John William Draper, *Composition*, daguerreotype, c. 1840–1845. Photographic History Collection, National Museum of American History, Smithsonian Institution, Washington.

placed at varying angles to one another. The print to the direct right of the central framed image is also a biblical figure, either Christ or perhaps John the Baptist. At the left side of the plate is a plaid drape held in place with a floral tie. And like *Still-Life*, *Composition* includes a piece of sculpture: in the lower left corner is the head of a blindfolded figure in profile.

Though Draper's composition might formally be related to the plate he and Morse produced, its ideological makeup is quite different. As with *Still-Life*, the images within *Composition* may have been chosen simply for their dramatic appearance or their strong black and white tones, which represent well in a daguerreotype. An educated man such as Draper, whose sister Dorothy Catherine gave painting and drawing lessons to help pay for her brother's medical education, probably would have owned at least some artistic prints and casts. The charged nature of the chosen images, however, suggests Draper put some thought into their meaning and

arrangement. The thickness of the rendered lines and the evident cross-hatching suggest that the large framed image of Christ in the center of the plate is probably a drawing or a lithograph. It is a copy of a portion of a painting by Raphael, *The Fall on the Road to Calvary* (1517, Museo del Prado, Madrid). Like Morse, Draper was the son of a minister, though Morse's father was Calvinist and Draper's Methodist. Religion was an important part of Draper's life, so much so that in 1874 he published a book on the topic: *History of the Conflict Between Religion and Science*. The text repeats a great deal of the information published in his 1862 book *History of the Intellectual Development of Europe*, and in essence it outlines the history of just what the title promises, beginning with ancient Egypt and progressing to current debates about evolution. According to the biographer Donald Fleming, although for Draper science was clearly the winner of this long conflict, Draper was also able to suggest a happy middle ground. Perhaps this daguerreotype, with its two religious figures so prominently placed, is an early manifestation of Draper's feelings about religion and science—feelings that would evolve into the 1874 book. But just what does the image say about religion and science? Is it a proclamation of the triumph of science over religion, as the Christ figure is "trapped" within the chemical emulsions of the daguerreotype plate (though it was trapped by the artist's pencil or lithographer's ink first)? Or does the central placement of the biblical figures suggest a happy conjoining of the two?

Added to this mix is a sculpture of a blindfolded head. This sculpture probably represents the figure of Justice, as there are no other classical figures that appear with a blindfold. The figure is placed in profile, and one can discern the open eyes underneath the fold. As with the earlier still life, this positioning sets up an exchange of looks—or what would be a look, if the cast's eyes were not covered—between the sculpted Justice and the drawn or printed Christ. Is Draper implying that we can be sightless when it comes to matters religious, possibly prevented from seeing and knowing properly? There is a strong difference between being blindfolded and being blind; a blindfold can be removed, suggesting again the possibility of a compromise. The blindfolded figure could also allude to the nature of photography and how it is able to capture and record things not visible to the eye, such as the infrared region of the solar spectrum that Draper was able to capture.

THE SCIENTIFIC COMMUNITY

Though Draper was among the few Americans using the daguerreotype to explore scientific questions, he did not work in a vacuum. The Franklin Institute, for example, encouraged experimenters to work with the daguerreotype, both through its journal and through its annual exhibition. The *Journal of the Franklin Institute* published accounts of the daguerreotype from Europe, notices of improvements, and

accounts of the few other instances of experimental research conducted by Americans, and described the daguerreotype's use as a copying tool for scientists as well as for artists. In 1845, for example, a Mr. Goadby wrote that he had used Hippolyte Fizeau's process of etching daguerreotype plates to make reproductions of "delicate difficult dissections of the lower animals" both with and without a microscope.[66]

Another scientist who published accounts of his experiments with the new medium was W. H. Goode, who had been John William Draper's assistant in the chemistry department at the University of the City of New York. Goode initially applied his experimentation toward obtaining portraiture, sharing his successes with Draper and Morse, who in turn used Goode's modifications in their short-lived studio. Goode outlined these improvements in an 1840 article in the *American Journal of Art and Science*. He described taking "proofs" of magnified objects under a solar microscope, as Draper had done.[67] After moving to New Haven at some point around 1840, he worked with Benjamin Silliman at Yale University, eventually publishing his findings in Silliman's journal, which described how he had made daguerreotypes with a solar microscope.[68]

Frederick Augustus Porter Barnard, a professor at the University of Alabama, was also experimenting with how to reduce exposure times. A graduate of Yale, he may have learned the daguerreotype from Morse. Though he had joined the faculty at Alabama in 1838, Barnard appears to have been connected with other experimenters further north. In July of 1841 he wrote to the *American Journal of Science* that "some artists in the Atlantic cities have been equally successful" as Daguerre in reducing exposure times, but he would not reveal to whom he was referring, noting he was bound by secrecy.[69] He probably was referring to Goode and Draper. Barnard also wrote of his own work in the medium: "This discovery has opened a new field of experiment, in which we are actively engaged. The results may be communicated hereafter."[70] Much later, in 1853, he published an article in the same journal on taking daguerreotypes with a stereoscope.[71]

Another notable early experimenter was Benjamin Silliman himself. Silliman's experimental work seems to have been more similar to Draper's than to that of anyone else who was experimenting with the daguerreotype, in that rather than experiment to improve upon the daguerreotype (though that, in the early days, was a scientific experiment in its own right), he used the daguerreotype to explore other scientific questions. In one notable article published in 1842, Silliman described an 1840 experiment in which he and W. H. Goode had made daguerreotype impressions from "galvanic light reflected from the surface of a medallion."[72] They had obtain images, but the images had soon faded because the early plates they had used had been inferior. Silliman explained why he had not published these results earlier: "A gentleman distinguished for his scientific investigations, was already engaged in studying this branch of the subject, with whose researches we had no wish to interfere."[73] It is

probable that the gentleman was Draper, as in 1840 few other experimenters were using the medium to explore philosophical questions about the nature of light.

DRAPER'S LATER WORK

Draper continued working with the scientific daguerreotype well into the 1850s, and particularly with making daguerreotypes through a microscope. As with his other work with scientific subjects, Draper's experimentation with microscopic imagery was almost immediate. He reported his early success in the same July 1840 article in which he outlined his work with artificial light, lunar photography, and duplication of daguerreotypes: "I arranged a gas microscope with a lime pea, and also with charcoal points; and procured an impression of part of a fly's wing without any difficulty."[74] As with his daguerreotypes of the moon, he presented these plates to the New York Lyceum of Natural History, which noted in its semi-annual report that at a meeting in September of 1840 "Dr. Draper exhibited a number of daguerreotype views, showing the advantage of taking magnified impressions of various parts of insects, blood, and other minute objects by the daguerreotype."[75]

Many early practitioners were interested in microscopic photography, and it was widely practiced from the onset of the medium. William Talbot also created photographic images via the solar microscope, and exhibited three microscopic images in his first exhibition in January of 1839, but did not pursue the process once he had ascertained its successful feasibility.[76] As was noted earlier in this chapter, the French scientist Alfred Donné was interested in using a microscope to reveal the way daguerreotype images were formed and in producing daguerreotype images of microscopic views, and in 1845 he and Léon Foucault produced the first medical textbook to feature engravings taken from daguerreotype micrographs.[77]

Although Draper's primary work in microscopy (*Human Physiology, Statistical and Dynamical, or a Treatise on the Conditions and Course of the Life of Man*, a textbook featuring woodcuts after daguerreotype micrographs and collodion prints) is outside the chronological scope of this study, it bears mentioning. Though the book was published in 1856, many of the images probably were made much earlier. Draper recounted that he used photographic representations of microscopic objects to aid his lectures at the university, recalling "there are many such objects, costing much time and trouble in their preparation, to preserve" and declaring that "a photograph is their best substitute."[78] Because Draper had many serviceable daguerreotype plates on hand while he was writing *Human Physiology*, he simply used some of those to illustrate his new text. A number of his plates were later exhibited at the 1876 Centennial Exposition in Philadelphia as "illustrations of the early history of the art."[79]

In addition to woodcuts after daguerreotypes and collodion prints, Draper's *Human Physiology* was also illustrated with engravings made after photographs of

engravings. Because the half-tone process that made mass reproduction of photographs possible was not in common use until the late nineteenth century, this curious layering of representations was not only accepted by the public; it was celebrated. A reviewer in *Harper's Magazine* declared that *Human Physiology* represented "the first time the attempt has been made, on an extensive scale, to illustrate a book on exact science by the aid of Photography."[80] The anonymous reviewer acknowledged that the illustrations were engravings after photographs, and that "human agency and human skill have a little too much to do with the result," but contended that "nonetheless the reader will find that the advantages at once accruing are very great—indeed far greater than he probably would have had any anticipation of."[81]

By 1856, though, there was greater consensus on what constituted a scientific daguerreotype. The success of John Adams Whipple's lunar daguerreotype at the 1851 Crystal Palace Exhibition in London is an example of this. Daguerreotypes from the United States dominated the show, garnering praise and awards from commentators on both sides of the Atlantic. Whipple's lunar daguerreotype, one of a series of astronomical plates he had made using the great refracting telescope at Harvard University under the direction of William Cranch Bond, caused much excitement both at home and abroad.[82] Whipple was recognized by either the Royal Society or the Royal Society of Arts and Manufactures and by the Académie des sciences in Paris, and the fanfare surrounding his work established a precedent for funding astronomical photography projects at the Harvard Observatory.[83] The *Daguerreian Journal* described daguerreotypes of the moon that had preceded Whipple's as "mere whitish dots about the size of a pinhead, not marking in the least the well known rough and mountanous surface of that satellite."[84] As we have seen, however, Whipple's famous image was not the first successful daguerreotype of the moon. Draper had managed to capture a fairly accurate image—so accurate, in fact, that the plate clearly showed the lunar maria, the large, dark, basaltic plains on the moon's surface, hardly a "mere whitish dot."

The fact that Whipple's plate was celebrated on two continents and Draper's remained largely unknown is indicative, in many ways, of the unsettled state of scientific photography during the 1840s. By 1851, however, the American daguerreotype had a distinct identity within both the profession and in the broader popular culture. Whipple, a successful commercial photographer highly invested in promoting his work, was part of that culture; Draper, a scientist who had worked in a laboratory more than ten years earlier, was not.

The consensus on what constituted a "scientific" photograph was part of the continuing professionalization of science and of photography, one aspect of which was an increasing distinction between hard scientists and machinists (i.e., those who used the results of science to improve or create practical, utilitarian advancements).

4 "THE AMERICAN PROCESS": THE DAGUERREOTYPE AND TECHNOLOGY

In 1839, technology was at the forefront of Morse's mind. Particularly, he was considering the attitudes of Americans versus Europeans toward new technologies, and even more particularly, those attitudes toward the electromagnetic telegraph. As was mentioned in chapter 1, Morse prophesized that what he termed the "go-ahead" character of Americans, rather than what he believed to be the more traditional mindset of Europeans, would prove beneficial to the telegraph's success, particularly after he failed to receive funding for the telegraph in France in 1838–39. Morse read his fellow countrymen correctly: when first demonstrated in 1844, the telegraph was greeted with an abundance of praise, held up as a shining example of American innovation, inventiveness, and ingenuity, and in one instance called "the most wonderful climax of *American* inventive genius."[1]

Morse wasn't the only one to label America as "go-ahead." In 1846, the *Mechanics' Mirror*, an American monthly, cited "Go-A-Head" a "a word in general use, all over the country" and added that it "implies perseverance, enterprise, and assiduity, in the performance of some labor, with the view of attaining some object."[2] Regardless of whether it was founded in reality, the *idea* that technological innovation was an American trait, clearly well in place during the 1840s, continued throughout the remainder of the nineteenth century (and arguably continues today). Abraham Lincoln discussed it in his 1858 Lecture on Discoveries and Innovations: "The great difference between Young America and Old Fogy, is the result of Discoveries, Inventions, and Improvements."[3] In 1878, the *New York Herald* proclaimed Americans "the most inventive people in the world."[4]

The idea of inventiveness as a national trait was immediately applied to the daguerreotype. Though it was not an American invention, within ten years of its arrival to the United States it was called "the American process." The nickname's origins came from American improvements made to the daguerreian process within

the first ten or so years of its existence, and although the moniker was originally European it was not widely applied in Europe.[5] The relatively limited European use of the nickname "the American Process," however, did not seem to faze Americans, who gleefully seized the label and ran with it. For example, the opening issue of the *Daguerreian Journal* noted that "most of the [daguerreian] artists successfully pursuing this art in France, England and Germany, consider it to their advantage to say 'Daguerreotypes by the American process.'" The term is more indicative of nineteenth-century American exceptionalism than it is of actual European ideas about American photography, yet it is Americans' very embracing of the term that signals its significance. The ability to rename a French invention as American, thanks to American improvements such as gilding and reduced exposure times, neatly fit into the already existing national story of American inventiveness. The story of the daguerreotype's success in the United States can be read as a "technological foundation story" within American culture, as defined by the historian of technology David E. Nye. In such tales, Nye writes, "Americans constructed stories of self-creation in which mastery of particular technologies played a central role."[6] Such was certainly the case with the daguerreotype: by embracing the label "the American process," American culture not only co-opted the French invention, but declared their mastery over it.

There has been much speculation among scholars as to why the metal-plated daguerreotype enjoyed greater longevity and popularity in the United States than in other countries. Proposed reasons have ranged from the American desire for verisimilitude and reality (particularly in portraiture) to an American appetite for the new, to the appeal of the handcrafted, and even to an American fear of reproduction and possible counterfeit bank notes due to the contemporary financial crisis (recall that the daguerreotype on its metal plate does not have a negative, therefore can only be copied onto another metal plate, unlike a negative-positive paper process).[7] Surely each of these is, on some level, partially true, but it also may have been the sheer physicality of the daguerreotype, with its origins in the mechanical, that appealed to Americans. As a "nation of tinkerers," nineteenth-century Americans may have been drawn to a visual product that required tinkering in a way that painting, drawing, and even lithography or paper photography did not. Plates had to be manufactured, as did cameras, plate-holders, chemical mixtures, and developing and fixing trays. Plates were eventually buffed by machine, which resulted in an object that looked and felt mechanical. The hard, metal, glossy, brash, manufactured plate may well have been what appealed to the "go-ahead" Americans more than paper photography, with its soft, muted, subtle tones. Even if they hadn't invented the daguerreotype, Americans could show their mastery over its technology in a way they could not over the paper negative-positive process, and thus could build yet another foundational technology story around the medium, as they had done with the axe, the canal, and the railroad. "For most Americans," Nye has explained, "the foundational

belief in naturally abundant power described (and was inseparable from) a laissez-faire ideology in which the self-reliant individual had only to exert himself in order to rise in the world. This story flourished in the nineteenth century in many forms."[8] The fact that anyone, anywhere, could learn the skills that were needed to become a successful daguerreotypist was part of the medium's reputation (much to the lament of those attempting to apply standards to the profession by the early 1850s) and qualifies the daguerreotype as a story of technological foundation.

Like art and science, technology was becoming professionalized in the United States while the daguerreotype was flourishing there. The term "technology" was introduced in 1828. Although most of the societies devoted to the mechanical arts (including the Franklin Institute in Philadelphia and the American Institute in New York) were already in existence, through the 1830s hard science was separating itself from these institutions, which began to focus more on what were also sometimes termed the "mechanical arts," encompassing "machines, patents, and systems of production."[9] In response to popular demand, new publications within the field arose, such as *Scientific American* (successor to the *American Mechanic*), which, despite its name, promised "the advancement of more extensive intelligence in Arts and Trades in general, but more particularly in the several new, curious and useful arts, which have but recently been discovered and introduced."[10]

This chapter focuses on how the daguerreotype was incorporated into and altered the existing sphere of technology in the middle of the nineteenth century. Just as to some degree all early daguerreotypists became, by default, image makers and scientists because of the specifications of the process, anyone working with the daguerreotype in its first few years also became involved in technological progress and innovation. The equipment needed to create the plates—the cameras, the plates themselves, developing boxes, and so on—was not yet readily available and had to be manufactured either by the daguerreotypists themselves or (as in the case of Morse and his machinist George W. Prosch) by someone the daguerreotypist hired. But not only did Morse turn to Prosch to fill the gaps in his knowledge; he also teamed up with Draper. Such cross-disciplinary alliances engendered by the arrival of the daguerreotype were quite common in the medium's early years, and many of the early alliances relied on one partners' being a machinist or otherwise involved in technology. Even though most of the early practitioners were in different cities, they were acquainted with one another, constituting a network that exchanged ideas, information, supplies, and images.

THE NETWORK OF EXPERIMENTERS

The allure of the daguerreotype's potential was keenly felt upon the medium's introduction, and those who began to work with it came from many fields. Although by

1851 the *Photographic Art Journal* would be dismissive of the "mere mechanics, dabsters, or … those operators who jump from the stable, the fish-market, the kitchen and the poultry-yard into the operating room of the Daguerreotypist," in the early days it was exactly the "mere mechanics" and "dabsters" from other disciplines and professions whose experimentation expanded and professionalized the field.[11] They tinkered with cameras, plates, developing boxes, chemical formulas, exposure times, and polishing techniques, advancing daguerreotypy until it earned that nationalistic nickname.

One of the important early practitioners was Alexander Wolcott, a manufacturer of dental equipment with experience in optics. Wolcott apparently was already acquainted with John Johnson, who had worked as a jeweler and watchmaker's assistant, when Johnson read about the daguerreotype in early October of 1839. Johnson later reported that he brought the newspaper article to Wolcott, after which the two agreed that Wolcott (who had experience as a mechanic) would construct a camera, and that Johnson would acquire the other necessary materials the process required.[12] In a series of articles published in 1846 in *Eureka—Or, the Journal of the National Association of Inventors,* Johnson detailed his and Wolcott's early experiments. This series of articles reveals the concerns of the early daguerreian experimenter, and it is worthwhile to compare Wolcott and Johnson's experience with Morse's to assess areas of similarity and divergence.

Among the more striking features of Johnson's account is that the pair immediately worked not just to achieve Daguerre's process but to improve it. Like Morse, they were able to create an image fairly easily (according to Johnson, they made a portrait on the same day they built a camera), but they also immediately began working to shorten the exposure time needed to create an image. Wolcott's reflecting camera, described in chapter 2, was one of their greatest accomplishments in this regard. Appropriately for a journal on inventing (a field in which primacy equaled patents, which in turn was expected to equal profits), Johnson wanted to make his readers aware of questions of priority, and emphasized that Wolcott's camera was the first to attempt to lessen exposure times. This emphasis on primacy is also evident in a contemporary notice mentioning Wolcott: "[Daguerre], it is well known, could not succeed in taking likenesses from the life. … Mr. W[olcott] has succeeded in taking miniatures from the living subject, with absolute exactness, and in a very short space of time."[13] The insistence on priority, and on Wolcott's having improved the French inventor's process, also was evident in advertisements and notices surrounding Morse's early achievements—for example, "Prof. Morse has succeeded in taking the miniature of his daughter, by improving upon the discovery of M. Daguerre."[14] Johnson also reported that he discovered a chemical mixture for developing plates, which in London became known as "Wolcott's Mixture."[15] Wolcott and Johnson wanted not only to establish priority over their fellow American competitors but

also to make sure that their names and accomplishments were known abroad. Their insistence on American (and personal) inventiveness can be folded neatly into the larger national story about ingenuity as a particularly American trait.

Another striking aspect of Johnson's account, reminiscent of Morse, is how he described the obstacles that he and Wolcott encountered when trying to source equipment, particularly plates. Searching for a solution, they approached the Scovill Manufacturing Firm, just as Morse had. Again, like Morse, Johnson and Wolcott worked at making the daguerreotype not only commercially viable but profitable, by improving the process and eventually setting up, in New York City's Granite Building, what probably was the first commercial daguerreotype operation.

Wolcott and Johnson were able to achieve as much early success as they did, both technologically and commercially, because of their backgrounds in mechanics and scientific or technical instrument making. As with the fine arts, the daguerreotype was entering into a field where mechanics and inventors had an established network, signified by the numerous professional organizations and journals around the mechanical arts that existed and were continuing to grow. Thanks to the hybrid nature of the new medium, practitioners with backgrounds in the arts and sciences, like Morse and Draper, were able to engage with this network and create a new network of daguerreotypists. Morse, of course, recognized this, and originally approached Wolcott to be his photographic partner, turning to Draper only after Wolcott had turned him down. The new network allowed for the dissemination of ideas and improvements. For example, at a late 1839 or early 1840 meeting of the Mechanic's Institute in New York, a friend of Wolcott's named Mr. Kells drew a diagram of Wolcott's reflecting camera on a blackboard.[16] This led many of those who had been attending the meeting to visit Wolcott and have their images made. One of the attendees was probably James J. Mapes, whose daguerreian likeness by Wolcott was eventually shown at the annual exhibition of the Pennsylvania Academy of Fine Arts. Johnson acknowledges this network in his articles, mentioning his and Wolcott's association with Morse, the early efforts of Paul Beck Goddard and Robert Cornelius in Philadelphia, and the assistance of James Chilton, the pharmacist or chemist who supplied most of the early New York daguerreians with the chemicals they needed to create plates. Johnson also noted that he had received assistance from Draper, who had recommended buffing plates with velvet rather than leather, and from Henry Fitz Jr., who had assisted with the optics of the reflecting camera. Eventually, Wolcott and Johnson sold their business (probably around 1842) to "a Mr. Van Loan"—probably Samuel Van Loan, later to become a well known daguerreotypist.[17]

James Chilton's pharmacy shop probably served as a gathering and meeting place for early daguerreotypists in New York, and certainly Fitz would have been included in this milieu. Fitz originally trained with William Day in New York to work as a locksmith, then traveled the country as an itinerant.[18] During all of his travels, Fitz

continued to explore his love of astronomy, first buying telescopes and lenses and then making his first telescope in 1838. He began working with Alexander Wolcott in the spring of 1839, perhaps as a speculum maker, before traveling to Europe that summer. Upon his return Fitz worked with Wolcott and Johnson to help improve the lenses for Wolcott's new camera. Whether Fitz learned the daguerreian process while in France in the summer of 1839 or picked it up from Wolcott and Johnson in New York that autumn is not known, but by November of 1839 he had used the Wolcott camera to create one of the oldest extant self-portraits (figure 4.1). Fitz may have worked as an operator for Wolcott and Johnson's studio in the Granite Building in February or March of 1840, but soon, in order to be closer to his father, he moved to Baltimore, where he then opened what may have been that city's first daguerreotype studio. Fitz's Baltimore studio was in existence until at least 1842. He probably used funds earned from daguerreotyping to return to New York in 1845, where he opened a laboratory and shop devoted solely to telescopes.

FIGURE 4.1
Henry Fitz Jr., *Self-Portrait*, daguerreotype, 1839.
Photographic History Collection, National Museum
of American History, Smithsonian Institution.

Most of the extant Fitz daguerreotypes feature the simple head-and-shoulders format exhibited in most early plates (though several of his portraits of women are half length), and most are surrounded by brass mats.[19] Unlike other very early portraits, though, most of Fitz's are not strictly frontal. For example, in a portrait of a gentleman owned by the Metropolitan Museum (figure 4.2) the figure is turned slightly to the right, and in a portrait of a young woman now in the National Museum of American History (figure 4.3) the subject is turned slightly to the left. Though subtle, these shifts still create more nuanced images than those seen in many other early daguerreotypes. The self-portrait, easily the best known and most recognizable of all extant Fitz images, is also one of the most dynamic: Fitz's closed eyes and three-quarter turn away from the camera give the piece an air of liveliness and drama.

Fitz's use of brass mats seems to have been a conscious and consistent choice. He did not utilize the brass leftover from his telescope makings, which would be the logical choice, so he must have contacted another local source.[20] There is evidence

FIGURE 4.2
Henry Fitz Jr., *Gentleman*, ninth-plate daguerreotype, c. 1840. Gilman Collection, purchase, The Horace W. Goldsmith Foundation Gift, through Joyce and Robert Menschel, 2005. Image © The Metropolitan Museum of Art. Image source: Art Resource, New York.

FIGURE 4.3
Henry Fitz Jr., *Unidentified Young Woman*, daguerreotype, c. 1840–1842. Photographic History Collection, National Museum of American History, Smithsonian Institution

that Fitz often scraped down and reused plates, much as in his work with the telescope he would repurpose usable materials when necessary. This practice of reusing plates also indicates that Fitz approached daguerreotyping like an experimenter, tinkering, re-taking, and adjusting until he perfected his process. Of course, Fitz was also working on his telescope lenses during this period, experimenting and fine-tuning both technologies simultaneously.

One of the most compelling images Fitz created is a daguerreotype of a broadside or advertisement for his own studio (figure 4.4). The image is in reverse, so it can't have been taken with the Wolcott mirror or reflecting camera that Fitz helped perfect, which would have flipped the text to be legible. The broadside advertises Fitz's studio, proclaiming in part "Perfect Daguerreotype Likenesses! ... The Living Expression," and provides details of location and price. Though broadsides advertising studios themselves were common, a daguerreotype of a broadside is a very unusual image in early photography. Almost like the previously discussed daguerreotypes of prints based on paintings that were in turn based on daguerreotypes, this plate offers a meditation on the act of representation itself through its layering of information. It also acts as a double form of advertising: not only are we informed of the exactness of the process, we are so informed through an example of that process. It is particularly curious, then, that Fitz chose to create this image using a non-mirrored camera, or one that did not reverse the image on the final plate to its "correct" side. Perhaps there was a separate image made using a Wolcott camera, to demonstrate its abilities. Or perhaps this image was simply an exercise, or a means of recording the basics of Fitz's advertising.

The network of very early daguerreian activity extended to Philadelphia, and many of the experimenters were from the fields of science and technology. One example of the rich daguerreian exchange between New York and Philadelphia was James Mapes's bringing Wolcott's daguerreotype to the Franklin Institute. A notable member of this early community was John McAllister Jr., a prominent optician, who seemed to be for Philadelphian experimenters what Chilton the chemist was for New Yorkers. McAllister supplied lenses and other equipment to the experimenters, displayed daguerreotypes in his shop, and allowed his shop to serve as a gathering place for those interested in pursuing the new medium. Among those McAllister supplied were Robert Cornelius (a metallurgist and a lamp manufacturer), William Mason (an engraver), Paul Beck Goddard (a chemist), and Joseph Saxton (an instrument maker). For the most part, this group of experimenters focused their lenses on their surroundings, primarily creating city views and portraits. Joseph Saxton, for example, turned his camera on the buildings closest to him; to the best of our knowledge he never created a portrait. Like Draper, Saxton seemed less interested in what he captured on the plate than in the fact that he could capture anything. Whereas Draper used the daguerreotype as a means to answer philosophical questions

FIGURE 4.4
Henry Fitz Jr., broadside advertising Fitz Studio, c. 1840–1842. Photographic History Collection, National Museum of American History, Smithsonian Institution.

about the nature of light, Saxton appeared to be motivated by the purely technological aspects of the daguerreotype, which coincided nicely with the kind of work with which he was already involved. Saxton had apprenticed to a silversmith, watchmaker, and engraver in his home town of Huntingdon, Pennsylvania, and later had worked in Philadelphia with Christian Gobrecht, who had introduced him to medal ruling machines, in which images were mechanically reproduced from coins, cameos, or other objects with relief on their surfaces.[21] Saxton built new machines that eliminated distortions in the resultant images. Though not a fine artist, Saxton

had a background in image making of a sort, and one that was more related to the daguerreian process than the backgrounds of Talbot and some of his other European counterparts. Like Morse, Saxton was actively involved in direct mimetic representation via mechanical means.

Once Saxton read how to create a daguerreotype from Alexander Dallas Bache's description of Daguerre's process in the October 1839 issue of the *United States Gazette*, he had the necessary mechanical and technical experience to make equipment on his own. He built a camera from a cigar box and a spectacle lens, a sensitizing box from a container for laxative powder, and a mercury bath for developing plates from a piece of sheet iron and a block of wood. Probably on October 16, 1839, he pointed his makeshift camera out of the second-story window of his laboratory and obtained the image reproduced here as figure 4.5. That image, now held by the Historical Society of Pennsylvania, is among the oldest extant daguerreotypes in the United States. It features a grainy, hazy view of several buildings overlapping, appearing more like simple geometric forms than actual structures: the triangle of a roof, the squares and rectangles of windows and shutters, the cylinder of a tower. Of greater interest than the plate's potential priority, however, are two points: first, that Saxton's

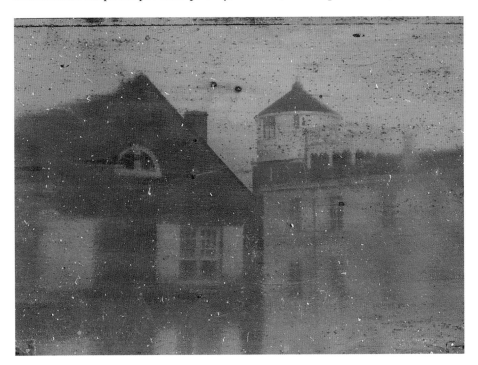

FIGURE 4.5
Joseph Saxton, *Central High School, Philadelphia*, daguerreotype, c. September 25, 1839. Historical Society of Pennsylvania Treasures Collection.

experience almost mirrors that of Draper in New York (each creating a camera from a cigar box, pointing it outside a second-story laboratory window, and taking a view of the nearby buildings), and second, that Saxton's priority is less important than the question "Why Saxton at all?" Indeed, we could ask the same about Draper.

This question—why certain experimenters were drawn to the early daguerreotype and others were not—potentially finds its answer in the interest in mechanical copying, mimetic representation, and technical innovation. Saxton was interested in the process from a technical rather than an artistic perspective, just as Draper was interested from a scientific perspective. Could a certain mix of chemicals result in an image, any image, on the plate? What could that plate reveal about the nature of light? How could the chemical mix, the plate, the polishing process, or the lens be improved to create a clearer image? Such questions drove many of the early experimenters.

Soon after Saxton asked the local metallurgist Robert Cornelius to make some silver-coated copper plates, Cornelius began his own experimentation in daguerreotyping.[22] Saxton collaborated with other early experimenters, among them Paul Beck Goddard and William Mason. Only a few hints of what else Saxton might have photographed or experimented with exist, however. In 1840, the *American Repertory of Arts, Sciences and Manufactures* reported that Saxton had exhibited at the Franklin Institute a "copy from a photographic plate" and a "Daguerreotype plate."[23] These apparently had been produced not by re-photographing the existing plates but instead by means of galvanism—that is, using an electrical current from a chemical reaction to create a copy in metal. (James Chilton in New York was also mentioned in the article, though for work with galvanism not related to photography.) A related image of Saxton's that survives is an image of the United States Mint in Philadelphia that was published in the 1842 text *A Manual of Gold and Silver Coins of All Nations Struck within the Past Century* (figure 4.6). Saxton had taken a daguerreotype of the Mint, engraved a copy of that image in metal, and then created another copy in copper by means of the galvanic process of electrotyping, from which the engraving had been produced. In 1842, of course, Saxton also ruled the diffraction grating from which Draper would create his daguerreotype of the diffraction spectrum. In 1844, Saxton moved to Washington to assume supervision of the Federal Office of Weights and Measures, after which he does not seem to have continued with experiments of these kinds. Like other early experimenters, Saxton seems not to have been interested in setting up a studio or in establishing himself as a professional photographer. Rather, he seems to have been motivated by an interest in the process of copying, in mechanical reproduction, in chemical reactions, and in advancing or improving upon known processes.

The details of Saxton's relatively limited activity with the daguerreotype illustrate how early experimenters collaborated to advance the new technology. Draper might not have been able to create his plate of the diffraction spectrum had he

FIGURE 4.6
United States Mint, engraving from an electrotype from a daguerreotype by Joseph Saxton. Published as frontispiece of Jacob Eckfeldt and William DuBois, *A Manual of Gold and Silver Coins* (Philadelphia, 1842).

not contacted Saxton for the grating. If Saxton had not contacted Cornelius, the latter might not have engaged in photography at all, or at least at not such an early date. Cornelius was working in his family's lamp-manufacturing business when he learned the process from Saxton, after which he built his own camera with lenses purchased from John McAllister. Rather than turning this camera onto his surroundings, though, Cornelius focused the lens on himself and his family, creating images of his children in their front yard and, like Fitz, creating a famous image of himself (figure 4.7).[24] But whereas Fitz captured himself with his eyes closed, Cornelius managed to keep his eyes open. Cornelius later reported that he had dashed in front of the camera to create the image; that would explain why he is off center in the image.

FIGURE 4.7
Robert Cornelius, *Self-Portrait*, daguerreotype, October or November 1839. Prints and Photographs Division, Library of Congress, Washington.

As Morse and Draper had done, and as Wolcott and Johnson had done, Cornelius formed a partnership with someone whose knowledge complimented his mechanical and technological skills: Paul Beck Goddard, a chemistry professor at the University of Pennsylvania. He did so no later than December of 1839. Goddard worked under Robert Hare, who had also been Draper's advisor at the university. Goddard is credited with suggesting the use of bromine as an accelerator to increase the sensitivity of daguerreotype plates, and by December of 1839 he and Cornelius were producing daguerreotype portraits by that method. Like Saxton, Wolcott, and other mechanically minded experimenters, Cornelius made all his own equipment (camera, plates, mats, developing boxes, and so on), having acquired many of the raw materials (particularly for plates and mats) from his family's brass-manufacturing factory.[25] Cornelius displayed portraits at both the American Philosophical Society and the Franklin Institute, and they were celebrated in the press. *Godey's Lady's Book* of April 1840 declared his daguerreotypes "unsurpassable" and asserted that he had "outstripped the great master of the art, a thing, by the way, peculiar to our countrymen," possibly a reference to Daguerre. The writer of this notice also acknowledged the incredulity that originally surrounded the process, informing readers that "catching a shadow is no more a thing to be laughed at."[26]

After visiting Wolcott's studio in New York in the early spring of 1839, Cornelius opened a portrait studio at Eighth Street and Lodge Alley in May of 1840, with Paul Goddard acting as a silent partner. The optician John McAllister, Cornelius's first paying customer, later described sitting at a "Southern facing window" that had a blue glass pane to mitigate the heat of the strong light needed to create the image shown here as figure 4.8.[27] Cornelius seems to have used a system of mirrors similar to Wolcott's to direct light onto his sitter, and may have been inspired to use the blue glass either by Wolcott (who had used a sheet of glass filled with a blue copper sulfate solution in his studio to the same effect) or by Daguerre (who had suggested the use of blue glass).[28]

There are a great deal more extant plates from Cornelius's early studio than from Wolcott and Johnson's or Morse and Draper's. Most of the portraits are similar to others made before 1842—simple, straightforward, head-and-shoulders views, such as that shown here in figure 4.9. But as Cornelius became more familiar with the medium and as his proficiency grew, a formal progression occurred in his work. Straightforward shots gave way to portraits that were more carefully and artfully posed, drawing on conventions of portrait painting. For example, in *Grandma Toppan* (figure 4.10), the sitter is arranged in a three-quarter view, resting her arm on a side table. In these more accomplished portraits the lighting is softer and subtler lighting than that in the earlier examples. The historian William Stapp surmises that Cornelius may have begun using a new lens after moving, in June of 1841, to a studio at 278 (now 810) Market Street, which may have contributed to these improvements.[29]

FIGURE 4.8
Robert Cornelius, *John McAllister*, daguerreotype, May 6, 1840. Prints and Photographs Division, Library of Congress, Washington.

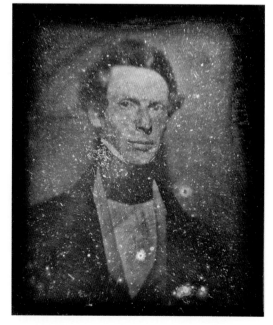

FIGURE 4.9
Robert Cornelius, *Robert Davidson*, daguerreotype, May 1840. Library Company of Philadelphia.

FIGURE 4.10
Robert Cornelius, *Grandma Toppan*, daguerreotype, c. 1841.
Library Company of Philadelphia

Another better-lit and better-positioned portrait by Cornelius is of the inventor Solomon Andrews; it is shown here as figure 4.11. Though also trained as a medical doctor, Andrews, like Cornelius, was a mechanic and an innovator. He was best known for his creation of an unbreakable combination lock and for his later efforts to realize a navigable balloon.[30] Cornelius's portrait of him probably was created around 1842, the year Andrews's tamper-proof lock was put into use by the United States Postal Service. The image is fairly typical of Cornelius's portraits of the period: Andrews is pictured at half length, holding a silver-tipped cane against his chest, with his head tilted slightly to the left. The image is evenly lit. It is not known whether Cornelius and Andrews knew each other through their various inventive pursuits—Andrews invented and patented an improved burner for gas lamps (U.S. Patent 14,994, dated June 3, 1856), and Cornelius's family were lamp manufacturers—or whether Andrews simply chose Cornelius's studio out of the several that had opened by 1842, but the two are linked by their shared interest and background as American "tinkerers."

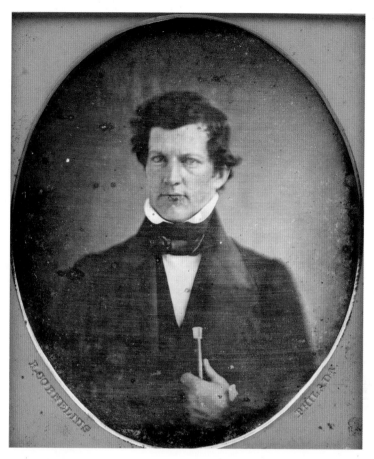

FIGURE 4.11
Robert Cornelius, *Solomon Andrews*, daguerreotype, 1842. National Portrait Gallery, Smithsonian Institution.

Some of Cornelius's most remarkable portraits are of Martin H. Boyè, a Danish-born chemist, physicist, and geologist who worked in Robert Hare's laboratory at the University of Pennsylvania in the late 1830s. Over several years, Cornelius photographed Boyè both in and out of his studio. In the first portrait (figure 4.12), made in May of 1840, the image is similar to the typical head-and-shoulders, brass-framed shots from Cornelius's first year in business. In December of 1841, Cornelius made two additional portraits of Boyè, both showing the scientist in partial profile, sitting at a desk and reading a book (figures 4.13 and 4.14). In the portrait shown here in figure 4.14, Boyè is turned more toward the camera, and he is more clearly lit than in figure 4.13; thus, his features and the details of his clothing are more

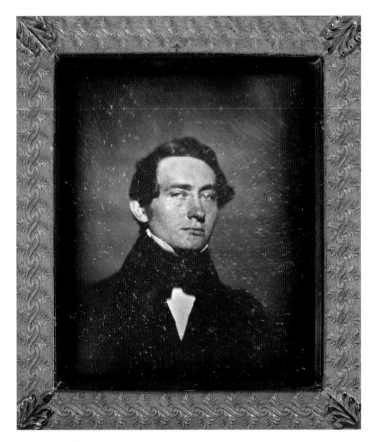

FIGURE 4.12
Robert Cornelius, *Martin Hans Boyè*, daguerreotype, May 1840. Courtesy of George Eastman House, International Museum of Photography and Film.

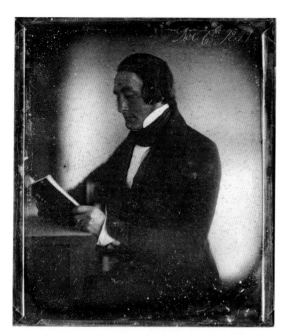

FIGURE 4.13
Robert Cornelius, *Martin Hans Boyè*, daguerreotype, December 1841. Courtesy of George Eastman House, International Museum of Photography and Film.

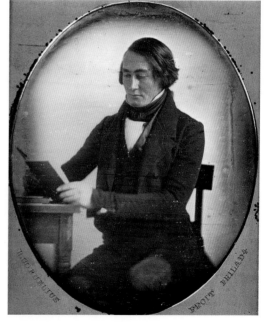

FIGURE 4.14
Robert Cornelius, *Martin Hans Boyè*, daguerreotype, December 1841. Courtesy of George Eastman House, International Museum of Photography and Film.

easily distinguishable. In May of 1842, Cornelius produced a fourth portrait of Boyè (figure 4.15); it belongs to the second group of his portraits from his later studio, whose subjects were better lit and well-positioned. In this three-quarter-length shot, Boyè faces the camera, yet his head is turned at a slight angle and his gaze is turned slightly upward. He has a slight smile on his face, and one arm rests against a small side table. Cornelius has lit Boyè's head well enough that we can easily distinguish his fuzzy sideburns, the light shining off his hair, and his light-colored eyes.

Cornelius closed his studio by 1842 and appears, for the most part, to have returned to his family's metallurgy business. But in December of 1843 Cornelius and Boyè again collaborated to produce a series of images showing both men using chemistry equipment and engaging in experiments. Several of these daguerreotypes, it appears, were created to be copied as woodcut illustrations for articles by Boyè on chemical analysis that were to be published in James Curtis Booth's 1850 *Encyclopedia of Chemistry, Practical and Theoretical*.[31] This group of images demonstrates the relative sophistication of Cornelius in embarking on such a project at this early date, and the continued progression of his daguerreian practice in a very short span of time. It also demonstrates the continued intersections of science and technology though the medium in this period, not only through the interaction of Cornelius and Boyè—the metallurgist-turned-photographer who took the scientist's photograph repeatedly—but also in the use of the images in a scientific publication, requiring the merging of two technologies (daguerreotypes and woodcut printing) to create the final, published images themselves.

An analysis of this group of images can begin with a yet another portrait of Boyè (figure 4.16), the fifth Cornelius is known to have made. As in the latter three, Boyè is carefully posed, seated next to the table of equipment, book in hand. As in much of his work from this later period in his relatively short career, Cornelius has employed subtly nuanced lighting from the side window to reveal a patterned rug, a tablecloth, and the gleam of the scientific instruments. We can easily see Boyè's face, the pinned cloth behind him (perhaps covering another window), and the details of the equipment on the table. In the second daguerreotype (figure 4.17), the focus is on the careful pouring that the experiment requires. The third daguerreotype (figure 4.18) features not Boyè but Cornelius. It is not known why Cornelius placed himself in front of the lens, or whether the shot was taken by Boyè rather than Cornelius. This image too shows the hands of a scientist pouring chemicals in the midst of an experiment (in fact, it accompanies the section of the article on "pouring" in Booth's encyclopedia). What is remarkable is the way Cornelius and Boyè are using the daguerreotype as illustration, as a reproductive tool for a scientific publication, at this very early date of 1843, and collaborating to do so. Though the daguerreotype was used to create woodcut or lithographed portraits quite often during this period, very seldom was it utilized for more complex illustrations such as those shown in Booth's encyclopedia. Even more remarkably, in each of these works, the sitter's face, normally the

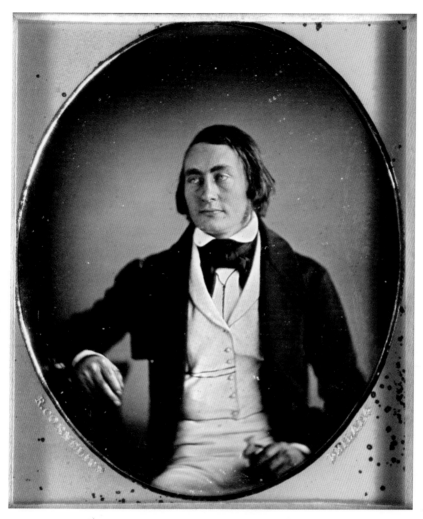

FIGURE 4.15
Robert Cornelius, *Martin Hans Boyè*, daguerreotype, May 1842. Courtesy of George Eastman House, International Museum of Photography and Film.

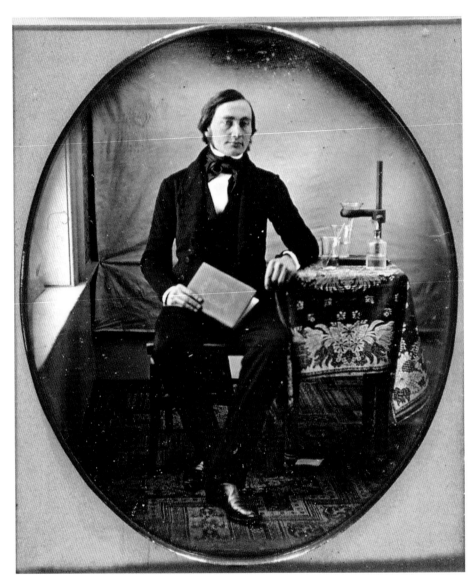

FIGURE 4.16
Robert Cornelius, *Martin Hans Boyè*, daguerreotype, December 1843. Courtesy of George Eastman House, International Museum of Photography and Film.

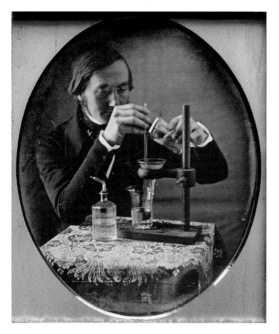

FIGURE 4.17
Robert Cornelius, *Martin Hans Boyè Pouring*, quarter-plate daguerreotype, December 1843. Historical Society of Pennsylvania Treasures Collection.

FIGURE 4.18
Photographer Unknown, *Robert Cornelius Pouring*, daguerreotype, December 1843. Courtesy of George Eastman House, International Museum of Photography and Film.

focus of a daguerreotype image in 1843, is completely eclipsed by his hands and the glass instruments. The woodcut (figure 4.19) in Booth's encyclopedia, made from the daguerreotype of Boyè "pouring," features the hands and chemical instruments in the act of the experiment, with the head and the figure completely erased; the woodcut (figure 4.20) that was taken from the daguerreotype featuring Cornelius does likewise.

Philadelphia—home to McAllister's shop, to Saxon, to Cornelius, to Goddard, to Boyè, to Mason, and to the Langenheims—was a hotbed of early daguerreian activity. Some of this might have had to do with Philadelphia's already-active community of scientists and inventors. Hare's laboratory at the University of Pennsylvania produced several chemists who worked in early photography—Goode, Draper, Goddard, and Boyè—and the presence of the American Philosophical Society and the Franklin Institute helped to foster an environment of thinkers who would be receptive to innovating a new technology. Indeed, at least one newspaper account in 1850 reported that Philadelphia's daguerreian activity exceeded that of New York both in number of operating studios and in profits, and that "of these establishments but a small portion are productive or profitable." "The principal business," it stated, "is confined to a few leading daguerreotypists who, by superior taste and genius, have managed to concentrate the business and monopolize the profits."[32] That article was referring primarily to Marcus Aurelius Root, but also active in Philadelphia during this period were the Langenheim Brothers, Montgomery P. Simmons, the Collins Brothers, Van Loan and Mayall, Samuel Broadbent, Frederick De Bourg Richards, and others. What is most striking about this list is that none of the early experimenters who had pioneered the advances in the medium that made the very profession possible were included in this list of "leading daguerreotypists." Why did so few of the mechanically minded early daguerreans not follow through with the profession they had helped establish? Why did Johnson, Cornelius, Fitz, Draper, and Saxton, for example, not establish national franchises and become famous, as Marcus Aurelius Root, Mathew Brady, John Plumbe, and Jeremiah Gurney did? It seems clear that the early experimenters were far more interested in technological innovation and invention than in becoming "photographers" themselves. Most of the major technical and scientific advances to the daguerreotype process (gilding the image, using bromine as an accelerating agent to shorten exposure times, techniques of polishing, the mercury bath) had been made by 1845.[33] Once they had taken the medium as far as the available science would allow, most of the early experimenters turned to other activities that they could continue to advance (for example, Fitz and his work with the telescope). Some of them returned to their previous careers (for example, Saxton's work with weights or Cornelius's return to metallurgy). Even Draper and others who continued to work with the daguerreotype process did so in an experimental vein, rather than opening a studio or a chain of studios and reaping the financial benefits of what they had helped create.

FIGURE 4.19
Woodcut reproduced in James Curtis Booth, *Encyclopedia of Chemistry, Practical and Theoretical, assisted by Campbell Morfit* (Philadelphia: H. C. Baird, 1850).

FIGURE 4.20
Woodcut reproduced in James Curtis Booth, *Encyclopedia of Chemistry, Practical and Theoretical, assisted by Campbell Morfit* (Philadelphia: H. C. Baird, 1850).

THE CULTURE OF TECHNOLOGY

Philadelphia exhibited some of the same patterns for display of early daguerreotypes as New York: just as very early examples were shown in Chilton's pharmacy shop in New York, they were also shown in McAllister's optical shop in Philadelphia. Eventually, early studios (among them the studio of Robert Cornelius) supplanted this practice and showed new works, a custom that remained common throughout the 1840s and the 1850s.

Other prominent spaces for display in both Philadelphia and New York were provided by institutions of learning, notably the Franklin Institute in Philadelphia and the American Institute in New York.[34] Annual exhibitions of "American Manufactures" showed and awarded prizes not only for new inventions or innovations but also for the highest-quality specimens of existing technologies, goods, and skills. There were displays of agriculture, clothing, shoes, hats, dental equipment, clocks, watches, drugs, chemicals, philosophical and optical instruments, fire engines, metalware, glassware, paper products, bookbinding, oysters, pickles, and so on. In the United States, these fairs began in the late 1820s and continued to grow in scope; the 1851 Crystal Palace Exhibition in London was followed by a New York version in 1853. A Centennial International Exposition was held in Philadelphia in 1876. Mechanics' and Industrial Fairs, popular in the middle of the nineteenth century, provided the public with the opportunity to examine and evaluate all manner of goods.

An examination of how the daguerreotype was treated within these fairs in the early years is illuminating in understanding how American society struggled to define the new technology. As Julie K. Brown has pointed out, by the early 1850s it was unthinkable to not include photography in an industrial fair. One journalist summed up the daguerreotype's place in these fairs this way: "To leave out the daguerreotype in any such enterprise, intending to exhibit the proficiency of the country in art and science, would be like the play of *Hamlet* with the part of Hamlet left out."[35] However, the organizers of these fairs were, like the American public, at first unsure of what, exactly, to do with the new medium. Under which category should it be displayed and judged? Was it art, or science, or industry?

The first display of a daguerreotype at a Manufactures Fair appears to have been shown at the 1839 Twelfth Annual Fair of the American Institute in New York. The *Journal of the American Institute*, which began publication in 1835 and had been reporting on the daguerreian discoveries as they were becoming known in early 1839, reprinted Morse's March 9 letter in its May 1839 volume. The American Institute, then, was poised to take notice of the daguerreotype as soon as it hit American shores. The inclusion of an example of the new medium in its September 1839 exhibition demonstrates how closely the Institute was following its progress. There is no description of the plate that was chosen for the September 1839 exhibition, but the journal

notes that the Institute awarded a diploma to D. W. Seager of 150 Greenwich Street for "a specimen of Daguerreotype"—probably one of the city views that Seager also exhibited at Chilton's Pharmacy around the same time.[36] It is not known if other examples were shown, though as there were so few American daguerreotypes in existence at that time, it seems probable that Seager's was the only one exhibited. Though there was a Fine Arts category at the Fair, the American Institute chose to place Seager's daguerreotype in "Dies and Engravings," which included prizes for wood engraving, line engraving, map engraving, seal engraving, lithography, and medallion engraving. It seems logical that the Institute would place daguerreotypes with another visual reproductive medium, despite the differences between the two processes. But such a choice also underscores the daguerreotype's newness, as it was *not* an engraving. The organizers of the Fair could just have easily placed the plate in the category of chemistry, metallurgy, or fine art. By choosing engraving, the Institute was emphasizing the daguerreotype's reproductive qualities over its other qualities.

The Franklin Institute in Philadelphia, on the other hand, does not seem to have included daguerreotypes in its 1839 exhibition. However, the Franklin Institute did show examples of daguerreotyping in 1840, when it awarded Joseph E. Parker of Philadelphia a premium for "his examples of heliography." "Throughout the [exhibition] room," the *Philadelphia Public Ledger* rather plainly noted, "are various specimens of the daguerreotype; they consist chiefly of miniature."[37] These were placed in the category of Fine Arts and were shown in the same room as engravings, pencil drawings, and an example of galvanism. Interestingly, Parker, like Alexander Wolcott, was involved in dentistry (though apparently as a practicing dentist rather than a manufacturer of dental equipment), was an active member of the Franklin Institute, and, like Saxton, he created scenes of Philadelphia's environs.[38] The American Institute, for its part, removed daguerreotypes from the "Dies and Engravings" category for its 1840 fair and, like the Franklin Institute, placed daguerreotypes under Fine Arts. The Institute went even further, creating a sub-category of "Daguerreotype Likenesses" and awarding diplomas to Alexander Wolcott and Christian Mayr for their portraits.[39]

Among the works included in the Fine Arts category of the American Institute Fair were stained glass, an arched lattice bridge, miniatures, and crayon drawings. The Fair appeared to exhibit works primarily by amateur artists and artisans; however, sometimes professional artists were also represented. For example, a watercolorist named George Harvey, who also showed at the National Academy of Design, won a silver medal at the 1840 American Institute Fair for his "beautiful specimens of histrionic, or atmospheric American landscape scenery."[40] Though the British-born Harvey did not work with the daguerreotype, he appears on the periphery of much early daguerreian activity, and his work incorporates some elements of scientific observation. His watercolor series documented different geographical sites at different times of the day and in different meteorological conditions. Hoping to have these

works engraved and sold to subscribers both in the United States and in England, he enlisted the help of the engraver William James Bennett. In 1841 Harvey published *Harvey's Four Scenes of the Primitive Forests of America, at the Four Periods of the Year* in slightly differing America and British editions.[41] He was friendly with Morse, having leased a studio in 1837 in the same university building in which Morse and Draper would later have their studio. By the time of the 1840 Fair, Harvey had a studio in the Granite Building on the corner of Chambers and Broadway, and he probably knew Wolcott, who also exhibited at that Fair. Since Harvey meant for his series to record different atmospheric and weather conditions at varying times of the day, he must have been interested in the daguerreotype's capabilities. He himself noted how his series was reminiscent of both the panorama and the diorama, technologies that have been associated with the same kinds of observing tied to photography.[42] Harvey also, eventually, translated his watercolors into "magic lantern" slides, and lectured in Britain on the North American landscape.[43] His decision to include several watercolors in the 1840 Fair (he would also exhibit at the 1842 Fair) illustrate his willingness to break away from the conventional fine-art exhibition venues and his deliberate positioning of his work, like the daguerreotype itself, as interdisciplinary.

The 1842 Franklin Institute Exhibition showed a selection of daguerreotypes by the Langenheim brothers of Philadelphia. (A salted paper print of one of those daguerreotypes is shown here as figure 4.21.) No mention of this was made in the *Journal of the Franklin Institute*, so it is not known under what category they were shown (though Fine Arts is the most probable), but other local papers reported on the plates, complaining that "the specimens at the exhibit [were] not placed in the most favorable light" and praising the daguerreotypes shown in the Langenheims' studio.[44] By 1843, the Franklin Institute was still placing daguerreotypes in the Fine Arts section of its exhibition. That year it gave a special commendation to "the collection of Daguerreotype miniatures … by J. Plumbe, Jr."[45] The judging committee acknowledged the difficulty of deciding what types of items should be placed where, and acknowledged that the Franklin Institute's exhibition differed from those of the Pennsylvania Academy of Fine Arts and the National Academy of Design, which tended to show works by professional artists: "The subjects more particularly appropriate to an exhibition like ours, are not those which constitute the most attractive parts of a picture, statue, or gallery. It is difficult, however, to draw the line between the appropriate and inappropriate."[46] Here, it seems, the men of the Franklin Institute were admitting their consternation about what constituted fine art and what did not, and about what was appropriate for that category and what was not. Though the report does not specifically mention the daguerreotype, the fact that the Institute was posing these types of questions about its Fine Arts category a mere three years after it began showing daguerreotypes seems significant. The members of the Franklin Institute must have been wondering, as much of the rest of the country was, how the new technology redefined this designation.

The American Institute, on the other hand, simply created a separate category for daguerreotypes in 1843, putting the plates under their own heading and awarding premiums to John Plumbe and Anthony Edwards for likenesses and coloring, to Plumbe for an electrotype copy of a daguerreotype, and to Joseph Courduan for plates. The Dies and Engraving and Fine Arts categories remained, mostly showing maps, miniatures, machine drawings, print coloring, and stained glass.[47] These categories, however, were not fixed. In 1847 the daguerreotype was listed under Fine Arts again, along with engraving, but in 1848 they were back in their own separate category, where they remained for the rest of the 1840s. The daguerreians who received the premiums continued to be those who came to define the early professionals of the emerging field: John Plumbe, Marcus Aurelius Root, Jeremiah Gurney, and Mathew Brady. The only member of the early group of experimenters mentioned by the fair was James Chilton, who represented analytic chemistry on the board of the American Institute.

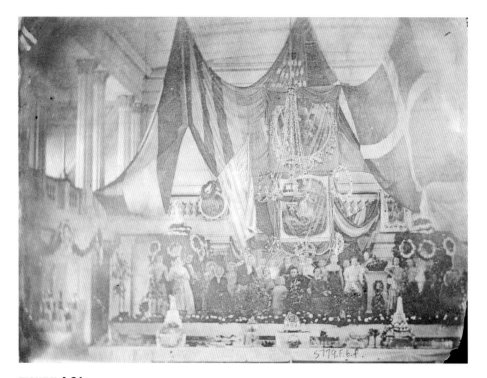

FIGURE 4.21
William Langenheim and Frederik Langenheim, *Exhibition of the Institute of American Manufactures at the Chinese Museum, October 1844*, salted paper print of daguerreotype, c. 1855). Library Company of Philadelphia.

At the 1850 American Institute Fair, daguerreotypes remained in their own category. Within Fine Arts, however, two awards were given for other forms of photography: a silver medal to the Langenheim brothers for talbotypes and a diploma to Bertha Wehnert Von Beekman & Brothers for "excellent photographic portraits," though there is no mention of what type of portraits those photographs might have been.[48] By 1850, then, the American Institute was acknowledging that the daguerreotype should be judged on its own terms, separate from Fine Art, even though it created a visual product, whereas the talbotype was appropriate to be judged *as* Fine Art. Was this because the softer, more muted tones of the talbotype were considered more appropriate for "art," a distinction the French Academy of Arts made upon the daguerreotype's introduction? Or was it because of technical aspects involved in the creation of the daguerreotype, or due to the daguerreotype's metal base rather than a paper one? A year later, the American Institute awarded medals for daguerreotype cameras, camera stands, and plate-buffing machines. In view of the mechanical emphasis of that institution, this kind of distinction between photographic media and the recognition of the supporting technology of the daguerreotype seems appropriate, and signals the Institution's awareness of and willingness to label the medium as an innovative technological process.

The Franklin Institute, on the other hand, kept the daguerreotype under the label of Fine Arts through the early 1850s. For several years in the mid 1840s, the judges repeatedly expressed frustration with the submissions to the Fine Arts category, complaining in 1844 that "with single exception, the specimens of the Fine Arts exhibited, are not very meritorious."[49] They seem to have considered the daguerreotype to be outside that category, even while exhibiting the plates under its heading: they awarded a silver medal to Samuel Van Loan of Philadelphia and honorable mentions to several other daguerreotypists. In 1845 the judges again criticized the Fine Arts category: "The display in this branch of the exhibition is inferior, with few exceptions to any offered for several years."[50] They pondered whether the lack of high-quality submissions might have to do with the simultaneous exhibition of the Artists Fund Society and the Pennsylvania Academy of Fine Arts. Again, the daguerreotype appears to have been excluded from this criticism, as the judges awarded two first premiums, one to a submission by the Philadelphia firm Simons & Collins and one to a submission by the Langenheim brothers, and a third premium to the firm of Van Loan & Mayall.

This trend toward treating daguerreotypes differently from other submissions, even though the Institute continued to place them in the category Fine Art, continued in 1846, though that year the judges found the Fine Arts submissions to be "of great merit." Now, however, they began to verbalize the differences between the two, though in general terms: "Among the paintings in oil and water colors are several pieces of great merit; but this branch of the fine arts being more dependent

upon creative imagination and fine taste, than upon mechanical execution, as some other branches of what is usually denominated the fine arts."[51] Clearly, the committee differentiated between "fine" art, such as oil paintings and watercolors, and the more "mechanical" types of art, such as the daguerreotype. The judges clarified that stance the following year: "Although the judges do not consider [the daguerreotype] as strictly belonging to the fine arts, still good collections of specimens are attractive and add to the interest of our exhibitions."[52] Not sure what to do with the plates, the fair's organizers defaulted to its primary function: being a visual product. However, they acknowledged the daguerreotype's mechanical nature and its inherent difference from the other types of fine art they exhibited.

As with the fine arts and science, in the realm of technology the daguerreotype entered into an existing culture of practitioners. The proliferation of inventions and the professionalization of fields within the first half of the nineteenth century, however, in conjunction with the relatively recent creation of the very term "technology," meant that the introduction of the daguerreotype helped define the developing field.

5 CONCLUSION

The indecisiveness of the industrial fairs of the 1840s as to how to categorize the daguerreotype is indicative of how uncertain the entire field of technology was about the new hybrid medium. The daguerreotype incorporated elements of science, the visual arts, and the innovation of mechanics. The concept of one object embodying all these qualities was new, and the object's identity had to be developed. This uncertainty was echoed by the discipline of the fine arts and the discipline of science. In the fine arts, artists struggled to define their place in relation to the new technology, to figure out how to utilize it and how to incorporate it into contemporary art-making practices, just as the emerging photographers struggled to place themselves within the already-existing flux of circulating visual imagery. The sciences also struggled with the daguerreotype, possibly because the scientific laws dictating the nature of light were still being explored and had not yet been defined.

Additionally, each of these fields—the art, science, and technology—was, to some extent, in the process of emergence within the United States. Art was certainly the most established of the three—the earliest fine arts organization in the United States, the American Academy of Fine Arts, had been founded in 1802. However, American science lacked a centralized institution during this period, and it was undergoing a process of specialization and professionalization as practitioners went from being generalists to specialists. The word "technology" had been coined in 1828 in an attempt to differentiate utilitarianism from hard science.[1] The idea of what constituted "technology" in relation to science, of course, had already existed, but both fields had expanded to the point that a new word was needed to properly differentiate between the two. The very word is a sign of the growth and development of both technology and science.

Of course, any daguerreotypist had to be conversant in all three fields—the visual, the scientific, and the technological—in order to create a successful plate. In the

rapidly changing and expanding landscape and social milieu of mid-nineteenth-century America, the daguerreotype was one of many new inventions Americans had to process, digest, and ultimately accept or reject. They embraced the daguerreotype, defined it in nationalistic terms, and, by labeling it the "American Process" (particularly in the face of European rejection of that very term), turned a French invention into one of America's "technological foundation stories," asserting that anyone could become a successful daguerreotypist.[2]

By 1851, the identity of the American daguerreotype was all but complete. Most of the important technical advancements of the medium had been achieved, and a distinct hierarchy of daguerreian studios and practitioners had been established. The development of an American daguerreian identity was due to advances in all three of the fields examined here, including the lavish spaces and national reputations of photographers such as Mathew Brady and John Plumbe, the scientific accomplishments of daguerreotypists such as John Adams Whipple, and the reputation of American daguerreotypes at venues such as the Crystal Palace in London. The field's two newly established journals continued to urge the betterment of the craft and the professionalization of all the photographers.

By the mid 1850s, though, new photographic technologies challenged the daguerreotype's supremacy. The introduction of the ambrotype around 1854, closely followed by the tintype, offered sitters cheaper and more durable photographic choices. Though both of those newer formats lacked the appealing high tonal contrast and brilliant surface of the daguerreotype, the cost difference and particularly the tintype's greater portability were more appealing to many consumers. Between these two new media and the introduction of albumen prints on paper, created from the wet collodion plate process introduced in 1851 (the same technology also behind ambrotypes and tintypes), the daguerreotype was rarely in use by the end of the 1850s and almost obsolete by the close of the Civil War. Its development throughout the 1840s, however, helped to chart how American photography would continue to develop and signaled one path for an ever-constant stream of emerging visual technologies.

Returning to Allan Sekula's notion of photography's "chattering ghosts" of art and science, we must acknowledge the all-important addition of the specter of technology.[3] Indeed, it is this third ghost that, much more than art or science, haunts photography still. Technology, in fact, not only haunts but continues to define photography today, particularly in view of twentieth-century and twenty-first-century advancements in a medium that has continued to morph, change, shift, and redefine itself more than any other form of visual imagery. One scholar has posited that the very essence of photography is its ability to adapt and evolve, further arguing that it never had a fixed meaning and that therefore there can be no "death" of the medium.[4] Though the daguerreian age had reached its conclusion by 1861,

supplanted and replaced by newer technologies such as the wet-plate process and the albumen print, a reexamination of how such an important medium became defined in American culture is useful. It can remind us of the long-standing, though ever-evolving, interdisciplinary nature of the photograph in general and its various manifestations in particular, and of our continued, and also evolving, effort to understand and comprehend photography's shifting, growing, and changing place in our lives.

NOTES

INTRODUCTION

1. "Art and Country Life," *Bulletin of the American Art-Union* 1 (1851): 93.

2. The spellings "daguerreian" and "daguerrean" appear to be interchangeable in texts of the period under discussion and in present-day. "Daguerreian" is favored by The Daguerreian Society and will be used throughout this book.

3. Henry Hunt Snelling, "The Daguerrean Art: Its Present State and Future Prospects," *Photographic Art Journal* 2 (1851): 100.

4. "Daguerrean Convention," *Photographic and Fine Art Journal* 2 (1851): 123.

5. The question of invention and authorship in relation to the daguerreotype is a murky one, as Louis-Jacques Mandé Daguerre at least collaborated and probably co-invented the process with Joseph Nicéphore Niépce and his son Isidore. On the history of the partnership of Daguerre and Niépce, see Mary Warner Marien, "Toward a New Prehistory of Photography," in *Multiple Views: Logan Grant Essays on Photography*, ed. Daniel P. Younger (Albuquerque: University of New Mexico Press, 1991), 17–39; Martin Gasser, "Histories of Photography 1839–1939," *History of Photography* 16 (spring 1992): 50–60; Geoffrey Batchen, *Burning with Desire: The Conception of Photography* (Cambridge: MIT Press, 1997); Stephen Pinson, *Speculating Daguerre: Art and Enterprise in the Work of L. J. M. Daguerre* (University of Chicago Press, 2012), 231–233.

6. Horace Greeley, *Glances at Europe* (New York: Dewitt & Davenport, 1851), 26.

7. *Crystal Palace Described and Illustrated by Beautiful Engravings Chiefly from Daguerreotypes by Beard & Mayall* (London: John Tallis, c. 1851), 136.

8. For example: "It is generally acknowledged that the Daguerreian Art is more successfully practiced in America than in any other country. Most of the artists successfully pursuing this art in France, England, and Germany, consider it to their advantage in advertising to say,

'Daguerreotypes by the American process.' This alone is sufficient proof of the high estimation in which the people of those countries hold our productions." "Editor's Note," *Daguerreian Journal* 1, 1850: 25. In a lecture at the 2011 symposium on Inventing American Photography at the Smithsonian Institution's National Museum of American History, François Brunet asserted that the term "American process" was in use for only a short period, and that Europeans in general were dismissive of early American photography. Despite this, it appears that Americans either were unaware of European condescension or did not care, as the term "American process" fit neatly into pre-existing ideas of nationalism and invention.

9. Alan Trachtenberg, "Photography: The Emergence of a Keyword," in *Photography in Nineteenth-Century America*, ed. Martha Sandweiss (New York: Abrams, 1991), 17–45. Trachtenberg traces this emergence primarily through literary sources.

10. "Invention … has found out the one new thing under the sun; that, by virtue of the sun's patent, all nature, animate or inanimate shall henceforth be its own painter, engraver, printer, and publisher." "New Discovery—Engraving," *Blackwood's Edinburgh Magazine* 45 (1839): 383.

11. Allan Sekula, "The Traffic in Photographs," *Art Journal* 41 (spring 1981): 15.

12. Larry Shiner, *The Invention of Art: A Cultural History* (University of Chicago Press, 2003).

13. On experimenters, including Young, who can be said to have worked with some of the basic elements of photography before the 1839 "start date" of the medium, see Batchen, *Burning with Desire*. On the changing nature of vision and observing in the years leading up to the invention of photography, see Jonathan Crary, *Techniques of the Observer: On Vision and Modernity in the Nineteenth Century* (Cambridge: MIT Press, 1990).

14. David E. Nye, *American Technological Sublime* (Cambridge: MIT Press, 1994), 45–46.

15. This is a well-discussed topic among historians of technology. See, for example, Brooke Hindle and Steven Lubar, *Engines of Change: The American Industrial Revolution, 1790–1860* (Washington: Smithsonian Institution Press, 1986); Alan I. Marcus and Howard P. Segal, *Technology in America, A Brief History* (New York: Harcourt Brace Jovanovich, 1989); Paul Israel, *From Machine Shop to Industrial Laboratory: Telegraphy and the Changing Context of American Invention, 1830–1920* (Baltimore: Johns Hopkins University Press, 1992).

16. David E. Nye, *America as Second Creation: Technology and Narratives of New Beginnings* (Cambridge: MIT Press, 2003), 2–11.

17. See Rosalind Krauss, "Photography's Discursive Spaces," in Krauss, *The Originality of the Avant-Garde* (Cambridge: MIT Press, 1986), 131–150; Joel Snyder, "Aesthetics and Documentation: Remarks Concerning Critical Approaches to the Photographs of Timothy H. O'Sullivan," in *Perspectives in Photography: Essays in Honor of Beaumont Newhall*, ed. Peter Walch and Thomas Barrow (Albuquerque: University of New Mexico Press, 1986), 125–150. The debate is summed up nicely on pp. 1–3 of Robin Kelsey, *Archive Style: Photographs and Illustrations for U.S. Surveys, 1850–1890* (Berkeley: University of California Press, 2007).

18. George H. Daniels, *American Science in the Age of Jackson* (New York: Columbia University Press, 1968), 35.

19. Ibid., 36.

20. See William T. Oedel and Todd S. Gernes, "*The Painter's Triumph*: William Sidney Mount and the Formation of a Middle-Class Art," in *Reading American Art*, ed. Marianne Doezema and Elizabeth Milroy (New Haven: Yale University Press, 1998), 128–149. For an alternative interpretation, see Elisabeth Roark, "Paint for the many? Rereading William Sidney Mount's *The Painter's Triumph*," *Prospect* 27 (2004): 155–184.

21. Oedel and Gernes, "*The Painter's Triumph*," 139.

22. The use of the term "index" to describe photography's causal relationship to its referent is based on Charles S. Pierce's division of signs into icons, indexes, and symbols. According to Pierce, a sign that is indexical is one that is physically caused by the object it is meant to represent, an icon resembles the object it represents, and a symbol represents an object without resembling it. See Pierce, "Logic as Semiotic: The Theory of Signs," in *The Philosophy of Pierce, Selected Writings* (New York: Harcourt Brace, 1950). Among the scholars who use "index" in relation to photography are Rosalind Krauss ("Notes on the Index, Part 2," in *The Originality of the Avant-Garde and Other Modernist Myths*) and Carol Armstrong (*Scenes in a Library: Reading the Photograph in the Book, 1843–1875*, MIT Press, 1998).

23. T. S. Arthur, "American Characteristics, The Daguerreotype," *Godey's Lady's Book* 38 (1849): 353; "Daguerreotype," *Barre Gazette*, 2.

24. See Trachtenberg, "Photography: The Emergence of a Keyword," 23–25; *The Knickerbocker* 26 (1846): 430.

25. "Daguerreotypes," *Littell's Living Age* 9 (1846): 552.

26. "Scientific—A Great Discovery," *New York Morning Herald*, April 26, 1839. The "Great Moon Hoax" refers to a series of six articles published in 1835 in the *New York Sun*. The articles, falsely attributed to Sir John Herschel, described fantastic animal and human-like figures living on the moon, said to be newly visible by means of an immense telescope. The hoax was eventually revealed, but not before many men of science embarrassed themselves by thinking it was genuine. See Matthew Goodman, *The Sun and the Moon: The Remarkable True Account of Hoaxers, Showmen, Dueling Journalists, and Lunar Man-Bats in Nineteenth-Century New York* (New York: Basic Books, 2008).

27. "Improvements on the Daguerreotype," *The Pathfinder* 5 (1843): 72.

28. See, for example, "Uses of the Daguerreotype," *Artist: A Monthly Lady's Handbook* 1 (1842): 235; "Daguerreotype," *Barre Gazette*, July 31, 1841, 2.

29. Arthur, "American Characteristics, The Daguerreotype," 353.

30. *Photographic and Fine Art Journal* 2 (October 1851): 110.

31. "New Discovery—Engraving," 383.

32. *Philadelphia Ledger*, May 22, 1844; Walt Whitman, "A Visit to Plumbe's Gallery," in *The Gathering of Forces*, volume 2, ed. Cleveland Rogers and John Black (New York: Putnam, 1920), 117.

33. See, for example, Rachael DeLue, *George Inness and the Science of Landscape* (University of Chicago Press, 2004); Margaretta Lovell, *Art in a Season of Revolution: Painters, Artisans and Patrons in Early America* (University of Pennsylvania Press, 2005); Kelsey, *Archive Style*; Wendy Bellion, *Citizen Spectator: Art, Illusion and Visual Perception in Early National America* (Chapel Hill: University of North Carolina Press, 2011); Jennifer Roberts, *Transporting Visions: The Movement of Images in Early America* (Berkeley: University of California Press, 2014).

34. It is not the purpose of this study to fully contextualize American daguerreotyping within international photographic trends, though Britain and France are treated briefly.

35. See Robert Taft, *Photography and the American Scene, 1839–1889* (New York: Macmillan, 1938); Beaumont Newhall, *The Daguerreotype in America* (New York: Duell, Sloan and Pearce, 1961); Richard Rudisill, *Mirror Image: the Influence of the Daguerreotype on American Society* (Albuquerque: University of New Mexico Press, 1971); William Welling, *Photography in America: The Formative Years* (New York: Crowell, 1978); George and Marion Rinhart, *The American Daguerreotype* (Athens: University of Georgia Press, 1981); Merry A. Foresta and John Wood, *Secrets of the Dark Chamber: The Art of the American Daguerreotype* (Washington: Smithsonian Institution Press, 1995).

36. Reese Jenkins, *Images and Enterprise: Technology and the American Photographic Industry, 1839–1925* (Baltimore: Johns Hopkins University Press, 1987).

37. John Wood, ed., *America and the Daguerreotype* (Iowa City: University of Iowa Press, 1991).

38. See Trachtenberg, "Photography: The Emergence of a Keyword." Also see the following essays by Trachtenberg: "Mirror in the Marketplace: American Responses to the Daguerreotype, 1839–1851," in *The Daguerreotype, A Sesquicentennial Celebration*, ed. John Wood (Iowa City: University of Iowa Press, 1989), 60–73; "The Daguerreotype: American Icon," in *American Daguerreotypes from the Matthew R. Isenburg Collection* (New Haven: Yale University Art Gallery,1989), 15–20; "Likeness as Identity: Reflections on the Daguerrean Mystique," in *The Portrait in Photography*, ed. Graham Clarke (London: Reaktion Books, 1992), 176–192.

39. Marcy J. Dinius, *The Camera and the Pencil: American Visual and Print Culture in the Age of the Daguerreotype* (Philadelphia: University of Pennsylvania Press, 2012).

40. Quentin Bajac, ed., *Le Daguerréotype Français: un Objet Photographique* (Paris: Musée d'Orsay, 2003); Grant Romer and Brian Wallis, eds., *Young America: The Daguerreotypes of Southworth & Hawes* (New York: International Center for Photography, 2005); Pinson, *Speculating Daguerre*.

41. Dolores Kilgo, The Sharp-Focus Vision: The Daguerreotype and the American Painter, PhD dissertation, University of Illinois, Urbana-Champaign, 1982; Mary Panzer, *Mathew Brady and the Image of History* (Washington: Smithsonian Institution Press, 1997).

42. Stephen Bann, *Parallel Lines: Printmakers, Painters, and Photographers in Nineteenth-Century France* (New Haven: Yale University Press, 2001); Jennifer Tucker, *Nature Exposed: Photography as Eyewitness in Victorian Science* (Baltimore: Johns Hopkins University Press, 2005); Stephen Bann, ed., *Art and the Early Photographic Album* (New Haven: Yale University Press, 2011).

43. Among earlier sources that consider scientific photography are the following: Jon Darius, *Beyond Vision* (Oxford University Press, 1984); M. Susan Barger and William B. White, *The Daguerreotype: Nineteenth-Century Technology and Modern Science* (Baltimore: Johns Hopkins University Press, 1991); Ann Thomas, ed., *Beauty of Another Order: Photography in Science* (New Haven: Yale University Press, 1997); Cory Keller, ed., *Brought to Light: Photography and the Invisible*, 1840–1900 (San Francisco Museum of Modern Art 2008); Tucker, *Nature Exposed*.

44. See Israel, *From Machine Shop to Industrial Laboratory*; Hindle, *Invention and Emulation*.

45. "Is It a Mere Coincidence?" *Scientific American* 38 (1878): 362.

CHAPTER 1

1. "Professor Morse's Great Historical Picture," *Yankee Doodle* 1 (October 10, 1846): 5.

2. Cited on p. 187 of Kenneth Silverman, *Lightning Man: The Accursed Life of Samuel F. B. Morse* (New York: Knopf, 2003).

3. They fall into a category of what Geoffrey Batchen has called a "proto-photographer." See Batchen, *Burning with Desire*, 50.

4. In his obituary, Draper is cited as stating Morse "supplied the aesthetic part, posed the sitters and all that, while I took the pictures" ("Dr. John Draper Dead," *New York World*, January 5, 1882). Morse recalled their work together in a similar vein: "[Draper pursued daguerreotypes] as to their bearing on philosophical investigations ... with great ingenuity and success, [and] I was left to pursue the more artistic results of the process, as more in accordance with my own profession." Morse to Marcus Aurelius Root, February 10, 1855, *Photographic and Fine Art Journal* 8, 1855: 280.

5. See Israel, *From Machine Shop to Industrial Laboratory*, 5–6; Hindle and Lubar, *Engines of Change*, 75–76.

6. Samuel F. B. Morse to Lucretia Pickering Walker, summer 1817, quoted in Samuel Irenaeus Prime, *The Life of Samuel F. B. Morse, LL.D., Inventor of the Electro-Magnetic Telegraph* (New York: Appleton, 1875), 103.

7. Samuel F. B. Morse to Jedidiah Morse, January 28, 1818, cited on p. 108 of Prime, *The Life of Samuel F. B. Morse*.

8. Samuel F. B. Morse to Sidney E. Morse, March 9, 1839, quoted in "The Dagguerrotipe," *New-York Observer*, April 20 1839. Early scholars of the history of photography assumed this letter referred to Morse's student days at Yale; Geoffrey Batchen, however, has demonstrated that the experiments referred to were conducted between 1821 and 1822. See Batchen, "'Some Experiments of Mine': The Early Photographic Experiments of Samuel F. B. Morse," *History of Photography* 15 (spring 1991): 37–42.

9. Morse's roommate during his 1832 stay in Paris, Richard W. Habersham of Savannah, Georgia, later claimed that Morse had described these experiments during their time abroad.

See *Samuel F. B. Morse, His Letters and Journals*, volume 1, ed. Edward Lind Morse (Boston: Houghton Mifflin, 1914) (hereafter cited as *Letters*), 42. There is no way to ascertain if Morse actually did so, or if Habersham was misremembering. On Wedgwood and Davy, see Geoffrey Batchen, "Tom Wedgwood and Humphry Davy, 'An Account of a Method,'" *History of Photography* 17 (summer 1993): 181.

10. As the art historian Nicolai Cikovsky Jr. has written, Morse's lectures comprise "[an] expression of his artistic views so complete in their substance and so adaptable to varying uses … they are virtually a canonical statement." Cikovsky, "'To enlighten the public mind … to make the way easier for those who come after me': Samuel Morse as a Writer and Lecturer," in *Samuel F. B. Morse, Educator and Champion of the Arts in America* (New York: National Academy of Design, 1982), 60–61.

11. Samuel F. B. Morse, *Lectures on the Affinity of Painting with the Other Fine Arts*, ed. Nicolai Cikovsky Jr. (Columbia: University of Missouri Press, 1983), 61, 112.

12. *Letters*, volume 2, 26. On Morse's desire to uplift the American public through his art, see Paul J. Staiti, *Samuel F. B. Morse* (Cambridge University Press, 1989).

13. Anne McCauley, "François Arago and the Politics of the French Invention of Photography," in *Multiple Views: Logan Grant Essays on Photography, 1983–89*, 43–69.

14. "With the committee of the Academy came several members of the Chamber of Deputies, one of whom observed to me: 'The Government should by all means own this Invention; it is of vastly more importance than the daguerreotype, which is proposed to the Chambers. Why has it not been offered to the Government?'" Samuel F. B. Morse to Francis O. J. Smith, February 2, 1839, Francis O. J. Smith Papers, Maine Historical Society.

15. Ibid.

16. "A few days ago I addressed a note to Mr. D[aguerre], requesting, as a stranger, the favor to see his results, and inviting him in turn to see my Telegraph. I was politely invited to see them under these circumstances, for he had determined not to show them again, until the Chambers had passed definitely on a proposition for the Government to purchase the secret of the discovery, and make it public." Samuel F. B. Morse to Sidney E. Morse, March 9, 1839, reprinted in "The Daguerrotipe." On Walsh's suggesting that Morse contact Daguerre, see Samuel F. B. Morse to Edward L. Wilson, November 18, 1871, reprinted in "Our Picture," *Philadelphia Photographer* 9 (January 1872): 3. On March 1, Morse wrote to Daguerre begging to re-schedule: "The time, Mon. Daguerre, in his great kindness, has fixed to show his most interesting experiments is unfortunately one that will deprive M. [Morse] of the pleasure. … Will Monday or any other day be agreeable to Mon. Daguerre." Samuel F. B. Morse to Louis-Jacques Daguerre, March 1, 1839, Samuel F. B. Morse Papers, Manuscript Division, Library of Congress (hereafter cited as Morse Papers).

17. Samuel F. B. Morse to Francis O. J. Smith, March 2, 1839, Francis O. J. Smith Papers, Maine Historical Society.

18. Morse relays that the two met "at [Daguerre's] rooms in the Diorama" ("The Daguerrotipe," 62). For more on the "Maison du Diorama," see Helmut Gernsheim and Alison Gernsheim, *L. J. M. Daguerre: The History of the Diorama and the Daguerreotype* (New York: Dover, 1968), 15; Pinson, *Speculating Daguerre*.

19. On the larger trend of optical experiences and illusions, see Crary, *Techniques of the Observer*.

20. "The Daguerrotipe," 62.

21. There is an outside possibility that the two men met later, as Morse returned to Europe in 1845 and, with help from Arago, demonstrated the improved telegraph to the Académie on November 10 of that year. See Prime, *The Life of Samuel F. B. Morse*, 538. Daguerre had retired to Bry-sur-Marne in 1840 or 1841, but came to Paris monthly; see Gernsheim and Gernsheim, *L. J. M. Daguerre, The History of the Diorama and the Daguerreotype*, 125.

22. "The Daguerrotipe," 62.

23. Two other articles on photography appear to predate Morse's letter in the American press. The first is "The New Art, or, 'The Pencil of Nature,'" *National Intelligencer*, March 7, 1839, 2, a reprint of an article published earlier in the *Boston Mercantile Journal*. The second is "The Pencil of Nature, A New Discovery," *The Corsair* 13 (April 13, 1839): 70–72; this is also a reprint, taken from "New Discovery—Engraving," *Blackwood's Edinburgh Magazine* 45 (March 1839): 382–390.

24. Morse's March 9 letter was reprinted in the *New York Commercial Advertiser* (April 22), in the *Boston Daily Advertiser* (April 22), in the *Boston Courier* (April 29), in *Niles' National Register* (April 27), in the New York *Evening Post* (April 25, reprinted from the *New Orleans Observer*), and in the *National Gazette*, published in Philadelphia (April 22). No doubt it was also reprinted elsewhere.

25. Among educated citizens in the mid-nineteenth-century United States, a casual reference to Rembrandt seemingly connoted the skillful use of light and shadow. For example, in 1834 a literary reviewer commented that an author possessed "a Rembrandt sort of skill in light and shade, which communicates an effect to her descriptions in strict keeping with the characters and events that are introduced" (*The Museum of Foreign Literature, Science, and Art* 24, April 1834: 388). Similarly, a 1838 article in *The New-Yorker* commented that witnessing a funeral "throws, like the shadows in Rembrandt's pictures, a reasonable darkness and gravity over the otherwise gay and frivolous scene" ("On Walking the Streets," *The New-Yorker* 4, March 3, 786).

26. Morse relayed this to Marcus Aurelius Root in a letter dated February 10, 1855: "In my intercourse with Daguerre, I specially conversed with him in regard to the practicality of taking portraits of living persons. He expressed himself somewhat skeptical as to its practicability, only in consequence of the time necessary for the person to remain immovable. The time for taking an out-door view was from fifteen to twenty minutes, and this he considered too long a time for any one to remain sufficiently still for a successful result," reprinted in "Who Made the First Daguerreotype in This Country?" (*Photographic and Fine Art Journal* 8, September 1855: 280) Whether or not Daguerre was successful in achieving a portrait before 1839, it is important that, according to Morse, Daguerre appeared unconvinced of its practicality.

27. "The Daguerreotipe," 62.

28. On the Great Moon Hoax, see note 26 to the introduction.

29. The photographic works Talbot called "photogenic drawings" were created in a variety of ways. Some were, in essence, photograms: Talbot placed a sheet of paper sensitized with salt and silver nitrate into a printing frame, placed an object (such as a piece of lace or a leaf) on the paper, then left the paper and the object in the sun, so that a direct-contact image was created. In other instances, Talbot placed sensitized paper into small camera obscuras, with which he then made images of buildings and landscapes. The majority of Talbot's work with photogenic drawings before 1839 took place in 1834 and 1835. He responded to the news of Daguerre's invention by showing a range of his works to the Royal Society in London on January 25, 1839. On January 31, Talbot's paper "Some Account of the Art of Photogenic Drawing" was read to the Society by Michael Faraday. See Larry J. Schaaf, *Out of the Shadows: Herschel, Talbot, and the Invention of Photography* (New Haven: Yale University Press, 1992), 36–54.

30. "National Academy of Design," *New-York Commercial Advertiser*, April 24, 1839, reprinted in *New-York Spectator*, April 25, 1839. This fascinating reference provides more questions than answers. Who was the mysterious owner of the portfolio of photogenic drawings? Who produced the drawings? What became of the portfolio? There is no further information on the drawings in the recent literature on Talbot; indeed, this reference is thus far the only proof they even existed. Were they even by Talbot, or were they by another practitioner of the process? Several Americans were experimenting with photogenic drawings in the spring of 1839, including two Harvard students and Dr. John Locke of Cincinnati, Ohio. Very little is known of the Harvard experiments, and Locke's were not reported in the New York press until several weeks after the Academy party. On the Harvard students, see Welling, *Photography in America*, 7. A report of Dr. John Locke's experiments appeared in the *New-York Observer* of May 18, 1839, about three weeks after the April 23 party.

31. "Notwithstanding the efforts being made in England to give to another the credit which is your due, [I assure you] that throughout the United States your name alone will be associated with the brilliant discovery which justly bears your name. ... Should any attempts be made here to give to any other than yourself the honor of this discovery, my pen is ever ready in your defense." Samuel F. B. Morse to Louis-Jacques Daguerre, May 20, 1893, Morse Papers.

32. I borrow the term "Lone Inventor" from Silverman, *Lightning Man*.

33. Trachtenberg, "The Daguerreotype: American Icon," 16.

34. Some scholars have speculated that the greater sharpness of the daguerreotype relative to the more muted tonalities of the calotype enhanced the former's popularity in the United States. See, for example, Kilgo, The Sharp-Focus Vision: The Daguerreotype and the American Painter; Trachtenberg, "Likeness as Identity: Reflections on the Daguerrean Mystique."

35. For a comprehensive outline of the various possibilities, see R. Derek Wood, *The Arrival of the Daguerreotype in New York* (New York: American Photographic Historical Society, 1994).

36. "The Daguerreotype," *New York Journal of Commerce*, September 28, 1839.

37. *New York Journal of Commerce*, September 30, 1839.

38. "Some copies of [Daguerre's manual] were immediately sent to this country, one of which I received in the latter part of August or September; and immediately I had made for me the apparatus from the description in the book." ("Who Made the First Daguerreotype in This Country") Anthony Prosch, George W. Prosch's brother, recounts that Morse received his manual from Seager ("The First American Daguerreotype," *Anthony's Photographic Bulletin* 14, March 1883: 76).

39. "The First American Daguerreotype," 75.

40. Charles E. West, "The Daguerreotype," *New York Times*, February 19, 1883.

41. Alfred Vail to Samuel F. B. Morse, January 13, 1840, cited in *Letters,*, volume 2, 153.

42. The telegraph machine Vail requested in January was still not complete by September. On the seventh of that month, Morse wrote to Vail: "As to the telegraph, I know not what to say. The delay in finishing the apparatus on the part of Prosch is exceedingly tantalizing and vexatious." (Morse Papers)

43. West, "The Daguerreotype."

44. "The greatest obstacle I had to encounter was in the quality of the plates." ("Who Made the First Daguerreotype in This Country?")

45. J. M. L. Scovill to W. H. Scovill, October 15, 1839, quoted on p. 246 of Theodore F. Marburg, Management Problems of a Manufacturing Enterprise, 1802–1852: A Case Study of the Origin of the Scovill Manufacturing Company, PhD dissertation, Clark University, 1945.

46. J. M. L. Scovill to W. H. Scovill, probably October 17, 1839, quoted on p. 158 of Rinhart and Rinhart, *The American Daguerreotype*.

47. J. M. L. Scovill to W. H. Scovill, December 31, 1839, quoted on p. 249 of Marburg, Management Problems of a Manufacturing Enterprise.

48. Marburg, Management Problems of a Manufacturing Enterprise, 250.

49. Samuel F. B. Morse to George Vail, October 26, 1839, Vail Telegraph Papers, Smithsonian Institution Archives, Washington.

50. Joseph Corduan was probably the first American manufacturer of daguerreotype plates. Corduan, Perkins & Co. seems to have operated in 1839 and 1840, and Corduan & Co. in 1840–1843. See pp. 162 and 423 in Rinhart and Rinhart, *The American Daguerreotype*. One extant Morse plate, *Still-life*, bears the mark "Corduan, Perkins & Co." Period articles describing Morse's first exhibited plate featuring New York's City Hall also mention Corduan, Perkins & Co.; see, e.g., the New York *Evening Post* of February 18, 1840.

51. Samuel F. B. Morse to Louis-Jacques Daguerre, November 16, 1839, quoted on p. 408 of Prime, *The Life of Samuel F. B. Morse*.

52. Samuel F. B. Morse to M. Lovering, September 30, 1840, Morse Papers.

53. Samuel F. B. Morse to George Vail, October 26, 1839, Vail Telegraph Papers, Smithsonian Institution Archives, Washington.

54. "I wished and intended to have had everything ready to come out for a day or two and Daguerreotype your picturesque place, while the trees were in such a state as to make a pleasing picture, but the season is so far advanced that I shall have to defer it to the spring." Samuel F. B. Morse to Alfred Vail, November 4, 1839, Vail Telegraph Papers, Smithsonian Institution Archives, Washington.

55. Ibid.

56. For a full description of the reflecting camera and Johnson and Wolcott's experiments, see John Johnson, "Daguerreotype," *Eureka* 1 (October 1846): 23–25.

57. Ibid., 25.

58. Donald Fleming, *John William Draper and the Religion of Science* (Philadelphia: University of Pennsylvania Press, 1950), 21.

59. This appears to be the most complete extant description of the Morse-Draper studio. Draper provided it in an interview, in about 1878, to the *New York World*. The interview has not been located, but it is discussed in an obituary on Draper in the January 5, 1882 issue of the same paper ("Dr. John Draper Dead"). This as-yet-unfound interview seems to provide the information included in a second obituary, "Professor John William Draper," *New York Herald*, January 5, 1882. The *Herald* obituary, in turn, inspired two additional articles on the studio: Dudley Armytage, "Who Took the First Photographic Portrait?" *The Field Naturalist* 1 (July, 1882): 28 and "The First Photographic Portrait," *Journal of the Society of Arts* 30 (August 18, 1882): 932.

60. Welling, *Photography in America*, 19.

61. "Portraits in Daguerreotype," *London and Edinburgh Philosophical Magazine and Journal of Science* 16 (June 1840): 535.

62. *New-York Observer*, April 18, 1840.

63. "Who Made the First Daguerreotype in This Country?" Five dollars appears to have been the standard rate for these early experimental studios, as it is also what Robert Cornelius charged in 1840. See Julius Sachse, "Early Daguerreotype Days, an Historical Remembrance," *American Journal of Photography* 13 (July 1892), 313. As the 1840s progressed, the price seemed to fluctuate between $1 and $5 per plate, depending on the size of the plate and the quality of the studio.

64. John William Draper, "Who Made the First Photographic Portrait?" *American Journal of Photography* 1 (June 1858), 5.

65. "Dr. John Draper Dead," 5. Theodore Frelinghuysen was Henry Clay's running mate in the 1844 election.

66. Samuel Breese to S[amuel] Sidney Breese and Helena Breese, June 30, 1840, Breese-Stevens-Roby Papers, 1705–1923, Rare Books, Special Collections & Preservation, Rush Rhees Library, University of Rochester.

67. Samuel Breese to Catherine Breese, July 9, 1840, Breese-Stevens-Roby Papers.

68. Samuel Breese to S[amuel] Sidney Breese and Helena Breese, August 10, 1840, Breese-Stevens-Roby Papers.

69. In addition, we are assured of Draper's involvement as the plate is in the Draper Collection at the National Museum of American History, Smithsonian Institution, which was donated to the museum by Draper's descendants.

70. Samuel F. B. Morse to Alfred Vail, November 4, 1839, Vail Telegraph Papers, Smithsonian Institution Archives, Washington. Also see "Memoranda of the Daguerreotype," February 1840, in Morse Papers.

71. On Morse and Gouraud's ongoing argument, see Sarah Kate Gillespie, "Samuel F. B. Morse's Daguerreotype Practice," *Daguerreian Annual* 2008, 100–104.

72. William Henry Fox Talbot, *Pencil of Nature* (London: Longman, Brown, Green and Longmans, 1844), n.p.

73. Bates Lowry and Isabel Lowry posit that the Morse-Draper daguerreotype was in direct reaction to Morse's viewing Daguerre's still lifes at the March 1839 meeting. See Lowry and Lowry, *The Silver Canvas: Daguerreotype Masterpieces from the J. Paul Getty Museum* (Los Angeles: The J. Paul Getty Museum, 1998), 141–142. Geoffrey Batchen reads *Still-Life* as a collaboration of art and science and suggests that the work "speaks to a new kind of visual culture in which everything is soon going to be transformed into a seamless, multi-directional flow of reproductions." Batchen, "Electricity Made Visible," in *New Media, Old Media, A History and Theory Reader*, ed. Wendy Hui Kyong Chun and Thomas Keenan (New York: Routledge, 2006), 36.

74. Howard McManus asserts in "Daguerreian Treasures at the Smithsonian Institution" (*Daguerreian Annual* 1996: 257) that the print in the lower right corner of the plate is a drawing signed by Morse. However, having examined it closely under a microscope, I do not believe that the signature is Morse's.

75. I am grateful to Guy Jordan for his assistance in identifying the print after Leonardo. The Louvre attributes the *Portrait of a Young Man* to Francesco Parmigianino. Sydney J. Freedberg, however, attributes it to Perino del Vaga and asserts that the sitter is Parmigianino. See Sydney J. Freedburg, *Painting in Italy, 1500–1600* (New Haven: Yale University Press, 1993), 692, n. 62.

76. Ossian supposedly was a third-century Scottish bard whose epic poems were rediscovered and published in the late eighteenth century, first appearing in 1760. The poetry was quite popular in both Europe and America in the late eighteenth century and in the nineteenth century. Morse was surely aware of the poems' existence and of the paintings they inspired. See Henry Okun, "Ossian in Painting," *Journal of the Warburg and Courtauld Institutes* 30 (1967): 237–356; Frederic I. Carpenter, "The Vogue of Ossian in America: A Study in Taste," *American*

Literature 2 (January 1931): 405–417; Georg Fridén, *James Fenimore Cooper and Ossian* (Cambridge: Harvard University Press, 1949).

77. Sybille Ebert-Schiffer, ed., *Deceptions and Illusions: Five Centuries of Trompe l'Oeil Painting* (Washington: National Gallery of Art, 2002), 181. According to this catalog, the earliest known painted deception of an engraving is *An Engraving of Galatea, Attached to a Board* (1644–1657) by Sebastian Stoskopff.

78. On Lewis's work with Jedidiah Morse, see Ralph H. Brown, "the American Geographies of Jedidiah Morse," *Annals of the Association of American Geographers* 31 (September 1941): 187–188. On Lewis's reputation at the time of his death, see Wendy Ann Bellion, Likeness and Deception in Early American Art, PhD dissertation, Northwestern University, 2001, 295.

79. On Morse's making daguerreotypes in Utica, see *Personal Reminiscences of the Late Mrs. Sarah Breese Walker* (compiled by James Eglinton Montgomery, privately printed, 1884), 50. Samuel Breese wrote of Morse's fondness for Thomas Walker: "Mr. Tom Walker [is] in the city … Finley is much taken with [him], so much so that he intends taking [him] with the Daguerreotype." Samuel Breese to Catherine Breese, October 6, 1840, Breese-Stevens-Roby Papers.

80. Andrew J. Cosentino, *The Paintings of Charles Bird King* (Washington: Smithsonian Institution, 1977), 80.

81. "In exhibiting the [*Gallery of the*] *Louvre*," Paul J. Staiti has remarked (*Samuel F. B. Morse*, 195), "Morse would be doing in miniature what an American art museum, had such a thing existed, ought to do."

82. Samuel F. B. Morse to Washington Allston, probably spring 1839, quoted on p. 405 of Prime, *The Life of Samuel F. B. Morse*.

83. Samuel F. B. Morse, "Annual Supper of the National Academy of Design," *New-York Commercial Advertiser* (April 27, 1840).

84. "Annual Supper of the National Academy of Design," *New-York Commercial Advertiser*, April 27, 1840.

85. Draper later recalled: "From April to the fall, when I was obliged to resume my duties of teaching, we kept our gallery open, and then Professor Morse, quite devoted to it, opened a gallery on his own account." "Dr. John Draper Dead."

86. Samuel F. B. Morse to Alfred Vail, September 7, 1840, Morse Papers.

87. The New York City Street directory for 1839–40 does not list Morse, but the 1840–41 directory lists him at 142 Nassau Street, the address of the offices of the *New-York Observer* and the university. The 1841–42 and 1842–43 directories list him at 138 Nassau Street and at the university, and still list the *New-York Observer* at 142 Nassau Street. According to the historian Bayard Sill, Morse left the university building on May 15, 1841. See unpublished memorandum from Bayard Sill to Carl Prince, December 16, 1977, John W. Draper Papers, University Archives, New York University.

88. Samuel F. B. Morse to Eben N. Horsford, Horsford Family Papers, Special Collections, Rensselaer Polytechnic Institute, Troy, New York.

89. Samuel Breese to S[amuel] Sidney Breese and Helena Breese, December 11, 1840, Breese-Stevens-Roby Papers.

90. Sidney E. Morse to Richard C. Morse, January 29, 1841, Morse Family Papers (MS 358), Manuscripts and Archives, Yale University Library.

91. Arthur, "American Characteristics: The Daguerreotypist," 352.

92. "[The daguerreotype's] ... off-center composition ... suggest[s] an early date." Pierre Apraxine, *Photographs from the Collection of the Gilman Paper Company Collection* (New York: White Oak Press, 1985), 437.

93. "It was in [Hargrave's cotton-picking] factory that Reuben Nelson, who afterward became one of the most prominent Methodist preachers, lost one of his arms, his hand being caught and drawn into the spreader where the bolts were made for the cards." Joyce Foote, *Morris New York, 1773–1923* (privately printed, 1970), 28. See also Leroy E. Bugbee, *Wyoming Seminary 1844–1944* (privately printed, c. 1945), 40–45.

94. Prime, *The Life of Samuel F. B. Morse*, p. 403. Prime was serving as the editor of the *New-York Observer* during this period (he held the position from 1840 to 1885) and was an eyewitness to these events. On Prime's involvement with the *Observer*, see "Founding and Early History of the *New York Observer*," undated manuscript, Morse Family Papers (MS 358), Manuscripts and Archives, Yale University Library.

95. A good discussion of the this time period can be found on pp. 18–25 of Davis, *The Origins of American Photography, 1839–1885*.

96. Samuel F. B. Morse to Reverend Edward S. Salisbury, February 24, 1841, Morse Papers. The painting commissioned by Salisbury does not seem to have been realized.

97. New York *Evening Post*, February 13, 1841.

98. *Niles' National Register* 60 (April 17, 1841): 112.

99. *New York Sun*, April 10, 1841.

100. On p. 38 of *Photography and the American Scene, 1839–1889*, Taft describes Broadbent as a former pupil of Morse's. An obituary for Broadbent does not classify him as such, but notes that Broadbent "studied and practiced portrait and miniature painting with much success, until his friend, Prof. Morse, brought to his notice the wonders of the daguerreotype process, which Morse had just brought from Europe." "Obituary, Samuel Broadbent," *The Philadelphia Photographer* 17 (October 1880): 309.

101. This advertisement ran weekly until August 21, 1841.

102. *New York Mechanic*, April 24, 1841.

103. *New York Mechanic*, May 1, 1841.

104. Thomas Smiley to Samuel F. B. Morse, August 24, 1841, Morse papers. N. V. Young is mentioned also in a December, 1841 letter from Samuel F. B. Morse to J. M. Edwards that is in the collection of Dennis A. Waters.

105. See Dennis A. Waters, Dating American Daguerreotypes, 1839–1842 (www.finedags.com/dating).

106. *Personal Reminiscences of the Late Mrs. Sarah Breese Walker*, 50–52.

107. Isaac Coffin to Samuel F. B. Morse, June 24, 1841, Morse Papers.

108. See pp. 212–214 of Silverman, *Lightning Man*.

109. Ibid., 213.

110. William W. Boardman to Samuel F. B. Morse, January 7, 1842, Morse Papers.

111. Isaac Coffin to Samuel F. B. Morse, June 24, 1841, Morse Papers.

112. Samuel F. B. Morse to Richard Cary Morse, April 2, 1849, Morse Family Papers (MS 358), Manuscripts and Archives, Yale University Library.

113. Asher B. Durand to Theodore Allen, February 23, 1843, Asher B. Durand Papers, New York Public Library.

114. "The Art Union Pictures," *Broadway Journal*, January 18, 1845.

115. Silverman, *Lightning Man*, 223; Samuel F. B. Morse, "Experiments Made with One Hundred Pairs of Grove's Battery, Passing through One Hundred Sixty Miles of Insulated Wire," *Silliman's American Journal of Science* 45 (October 1843): 390–394.

116. On the various lawsuits, see Carleton Mabee, *The American Leonardo, A Life of Samuel F. B. Morse* (New York: Knopf, 1943), 307–317; Silverman, *Lightning Man*, 307–324; David Hochfelder, Taming the Lightning: American Telegraphy as a Revolutionary Technology, 1832–1860, PhD dissertation, Case Western Reserve University, 1999, 167–263.

117. "Deposition of Joseph Henry in the Case of Morse versus O'Reilly, taken in Boston, September, 1849," *Extracts from the Proceedings of the Board of Regents of the Smithsonian Institution, In Relation to the Electro-Magnetic Telegraph* (Washington: Smithsonian Institution, 1858), 35–36.

118. Arthur Molella, Nathan Reingold, Marc Rothenberg, Joan F. Steiner, and Kathleen Waldenfels, eds., *A Scientist in American Life: Essays and Lectures of Joseph Henry* (Washington: Smithsonian Institution Press, 1980), 5.

119. Charles Ingham to Samuel F. B. Morse, October 13, 1849, Morse Papers.

120. Samuel F. B. Morse to James Fenimore Cooper, November 20, 1849, Morse Papers.

121. In *The Electro-Magnetic Telegraph, A Defense Against the Injurious Deductions Drawn from the Deposition of Professor Joseph Henry (in the several telegraph suits) with a Critical Review and Examination of Professor Henry's Alleged Discoveries Bearing Upon the Electro-Magnetic Telegraph*

(New York: Pudney, 1855), Morse claimed Henry had little to do with the technology behind the telegraph. Henry responded by submitting his case to the regents of the Smithsonian Institution and requesting they examine the accusations and present their findings. The regents found all of Morse's allegations against Henry false and characterized the publication as casting aspersions on Henry's character. See *Extracts from the Proceedings of the Board of Regents of the Smithsonian Institution, In Relation to the Electro-Magnetic Telegraph.*

122. On Morse's self-promotion as the "Father of American Photography," see François Brunet, "Samuel Morse, père de la photographie américaine," *Études Photographiques* 15 (November 2004): 4–30.

CHAPTER 2

1. On the proliferation of prints in early- and mid-nineteenth-century America, see Harry T. Peters, *America on Stone* (New York: Doubleday, 1931); *Art and Commerce: American Prints of the Nineteenth Century* (Charlottesville: University Press of Virginia, 1975); Wendy Wick Reaves, "Portraits for Every Parlor: Albert Newsam and American Portrait Lithography," in *American Portrait Prints*, ed. Wendy Wick Reaves (Washington: National Portrait Gallery, 1984), 83–114; Sally Pierce, *Early American Lithography: Images to 1830* (Boston Athenaeum, 1997); Elliott Bostwick Davis, "The Currency of Culture: Prints in New York City," in *Art and the Empire City: New York, 1825–1861*, ed. Catherine Hoover Voorsanger and John K. Howat (New Haven: Yale University Press, 2000), 188–225.

2. See Patricia Hills, et al., *Perfectly American: The Art Union and its Artists* (Tulsa: Gilcrease Museum, 2011).

3. "New Discovery in the Fine Arts—the Daguerreoscope," *The New-Yorker* 7, April 20, 1839, 71.

4. "New Discovery—Engraving," *Blackwood's Edinburgh Magazine*. Though this statement originally appeared in a British journal, it was reprinted at least twice in the United States, heavily edited and rearranged: once as the article listed in the preceding note and once as "The Pencil of Nature, New Discovery," *The Corsair.*

5. *Godey's Lady's Book* 20 (April 1840): 189.

6. See Davis, *The Origins of American Photography, 1835–1885*, 83–85.

7. Julius Sachse, "Early Daguerreotype Days, An Historical Reminiscence," *American Journal of Photography* 13 (December 1892): 548. It is not known whether the letter was read from the *New-York Observer* or from one of the other publications in which it was reprinted.

8. Samuel F. B. Morse to Sidney E. Morse, March 9, 1839, quoted in "The Dagguerreotipe."

9. Daguerre was listed as an "honorary member" of the Academy on May 8, 1839. See Inclusive Notes from the Minutes of the National Academy of Design, June 4–May 8, 1839, 16, National Academy of Design Archives.

10. Morse's speech was reprinted in "National Academy of Design" (*New-York Commercial Advertiser*, April 27, 1840) and in the New York *Evening Post* of April 27, 1840. There is no record of this request in the existing National Academy of Design minutes. Morse began his speech, however, by stating "I have been requested to give my opinion of the probable effects to be produced, by the discovery of Daguerre, on the Arts of Design."

11. "National Academy of Design," *New-York Commercial Advertiser*, April 27, 1840.

12. Ibid.

13. Samuel F. B. Morse to Washington Allston, probably fall 1839, quoted in Prime, *The Life of Samuel F. B. Morse*, 405.

14. Pinson, *Speculating Daguerre*, 137–139.

15. Of course there were some in the French artistic community who supported the advent of photography, notably the painter Paul Delaroche. See Stephen Bann, *Parallel Lines*, 91–109; Pinson, *Speculating Daguerre*, 139–140.

16. On critical reaction to the daguerreotype in France, see Dominique Panchon-de Font-Réaulx, "Splendeurs et mystères de la chamber noire, le daguerréotype sous l'oeil des critiques," in *Le daguerréotype français, Un objet photographique*, 55–72. Panchon-de Font-Réaulx does mention several early French critics who, like Morse, saw the value in the photographic real as a *step* to the imaginative process in painting. Those critics, though, were exceptions. On Hippolyte Bayard, see Nancy Boghossian Keeler, Cultivating Photography: Hippolyte Bayard and the Development of a New Art, PhD dissertation, University of Texas, Austin, 1991.

17. Quoted in Welling, *Photography in America*, 8.

18. "The Daguerreotype," *The Knickerbocker* 14 (December 1839), 561.

19. "National Academy of Design," *New-York Commercial Advertiser*, April 24, 1840.

20. Prime, like Morse, lived in the *New-York Observer* building and worked at the paper. He would eventually replace Sidney E. Morse as editor. Prime is quoted in *Memorial of Samuel Finley Breese Morse, Including Appropriate Ceremonies of Respect at the National Capitol, and Elsewhere* (Washington: Government Printing Office, 1875), 11.

21. *Crystal Palace Described and Illustrated by Beautiful Engravings Chiefly from Daguerreotypes by Beard & Mayall* (London: John Tallis, c. 1851), 138.

22. "Improvements in the Daguerreotype," *The Pathfinder* 5 (March 25, 1843): 72.

23. "The Daguerreotype," *Bulletin of the American Art Union* 2 (November 1850): 131.

24. Ibid.

25. "Influence of Photography upon the Fine Arts," *Bulletin of the American Art Union* 2 (October 1851): 115.

26. Brantz Mayer, *Commerce, Literature and Art: A Discourse, delivered at the Dedication of the Baltimore Athenaeum, October 23, 1848* (Baltimore: John Murphy, 1848), 34.

27. Mattias Weaver to Henry G. Weaver, December 21, 1839, quoted in Greg French, "A Daguerreian Letter 1839, One Person's Opinion," *Daguerreian Annual* 1999, 71–72. On Weaver, see Sarah Weatherwax, *Mattias Weaver: The Reluctant Lithographer*, unpublished manuscript, Library Company of Philadelphia.

28. Merritt Roe Smith, "Technology, Industrialization, and the Idea of Progress in America," in *Responsible Science: The Impact of Technology on Society*, ed. Kevin B. Byrne (San Francisco: Harper & Row, 1986), 4.

29. Ibid., 4–8. Ralph Waldo Emerson praised technology throughout the 1830s, but by the late 1840s became convinced that the machine had become unmanageable and a detriment to society. See Leo Marx, *The Machine in the Garden: Technology and the Pastoral Ideal in America* (Oxford University Press, 1964), 262–263.

30. Ibid., 243–353.

31. See in particular Trachtenberg, "Mirror in the Marketplace: American Responses to the Daguerreotype, 1839–1851"; Trachtenberg, "Photography: the Emergence of a Keyword."

32. "The Atlantic Cable and Photography," *American Journal of Photography* 7 (September 1, 1858): 111–113.

33. Quoted in Batchen, "Electricity Made Visible," 38.

34. "New Discovery—Engraving," *Blackwood's Edinburgh Magazine*, 383.

35. "Uses of the Daguerreotype," *The Artist: A Monthly Lady's Handbook* 1 (December 1842): 235.

36. "Drawing and the Daguerreotype," *New-York Mirror*, November 7, 1840.

37. See Van Deren Coke, *The Painter and the Photograph: From Delacroix to Warhol* (Albuquerque: University of New Mexico Press, 1972), 18–91.

38. *Crystal Palace Described and Illustrated by Beautiful Engravings Chiefly from Daguerreotypes by Beard & Mayall* (London: John Tallis, c. 1851), 138.

39. "Superior Daguerreotypes," *Brooklyn Daily Eagle*, June 15, 1852. The advertisement ran for several weeks.

40. Thomas B. Thorpe, "Personal Reminiscences of C. L. Elliott," *[New York] Evening Post*, October 1, 1868.

41. Thorpe, "Personal Reminiscences of C. L. Elliott," 1.

42. Beaumont Newhall, "The Daguerreotype and the Painter," *Magazine of Art* 42 (November 1949), 251.

43. The meeting between Elliott and Inman is recounted in a number of sources, one of the earliest being "The Lessons of Art: Charles L. Elliott, The American Portrait-Painter," *The Knickerbocker* 36 (July 1850): 86. The use of a daguerreotype is suggested by Theodore Bolton on p. 60 of "Charles Loring Elliott, An Account of His Life and Work," *Art Quarterly* 5 (winter 1942) and by Panzer on p. 80 of *Mathew Brady and the Image of History*.

44. "Daguerreotyping in New York," *Bulletin of the American Art-Union* 1 (September 1850): 101.

45. See Wolfgang Freitag, "Early Uses of Photography in the History of Art," *Art Journal* 39 (winter 1979/80): 117–123; Trevor Fawcett, "Graphic Versus Photographic in the Nineteenth-Century Reproduction," *Art History* 9 (June 1986): 185–212; Elizabeth Anne McCauley, *Industrial Madness: Commercial Photography in Paris, 1848–1871* (New Haven: Yale University Press, 1994), 265–300; Pierre-Lin Renie, "The Battle for a Market: Art Reproductions in Print and Photography from 1850 to 1880," in *Intersections: Lithography, Photography, and the Traditions of Printmaking*, ed. Kathleen Stewart Howe (Albuquerque: University of New Mexico Press, 1998); Stephen Bann, *Parallel Lines*; Stephen Bann, ed., *Art and the Early Photographic Album* (Washington: National Gallery of Art, 2011).

46. "New Discovery in Fine Arts—The Daguerreoscope," 71.

47. "The Daguerreotype," *Bulletin of the American Art-Union* 1 (November 1850): 181–182.

48. On *Infant Ceres* and its place in Palmer's career, see J. Carston Webster, *Erastus D. Palmer* (Newark: University of Delaware Press, 1983), 21–22. Webster makes no mention of the daguerreotype.

49. "Statues, busts, and other specimens of sculpture, are generally well represented by the Photographic Art; and also very rapidly, in consequence of their whiteness." William Henry Fox Talbot, *Pencil of Nature*, n.p.

50. As with the literature on the intersections of painting and early photography, the vast majority of scholarship on sculpture and early photography focuses primarily on European examples, neglecting American works. For examples, see Susan L. Taylor, "Fox Talbot as an Artist: The 'Patroclus' Series," *Bulletin of the University of Michigan Museums of Art and Archaeology* 8 (1986–88): 38–55; Eugenia Parry Janis, "Fabled Bodies: Some Observations on the Photography of Sculpture," in *The Kiss of Apollo: Photography and Sculpture 1845 to the Present*, ed. Jeffrey Fraenkel (San Francisco: Fraenkel Gallery, 1991), 9–23; Julia Ballerini, "Recasting Ancestry: Statuettes as Imaged by Three Inventors of Photography," in *The Object as Subject: Studies in the Interpretation of Still-Life*, ed. Anne W. Lowenthal (Princeton University Press, 1996), 41–58; Joel Snyder, "Nineteenth-Century Photography of Sculpture and the Rhetoric of Substitution," in *Sculpture and Photography: Envisioning the Third Dimension*, ed. Geraldine A. Johnson (Cambridge University Press, 1998), 21–34.

51. Two exceptions are daguerreotypes of bronze works by Henry Kirke Brown, including his sculpture of Dewitt Clinton (daguerreotype located in the Library of Congress) and his now-lost sculpture *Indian and Panther* (daguerreotype located at the National Academy of Design in New York).

52. "Contribution of the State of New York to the Washington Monument," *Bulletin of the American Art-Union* 1 (August 1850): 83.

53. "New Work by Palmer," *Bulletin of the American Art-Union* 2 (April 1851): 16.

54. The plate's brass mat is engraved "The Spirit's Flight / H. K. Brown / from E D Palmer."

55. "Powers's Statue of Calhoun," *Bulletin of the American Art-Union* 1 (October 1850): 117.

56. On the popularity of *The Greek Slave*, see Linda Hyman, "The Greek Slave by Hiram Powers: High Art as Popular Culture," *Art Journal* 35 (spring 1976): 216–223; Joy S. Kasson "Narratives of the Female Body: *The Greek Slave*," in *Reading American Art*, ed. Marianne Doezema and Elizabeth Milroy (New Haven: Yale University Press, 1998), 163–189.

57. Daguerreotypes of *The Greek Slave* can be found in the Metropolitan Museum of Art, in the Amon Carter Museum of Art, in the Smithsonian American Art Museum, in the Cincinnati Art Museum, and in the Getty Institute. There are likely others in additional institutions. Southworth and Hawes created many daguerreotypes after sculptures; some were contemporary works, such as the Powers, and others were copies of classical sculptures housed at the Boston Athenaeum. See Romer and Wallis, eds., *Young America: The Daguerreotypes of Southworth & Hawes*, 484–487.

58. "The Greek Slave—Daguerreotype Views," *Boston Daily Evening Transcript*, July 21, 1848.

59. Ibid.

60. "Copying," *Daguerreian Journal* 1 (November 1850): 45.

61. *Bulletin of the American Art-Union* 2 (April 1851): 21. The same advertisement appeared the following month.

62. *Outlines and Sketches by Washington Allston*, engraved by J. & S. W. Cheney (Boston: 1850).

63. Charles L. Moore claims the engravings were made by John Cheney, though the book of reproductions itself cites both brothers. See Two Partners in Boston: The Careers and Daguerreian Artistry of Albert Southworth and Josiah Hawes, PhD dissertation, University of Michigan, 1975, 227–229.

64. Ednah Cheney, *Memoir of Seth W. Cheney, Artist* (Boston: Lee and Shepard, 1881), 10.

65. Seth Cheney to John Cheney, April 17, 1839, quoted in ibid., 45.

66. Seth Cheney to Ward Cheney, May 10, 1841, "I have no doubt [Frank] will succeed with the daguerreotype," quoted in ibid., 63.

67. *Bulletin of the American Art-Union* 1 (May 1850): 18.

68. Ibid.

69. For example: "We should not ... be surprised to find the reflection of one single look in the mirror of the photograph strange and unresemblant and the miniature that is taken, entirely or partially from it, unsatisfactory." (*Photographic and Fine Art Journal* 2 (October 1851): 110)

70. See Kilgo, *Likeness and Landscape: Thomas M. Easterly and the Art of the Daguerreotype* (St. Louis: Missouri Historical Society Press, 1994), 140.

71. For all of Southworth and Hawes's daguerreotypes of graphic art, see *Young America: The Daguerreotypes of Southworth & Hawes*, 476–485.

72. "New Discovery—Engraving," *Blackwood's Edinburgh Magazine*, 384.

73. Richard Brilliant, *Portraiture* (Cambridge: Harvard University Press, 1991), 14.

74. *Pittsfield* [Massachusetts] *Sun*, May 12, 1841. On the daguerreotype's complex relationship with and possible continuation of the association between mourning and posthumous portraiture already established in miniature painting, see Robin Jaffee Frank, *Love and Loss: American Portrait and Mourning Miniatures* (New Haven: Yale University Press, 2000).

75. Geoffrey Batchen, *Forget Me Not: Photography and Remembrance* (Amsterdam: Van Gogh Museum, 2004), 15–17.

76. Batchen (ibid.) makes a compelling argument that perhaps in the nineteenth and twentieth centuries society *was* bothered by the photograph's insidious encroachment upon memory; he proposes on p. 94 that the trend in memorial photography of adding hair, cloth, and other physical signs of the sitter to the image can be seen as "the efforts of ordinary people to overcome—or at least reduce—the power of photography to replace living, emotive memories with static and historical images." Catherine Keenan ("On the Relationship between Personal Photographs and Individual Memory," *History of Photography* 22, spring 1998: 61) argues otherwise: "Whilst photographs *can* act in the service of forgetting, they can equally function as sites of memory."

77. N[athan] G. Burgess, "The Value of Daguerreotype Likenesses," *Photographic and Fine Art Journal* 8 (January 1855): 19. Burgess was also a specialist in post-mortem photography—see Rinhart and Rinhart, *The American Daguerreotype*, 300–302.

78. Timothy Shay Arthur, "American Characteristics: The Daguerreotypist," 352.

79. Marcus Aurelius Root, *The Camera and the Pencil, or the Heliographic Art* (1864 reprint, Pawlet: Helios, 1971), 43–44.

80. "The Daguerrean Art—Its Origin and Present State," *Photographic Art Journal* 1 (March, 1851): 136.

81. An even more common practice was to have subjects posed with a daguerreotype of a loved one, sometimes with the case open and sometimes with the case closed. "With endlessly varied inflections," Keith F. Davis remarks, "these images convey a dual message. On one hand, the absent person is represented symbolically—given fresh and relatively lasting pictorial life. On the other, we as viewers are reminded of the memorial function of every daguerreotype; the people honoring the memory of departed family members are now themselves long dead." Davis, *The Origins of American Photography, 1839–1885*, 90.

82. The painting in the daguerreotype is by Albert Gallatin Hoit. See *Young America: The Daguerreotypes of Southworth & Hawes*, 265.

83. The painting is Gilbert Stuart's unfinished life portrait of Washington from 1766. The Boston Athenaeum owned the work from 1831 on, and Southworth and Hawes copied the painting either there or in their studio. See *Young America: The Daguerreotypes of Southworth & Hawes*, 425.

84. See Wendy Wick Reaves, "Portraits for Every Parlor," in *American Portrait Prints*, 83–86.

85. "Uses of the Daguerreotype," *Artist; A Monthly Lady's Handbook* 1 (December, 1842): 235.

86. However, as Wendy Wick Reaves and Sally Pierce point out in "Translations from the Plate: The Marketplace of Public Portraiture," in *Young America: The Daguerreotypes of Southworth & Hawes*, that trend ended in the early 1860s.

87. Reaves and Pierce, "Translations from the Plate," 89.

88. See Brandon Brame Fortune, "Charles Willson Peale's Portrait Gallery: Persuasion and the Plain Style," *Word and Image* 6 (October–December 1990): 308–324.

89. Reaves and Pierce, "Translations from the Plate," in *Young America: The Daguerreotypes of Southworth & Hawes*, 93.

90. Alan Trachtenberg, *Reading American Photographs: Images as History, Mathew Brady to Walker Evans* (New York: Hill and Wang, 1989), 45.

91. Plumbe had at least sixteen studios by 1846, spanning from the major cities on the East Coast westward to Dubuque and southward to New Orleans. See Rinhart and Rinhart, *The American Daguerreotype*, 73.

92. Broadside located in the Prints Collection of the Library Company of Philadelphia.

93. On the concept of indexicality in photography, see note 22 to the introduction above.

94. "The Photographic Art Journal," *Bulletin of the American Art-Union* 2 (April 1851): 11.

95. "Visit to the Art Union," *Daguerreian Journal* 1 (November 1850): 9–11; J. K. Fisher, "Institutions for Promoting the Fine Arts," *Photographic Art Journal* 2 (September 1851): 150–153. The *Bulletin* took notice of this article and responded by criticizing Mr. Fisher, who apparently was a frustrated artist. See "The Photographic Art Journal," 11.

96. J. H. Fitzgibbon, "Daguerreotyping," *Photographic Art-Journal* 2 (August 1851): 91–92.

97. Henry Hunt Snelling, "The Daguerrean Art: Its Present State and Future Prospects," *Photographic Art-Journal* 2 (August 1851): 99.

98. Ibid.

99. New York *Evening Post*, February 13, 1841.

100. "Brady's Gallery of Daguerreotypes," broadside advertisement, Collection of American Antiquarian Society.

101. On Southworth as Morse's student, see Grant B. Romer, "'A High Reputation with All True Artists and Connoisseurs': The Daguerreian Careers of A. S. Southworth and J. J. Hawes," in *Young America*, 21–22.

102. John Stauffer, "Daguerreotyping the National Soul: The Portraits of Southworth & Hawes, 1843–1860," in *Young America*, 59.

103. Dinius, *The Camera and the Pencil*, 118–124.

104. Cited in Julius Sachse, "Early Daguerreotype Days, An Historical Reminiscence," *American Journal of Photography* 18 (March 1897): 105.

105. "Daguerreotypes," *Littell's Living Age* 9 (June 20, 1846): 552.

106. "New Gallery for Paintings," *New-York Mirror*, December 14, 1839.

107. On the multiplicity and variety of exhibition spaces in New York in the antebellum period, see Carrie Rebora Barratt, "Mapping the Venues: New York City Art Exhibitions," in *Art and the Empire City*, ed. Voorsanger and Howat.

108. The building also received a great deal of notoriety when John C. Colt, a brother of the gun maker Samuel Colt, killed the printer Samuel Adams in the fall of 1841. See Harold Schechter, *Killer Colt: Murder, Disgrace, and the Making of an American Legend* (New York: Ballantine Books, 2010).

109. See Gillespie, "Samuel F. B. Morse's Daguerreotype Practice," 100–104.

110. "The Daguerreotype," *The Knickerbocker* 14 (December 1839): 560.

111. "The Daguerreotype," *The New-Yorker*, December 14, 1839, 205.

112. John Johnson, "Daguerreotype," *Eureka—or, the Journal of the National Association of Inventors* 1 (October 1846): 25.

113. Unpublished list, Library Company of Philadelphia Archives.

114. Ibid. A daguerreotype of Mapes by Mathew Brady is illustrated here, as Wolcott's daguerreotype of Mapes has not been located.

115. *Journal of the Franklin Institute* 25 (May 1840): 301.

116. Of course, the Pennsylvania Academy often showed objects that were not in the traditional realm of fine art, among them stained glass, "pictures composed of South American feathers or moss," casts from nature, and impressions from gems. These, unfortunately, were excluded from the compilation of the Pennsylvania Academy's exhibition catalogs. See Peter Hastings Falk, ed., *The Annual Exhibition Record of the Pennsylvania Academy of Fine Arts* (Madison: Sound View, 1988–89), 4.

117. "Brady's Daguerreotype Establishment," *Humphrey's Journal* 5 (June 1853): 73–74.

118. See Rinhart and Rinhart, *The American Daguerreotype*, 72.

119. See Trachtenberg, *Reading American Photographs*, 33–45; Panzer, *Mathew Brady and the Image of History*, 39–46.

120. Whitman, "A Visit to Plumbe's Gallery," in *The Gathering of Forces*.

121. "Daguerreotypes," *Littell's Living Age* 9 (June 20, 1846): 551.

122. Pierce and Reaves, "Translations from the Plate," 99.

123. A well-known example is Augustine Joseph Hockney Duganne, *The Daguerreotype Miniature; or, Life in the Empire City* (Philadelphia: G. B. Ziebler, 1846). For an excellent discussion of this work, see pp. 31–33 of Trachtenberg, "Photography: the Emergence of a Keyword." Duganne wrote other books in the same vein, among them *Rose Warrington; or, the Daguerreotype Miniature. A True Tale of Real Life* (Philadelphia: T. B. Peterson and Brothers, 1859). Another example is Ned Buntline [Edward Judson], *Love at First Sight, or the Daguerreotype* (Boston: Lerow, 1846).

124. Samuel Breese to S[amuel] Sidney Breese and Helena Breese, December 11, 1840, Breese-Stevens-Roby Papers.

125. Jeff L. Rosenheim, "'A Palace for the Sun': Early Photography in New York City," in *Art and the Empire City*, ed. Voorsanger and Howat, 231.

126. On artist's studios later in the nineteenth century, see Annette Blaugrund, *The Tenth Street Studio Building, Artist-Entrepreneurs from the Hudson River School to the American Impressionists* (Southampton: Parrish Art Museum, 1997); Bruce Weber and Sarah Kate Gillespie, *Chase Inside and Out: The Aesthetic Interiors of William Merritt Chase* (New York: Berry-Hill Galleries, 2005).

CHAPTER 3

1. On the partnership of Daguerre and Joseph-Nicéphore Niépce, see Pinson, *Speculating Daguerre*, 231–232.

2. Dominique François Arago, "Report," reprinted in *Classic Essays on Photography*, ed. Alan Trachtenberg (New Haven: Leete's Island Books, 1980), 15–25.

3. See, for example, Douglas R. Nickel, "Nature's Supernaturalism: William Henry Fox Talbot and Botanical Illustration," in *Intersections: Lithography, Photography, and the Traditions of Printmaking*, ed. Kathleen Stewart Howe, 15–23; Anne Secord, "Botany on a Plate: Pleasure and the Power of Pictures in Promoting Early Nineteenth-Century Scientific Knowledge," *Isis* 93 (March 2002): 28–57; Tucker, *Nature Exposed*.

4. "The Daguerreotipe."

5. W. H. Goode, "The Daguerreotype and Its Applications," *American Journal of Science* 40 (1840): 137; F. A. Barnard, "Improvement in the Daguerreotype Process of Photography," *American Journal of Science* 41 (1841): 352; Benjamin Silliman and W. H. Goode, "A Daguerreotype Experiment by Galvanic Light," *American Journal of Science* 43 (1842): 185.

6. Larry J. Schaaf refers to Herschel as "the very embodiment of science" in early- and mid-nineteenth-century England" and writes that "Herschel and science were interchangeable terms, both to the man on the street and throughout the professional community." Larry J. Schaaf, *Tracings of Light: Sir John Herschel and the Camera Lucida, Drawings from the Graham Nash Collection* (San Francisco: Friends of Photography, 1990), 9.

7. Larry J. Schaaf, "Invention and Discovery: First Images," in *Beauty of Another Order*, 44.

8. On Brewster, see *"Martyr of Science": Sir David Brewster, 1781–1868*, ed. A. D. Morrison-Low and J. R. R. Christie (Edinburgh: Royal Scottish Museum, 1984); A. D. Morrison-Low, "Sir David Brewster and Photography," *Review of Scottish Culture* 4 (1988): 63–73; Graham Smith, *Disciples of Light: Photographs in the Brewster Album* (Malibu: J. Paul Getty Museum, 1990); A. D. Morrison-Low, "Brewster, Talbot and the Adamsons: The Arrival of Photography at St. Andrews," *History of Photography* 25 (summer 2001): 130–141.

9. Pinson, *Speculating Daguerre*, 212–213.

10. Theresa Levitt, "Biot's Paper and Arago's Plates: Photographic Practice and the Transparency of Representation," *Isis* 94 (September 2003): 461–466.

11. Corey Keller, "Sight Unseen: Picturing the Invisible," in *Brought to Light*, 27.

12. Levitt, "Biot's Paper and Arago's Plates," 469–472. A guillotine shutter drops from above, creating an opening for exposure, and then closes from above as well.

13. See ibid., 474. Also see Barger and White, *The Daguerreotype*, 66–67.

14. George H. Daniels, "The Process of Professionalization in American Science: The Emergent Period, 1820–1860," in *The Scientific Enterprise in America: Readings from* Isis, ed. Ronald L. Numbers and Charles R. Rosenberg (University of Chicago Press, 1996).

15. American Philosophical Society, Proceedings (1843), quoted in Ralph S. Bates, *Scientific Societies in the United States* (Cambridge: Technology Press, 1945), 6. A very similar listing of topics relating to the American Academy of Arts and Sciences is found on page 11 of the same book.

16. See Bates, *Scientific Societies in the United States*, 28–84; Nathan Reingold, "Definitions and Speculations: The Professionalization of Science in America in the Nineteenth Century," in *The Pursuit of Knowledge in the Early American Republic*, ed. Alexandra Oleson and Sanborn C. Brown (Baltimore: Johns Hopkins University Press, 1976), 33–69; David Cahan, "Institutions and Communities," in *From Natural Philosophy to the Sciences: Writing the History of Nineteenth-Century Science*, ed. Cahan (University of Chicago Press, 2003), 296.

17. Russel B. Nye, *Society and Culture in America, 1830–1860* (New York: Harper & Row, 1974), 246.

18. Joel R. Poinsett, *Discourse on the Objects and Importance of the National Institution for the Promotion of Science, established at Washington, 1840, Delivered at the First Anniversary* (Washington: P. Force, 1841), 5; Hugh Richard Slotten, *Patronage, Practice and the Culture of American Science: Alexander Dallas Bache and the U.S. Coast Survey* (Cambridge University Press 1994), 29.

See also Arthur P. Molella and Nathan Reingold. "Theorists and Ingenious Mechanics: Joseph Henry Defines Science." *Science Studies* 3 (1973): 323–351.

19. "The Art of Photography," editor's note, *Photographic Art Journal* 1 (January 1851): 1.

20. George H. Daniels has demonstrated that an almost equal number of articles relating to the physical sciences and relating to natural history were published in scientific journals between 1815 and 1844. Daniels, *American Science in the Age of Jackson*, 18–33.

21. "The Daguerreotype," *New-York Mirror* 16 (1839): 380.

22. Samuel L. Metcalf, "The Interest and Importance of Scientific Geology as a Subject for Study," *Knickerbocker* 3 (April 1834): 227.

23. Daniels, *American Science in the Age of Jackson*, 40.

24. Ibid., 41.

25. In the double-slit experiment devised by Young, a ray of sunlight was first made to pass though a screen with a single slit to make it coherent. The light was then made to pass though a screen with twin slits before falling onto a blank screen. The screen displayed the overlapping rays, which produced dark and red bands that Young dubbed "interference fringes." Young hypothesized that such fringes were possible only if light acted like a wave.

26. For an overview of Draper, see Deborah Jean Warner, "The Draper Family Material, " *History of Photography* 24:1 (2000): 16–23.

27. Draper began publishing in scientific journals in 1832, both in the United States and in Britain. The primary publications that featured his work were the *American Journal of Science*, the *Journal of the Franklin Institute*, the *London and Edinburgh Philosophical Magazine and Journal of Science*, and the *American Journal of Medical Science*.

28. John William Draper, "Experiments on Solar Light," *Journal of the Franklin Institute* 19 (1837): 470.

29. The term "proto-photographer" was coined by Geoffrey Batchen on page 50 of *Burning with Desire*.

30. "I succeeded with no other difficulty than the imperfection in silverplating in copying brick buildings, a church, and other objects seen from my laboratory windows." John William Draper, "Who Made the First Photographic Portrait?", 3.

31. John William Draper, "Remarks on the Daguerreotype," *The American Repertory of Arts, Science and Manufactures* 1 (1840): 401–404.

32. Arago, "Report," in *Classic Essays on Photography*, 21.

33. Daniel Norman, "The Development of Astronomical Photography," *Osiris* 5 (1938): 560.

34. Humboldt is quoted on p. 196 of Ann Thomas, "Capturing Light: Photographing the Universe," in *Beauty of Another Order*, ed. Thomas.

35. "Dr. Draper announced that he had succeeded in getting a representation of the moon's surface by the daguerreotype. A portion of the figure was very distinct, but owing to the motion of the Moon the greater part was confused. The time occupied was twenty minutes, and the size of the figure was about one inch in diameter. Daguerre had attempted the same thing but did not succeed. This is the first time that anything like a distinct representation of the moon's surface has been obtained." Quoted in Don Trombino, "Dr. John William Draper," *Journal of the British Astronomical Association* 90 (spring 1980): 567. A less complete citation is also in Henry Draper, "On the Construction of a Silvered Glass Telescope, Fifteen and a Half Inches in Diameter, and Its Use in Celestial Photography," *Smithsonian Contributions to Knowledge* 14 (January 1864): 33. The actual minutes have not been located.

36. "Lyceum of Natural History, Proceedings," *The American Repertory of Arts, Sciences and Manufactures* 2 (1840): 249.

37. Draper, "Remarks on the Daguerreotype," 402.

38. Fleming, *John William Draper and the Religion of Science*, 8.

39. John William Draper, "On the Process of the Daguerreotype and Its Application to Taking Portraits from the Life," *London and Edinburgh Philosophical Magazine and Journal of Science* 17 (1840): 217–225.

40. Ibid.

41. "My ultimate aim is the application of the Daguerreotype to accumulate for my studio models for my canvas." Samuel F. B. Morse to Reverend Edward S. Salisbury, February 24, 1841, Morse Papers.

42. For a complete history of this image, see Howard R. McManus, "The Most Famous Daguerreian Portrait: Exploring the History of the Dorothy Catherine Draper Daguerreotype," *Daguerreian Annual* 1995: 149–171.

43. John William Draper to editor of *London and Edinburgh Philosophical Magazine*, July 1840, John William Draper Family Papers, Manuscript Division, Library of Congress. Because there were several editors of the journal, it is not clear if Draper's note was addressed specifically to Brewster, but in view of Brewster's interest in and promotion of photography within the journal it seems likely that it was. There was no editorial comment in the *Philosophical Magazine* regarding the plate. It was forwarded to Herschel as had been requested.

44. Sir John Herschel to John William Draper, October 6, 1840, John William Draper Family Papers, Manuscript Division, Library of Congress.

45. Robert Hunt, *A Popular Treatise on the Art of Photography, Including Daguerreotype, and all the New Methods of Producing Pictures by the Chemical Agency of Light* (Glasgow: Richard Griffin 1841), 5.

46. For a complete history of imagery of the solar spectrum, see Klaus Hentschel, *Mapping the Spectrum: Techniques of Visual Representation in Research and Teaching* (Oxford University Press 2002). On Fraunhofer's early map, see pp. 34–36.

47. In the summer of 1842, the German physicist Ludwig Moser published a paper contending that all bodies possessed latent light. Draper claimed in November of 1842 that he had been the first to make that discovery. See John William Draper, "On Certain Spectral Appearances and the Discovery of Latent Light," *London and Edinburgh Philosophical Magazine* 21 (November 1842): 348–350. For an account of the entire exchange, see Barger and White, *The Daguerreotype*, 61–62.

48. Tithonus was married to Aurora, the goddess of the dawn. At Aurora's request, the Fates allowed for Tithonus to remain immortal but did not grant him eternal youth. As Tithonus became frail and elderly, Aurora took pity on him and changed him into a grasshopper. John William Draper, "On a New Imponderable Substance, and on a Class of Chemical Rays Analogous to the Rays of Dark Heat," *London and Edinburgh Philosophical Magazine* 21 (December 1842): 454–455.

49. Sir John F. W. Herschel, "On the Action of the Rays of the Solar Spectrum on the Daguerreotype Plate," *London and Edinburgh Philosophical Magazine* 22 (February 1843): 131.

50. Sir John F. W. Herschel to John William Draper, December 5, 1842, John William Draper Family Papers, Manuscript Division, Library of Congress.

51. Draper, "On Certain Spectral Appearances," 349; Herschel, "On the Action of Rays of the Solar Spectrum on the Daguerreotype Plate," 130. "Dispersion" refers to the breaking up of white light into its constituent parts when directed through a prism. Herschel seems to be suggesting that differences in prisms, rather than differences in sunlight, are the cause of the different results obtained by Draper.

52. On the scientific community's reaction to Draper's theory of tithonicity, see Barger and White, *The Daguerreotype*, 66.

53. John William Draper, *A Treatise on the Forces Which Produce the Organization of Plants* (New York: Harper, 1844), 53 and 56. See also George F. Barker, *Memoir of John William Draper* (New York: National Academy of Science 1886), 367. On Saxton, see Arthur H. Frazier, *Joseph Saxton and His Contribution to the Medal Ruling and Photographic Arts* (Washington: Smithsonian Institution Press, 1975).

54. Jon Darius has demonstrated that these letters do not correspond to those that Fraunhofer assigned to the sun's absorption lines. See Darius, *Beyond Vision*, 20.

55. Indeed, from the thirteen extant examples of spectra daguerreotypes by Draper (twelve of which are held in the Photographic History Collection of the Smithsonian Institution's National Museum of American History) it is almost impossible to discern which are interference spectra and which are prismatic spectra; most of the plates have faded to the point that undertaking such measurements would be impossible. Source: conversation between the author and Steven Turner, curator of Division of Science and Medicine, National Museum of American History, November 16, 2005.

56. As Geoffrey Batchen has said of Léon Foucault's daguerreotypes of the solar spectrum, the famous detail and clarity of the medium is reduced in these images to "an abstract graph, a picture of nothing—of nothing, that is, but its own capacity to represent." Batchen, "Light and Dark: The Daguerreotype and Art History," *Art Bulletin* 86 (December 2004): 770.

57. Draper, "On the Action of the Rays of the Solar Spectrum on the Daguerreotype Plate," 120; Sir John F. W. Herschel to John William Draper, December 5, 1842, John William Draper Family Papers, Manuscript Division, Library of Congress.

58. Darius, *Beyond Vision*, 20. On Foucault and Fizeau's work with photographing the solar spectrum, see Quentin Bajac, ed., *Le daguerréotype français*, 362–367.

59. John William Draper, *Scientific Memoirs, Being Experimental Contributions to A Knowledge of Radiant Energy* (New York: Harper, 1878), 97.

60. "A Treatise on the Forces which Produce the Organization of Plants," *Biblical Repertory and Princeton Review* 17 (April 1845): 345–347.

61. Hentschel, *Mapping the Spectrum*, 70.

62. See Notes on Photography and Photochemistry, Draper Family Collection, 1835–1908, Archives Center, National Museum of American History, Smithsonian Institution.

63. Root, *The Camera and the Pencil*, 342–343.

64. The labeling of images of the solar spectrum was standard practice for that time. See Hentschel, *Mapping the Spectrum*, 70.

65. It is likely the plate dates from after 1841. X-ray florescence spectrometry conducted at the Smithsonian Institution, where the plate is now held, revealed that *Composition* contained a discernible level of gold, indicating that it was gilded, and that the plate's surface was remarkably even. Early plates from 1839 and 1840, particularly American plates (though *Composition* has no plate marks), often show pitting and spots in the silver coating, as the technology for polishing the plates to create an even surface had not been developed.

66. Mr. Goadby, "On Fizeau's Process of Etching Daguerreotype Plates, and Its Application to Objects of Natural History," *Journal of the Franklin Institute* 40 (October 1845): 282.

67. W. H. Goode, "The Daguerreotype and Its Applications," 137.

68. "Daguerreotype Improvement," *The American Repertory of Arts, Sciences and Manufactures* 3 (October 1840): 22.

69. F. A. Barnard, "Improvement in the Daguerreotype Process in Photography," 352.

70. Ibid.

71. F. A. Barnard, "A Method of Taking Daguerreotypes for the Stereoscope," *American Journal of Science* 66 (November 1853): 348.

72. Silliman, "A Daguerreotype Experiment by Galvanic Light," 183.

73. Ibid.

74. "Remarks on the Daguerreotype," 51.

75. "Lyceum of Natural History Proceedings," *The American Repertory of Arts, Sciences and Manufactures* 3 (July 1841): 413.

76. Larry J. Schaaf, *The Photographic Art of William Henry Fox Talbot* (Princeton University Press, 2000), 86. One example is *Slice of Horse Chestnut, Seen through the Solar Microscope* (a salt print made on May 23, 1840 from a photogenic drawing negative).

77. Alfred Donné and Léon Foucault, *Cours de microscopie complementaire de études médicales* (Paris: J.-B. Balliére, 1845).

78. Draper, *Scientific Memoirs*, 338.

79. Ibid., 340. At least seven of Draper's micrographs are in the Draper Collection of the Photographic History Collection, National Museum of American History, Smithsonian Institution.

80. "On the Application of Photography to Printing," *Harper's New Monthly Magazine* 13 (September 1856): 433. Whether the reviewer was unaware of Donné and Foucault's work or whether he didn't consider it to be on "an extensive scale" is not known.

81. Ibid., 435.

82. William Cranch Bond, the observatory's director, appears to have been an active participant in the taking of these daguerreotypes, although initially he was reluctant to allow his telescope to be used for photography. See William Robinson, *A Certain Slant of Light: The First Hundred Years of New England Photography* (Boston: New York Graphic Society, 1980), 43–45. In the Juries' Report on the exhibition, the Whipple plate was described as "one of the most satisfactory attempts that has yet been made to realise, by a photographic process, the telescopic appearance of a heavenly body, and must be regarded as indicating the commencement of a new era in astronomical representation." *The Official Descriptive and Illustrated Catalogue to the Great Exhibition of the Works of Industry of all Nations* (London: Spicer, 1852), 601.

83. See Sally Pierce, *Whipple and Black: Commercial Photographers in Boston* (Boston: Northeastern University Press 1987); M. Grant, "John A. Whipple and the Daguerrean Art," *Photographic Art Journal* 2 (August 1851): 94–95. "The Royal Academy of Arts and Sciences," Grant writes, "has highly complimented Mr. Whipple for his great skill shown in these wonderful productions." It is not clear whether Grant is referring to the Royal Society of Arts and Manufactures or to the Royal Society in London.

84. "Lunar Daguerreotypes," *Daguerreian Journal* 2 (August 1851): 179.

CHAPTER 4

1. Quoted in Silverman, *Lightning Man*, 243.

2. Bramble Brae, "Go-A-Head," *Mechanics' Mirror* 1 (April 1846): 77.

3. Quoted in "Second Lecture on Discoveries and Inventions," in *Collected Works of Abraham Lincoln*, ed. Roy Basler (New Brunswick: Rutgers University Press, 1953), 358.

4. Quoted in "Is it a Mere Coincidence?" *Scientific American* 38 (June 1878): 362.

5. As I noted in the introduction, François Brunet has demonstrated that the term "American process" was used for a brief period of time, and that Europeans were generally dismissive of early American photography. François Brunet, lecture dated November 9, 2011, Inventing American Photography symposium, National Museum of American History, Smithsonian Institution.

6. Nye, *America as Second Creation*, 3.

7. See, for example, Dolores Kilgo, The Sharp-Focus Vision: The Daguerreotype and the American Painter; Trachtenberg, "Likeness as Identity: Reflections on the Daguerrean Mystique." On the relationship of the popularity of the daguerreotype to fears of reproducibility and counterfeiting bank notes, see Mazie Harris, "Photographic Currency: Making Money in Nineteenth-Century Photographic Studios," talk delivered at Center for Historic American Visual Culture, American Antiquarian Society, Worcester, Massachusetts, 2011.

8. Nye, *America as Second Creation*, 11.

9. *Scientific American* 1 (August 28, 1846): 1.

10. Nye, *American Technological Sublime*, 45–46.

11. Snelling, "The Daguerrean Art: Its Present State and Future Prospects," 100.

12. John Johnson, "Daguerreotype," *Eureka—Or, the Journal of the National Association of Inventors* 1 (September 1846): 7–8.

13. "Improvements in the Daguerreotype," *Burton's Gentleman's Magazine and American Monthly Review* 4 (May 1840): 246.

14. *New-York Observer*, April 18, 1840.

15. Johnson, "The Daguerreotype," *Eureka* 1 (February 1847): 92.

16. Johnson, "The Daguerreotype," *Eureka* 1 (October 1846), 25. See also Floyd Rinhart and Marion Rinhart, "Wolcott and Johnson: Their Camera and Photography," *History of Photography* 1 (April 1977): 129–134.

17. Rinhart and Rinhart, "Wolcott and Johnson," 123–133.

18. Julia Fitz Howell, "Holcomb, Fitz and Peate: Three 19th Century American Telescope Makers," *United States Museum National Bulletin* 26 (1962): 165–166.

19. All the known ninth-plates by Fitz have brass mats.

20. Lecture by Hanako Murata, Inventing American Photography symposium, National Museum of American History, Smithsonian Institution, November 8, 2011.

21. For the most comprehensive bibliographical account of Saxton, see Arthur H. Frazier, "Joseph Saxton and His Contributions to the Medal Ruling and Photographic Arts," *Smithsonian Studies in History and Technology* 32 (1975): 1–16.

22. Robert Cornelius to Julius Sachse, "Early Daguerreotype Days, An Historical Remembrance," *American Journal of Photography* 13 (July 1892): 310.

23. "Medals &c., Formed, by Precipitating Copper from Its Solutions, by Galvanism," *The American Repertory of Arts, Sciences, and Manufactures* 1 (June 1840): 349.

24. Robert Cornelius to Julius Sachse, "Early Daguerreotype Days, An Historical Remembrance," *American Journal of Photography* 13 (July 1892): 310; William A. Cornelius, "Brief History of Robert Cornelius," *Papers Read Before the Historical Society of Frankford* 3 (1937): 111.

25. Julius Sachse, "Early Daguerreotype Days, An Historical Remembrance," 312.

26. *Godey's Lady's Book* 20 (April 1840): 189.

27. William Stapp, *Robert Cornelius: Portraits from the Dawn of Photography* (Washington: Smithsonian Institution, 1984), 36.

28. For a description of Cornelius's studio, see "Daguerreotype," *Newport Mercury*, July 4, 1840. See also Stapp, *Robert Cornelius*, 37.

29. Stapp, *Robert Cornelius*, 39.

30. Solomon's dreams came to eventual but brief fruition in 1863, when he constructed a steerable self-propelled airship called the *Aereon*. Unable to attain government backing for the project, he eventually discarded the plan. Ann Shumard, "Curator's Choice, Solomon Andrews," unpublished manuscript, National Portrait Gallery, Smithsonian Institution.

31. James Curtis Booth, *The Encyclopedia of Chemistry, Practical and Theoretical, assisted by Campbell Morfit* (Philadelphia: H. C. Baird, 1850), 170, figures 17 and 18.

32. "About Daguerreotypes," *M'Makins Model American Courier*, December 7, 1850, 2.

33. Improvements to the equipment used in daguerreotyping, particularly items such as plateholders, continued to be made through the 1850s. Other major technical and scientific advances to the medium itself made after 1845, such as stereography, were not unique to the daguerreotype but rather were developed and applied to many types of photographic imagery. Of course some experimenters continued the quest for color, but most decided early that this was not feasible. For a fairly complete account of the early technological innovations made to the process, see Rinhart and Rinhart, *The American Daguerreotype*, 157–190.

34. There were also mechanics' fairs in other major cities, particularly Cincinnati, Boston, and Worcester. Here I am concentrating my attention on New York and Philadelphia, easily the most prominent of these fairs, because it is consistent with the focus of this book.

35. "25th Annual Fair American Institute," *Humphrey's Journal* 4 (October 1852), 201, quoted in Julie K. Brown, *Making Culture Visible: The Public Display of Photography at Fairs, Expositions and Exhibitions in the United States, 1847–1900* (Amsterdam: Harwood, 2001), 3.

36. "Premiums Awarded for the Twelfth Annual Fair at the American Institute, held at Nibolo's Gardens, October, 1839," *Journal of the American Institute* 4 (September 1839): 666. Seager displayed a city view of St. Paul's Church at Chilton's pharmacy in late September 1839; see "The New Art," *New York Morning Herald*, September 30, 1839.

37. *Journal of the Franklin Institute* 26 (July–December 1840): 328.

38. "Exhibition of the Franklin Institute," *Philadelphia Public Ledger*, October 12, 1840.

39. Cyrus Mason, *The Oration on the Thirteenth Anniversary of the American Institute, Delivered by Cyrus Mason, at the Broadway Tabernacle, October 15, 1840, Together with a List of Premiums Awarded at the Fair at Niblo's Garden* (New York: Hopkins & Jennings, 1840), 47.

40. Ibid.

41. Roberta J. M. Olson, "George Harvey's Anglo American Atmospheric Landscapes," *Antiques* 176 (October 2009): 112–121.

42. Ibid. Also see Crary, *Techniques of the Observer*.

43. Olson, "George Harvey's Anglo American Atmospheric Landscapes."

44. "Daguerreotype Miniatures by Messrs. W & F. Langenheim," *North American*, October 24, 1842, 2.

45. *Journal of the Franklin Institute* 36 (December 1843): 411.

46. *Report of the Committee on Exhibitions of the Franklin Institute*, Address of John Wiegland, Chairman of the Committee on Exhibitions, 1843.

47. *Third Annual Report of the American Institute, on the subject of Agriculture* (New York, 1844), 56.

48. *Transactions of the American Institute of the City of New-York, for the Year 1850* (Albany: Charles Van Benthuysen, 1851), 46.

49. "Report on the Committee on Exhibitions," *Journal of the Franklin Institute* 38 (October 1844): 397.

50. *Journal of the Franklin Institute* 40 (December 1845): 391.

51. *Journal of the Franklin Institute* 42 (July 1846): 62.

52. *Journal of the Franklin Institute* 44 (October 1847): 260.

CONCLUSION

1. Nye, *American Technological Sublime*, 45.

2. Nye, *America as Second Creation*, 3.

3. Sekula, "The Traffic in Photographs," 15.

4. See Geoffrey Batchen, "Ectoplasm," in *Each Wild Idea: Writing, Photography, History* (Cambridge: MIT Press, 2001).

BIBLIOGRAPHY

PAPERS AND ARCHIVES

Breese-Stevens-Roby Papers, 1705–1923, Rare Books, Special Collections and Preservation Department, Rush Rhees Library, University of Rochester, Rochester, New York

Draper Family Papers, New York University Archives

Draper Family Collection, 1835–1908, Archives Center, National Museum of American History, Smithsonian Institution, Washington

Francis O. J. Smith Papers, Maine Historical Society

Horsford Family Papers, Rensselaer Polytechnic Institute

John William Draper family papers, 1777–1951, Manuscript Division, Library of Congress, Washington

Morse Family Papers (MS 358), Manuscripts and Archives, Yale University Library, New Haven, Connecticut

Samuel F. B. Morse Papers, 1793–1919, Library of Congress, Washington

Vail Telegraph Papers, Smithsonian Institution Archives, Washington

PUBLICATIONS

"Annual Supper of the National Academy of Design." *New-York Commercial Advertiser* (April 27, 1840).

Apraxine, Pierre. *Photographs from the Collection of the Gilman Paper Company Collection.* New York: White Oak, 1985.

Arago, Dominique François. "Report." In *Classic Essays on Photography*, ed. Alan Trachtenberg. New Haven: Leete's Island Books, 1980.

Armstrong, Carol. *Scenes in a Library: Reading the Photograph in the Book, 1843–1875*. Cambridge: MIT Press, 1998.

Arthur, Timothy Shay. "American Characteristics: The Daguerreotypist." *Godey's Lady's Book* 38 (May 1849): 352–355.

Bajac, Q., ed. *Le Daguerréotype Français: un Object Photographique*. Paris: Musée d'Orsay, 2003.

Bann, Stephen, ed. *Art and the Early Photographic Album*. New Haven: Yale University Press, 2011.

Bann, Stephen. *Parallel Lines: Printmakers, Painters, and Photographers in Nineteenth-Century France*. New Haven: Yale University Press, 2001.

Barger, Susan M., and William B. White. *The Daguerreotype: Nineteenth-Century Technology and Modern Science*. Baltimore: Johns Hopkins University Press, 1991.

Batchen, Geoffrey. *Burning with Desire: The Conception of Photography*. Cambridge: MIT Press, 1997.

Batchen, Geoffrey. "Electricity Made Visible." In *New Media, Old Media: A History and Theory Reader*, ed. Hui Kyong Chun Wendy and Thomas Keenan. New York: Routledge, 2006.

Batchen, Geoffrey. "Light and Dark: The Daguerreotype and Art History." *Art Bulletin* 86 (December 2004): 746–776.

Batchen, Geoffrey. "'Some Experiments of Mine': The Early Photographic Experiments of Samuel F. B. Morse." *History of Photography* 15 (spring 1991): 37–42.

Bates, Ralph S. *Scientific Societies in the United States*. Cambridge: MIT Press, 1945.

Brown, Julie K. *Making Culture Visible: The Public Display of Photography at Fairs, Expositions and Exhibitions in the United States, 1847–1900*. Amsterdam: Harwood, 2001.

Brunet, François. "Samuel Morse, père de la photographie américaine." *Études Photographiques* 15 (November 2004): 4–30.

Cahan, D., ed. *From Natural Philosophy to the Sciences: Writing the History of Nineteenth-Century Science*. University of Chicago Press, 2003.

Cikovsky, Nicolai, ed. *Lectures on the Affinity of Painting with the Other Fine Arts*. Columbia: University of Missouri Press, 1983.

Cikovsky, Nicolai. "'To enlighten the public mind … to make the way easier for those who come after me': Samuel Morse as a Writer and Lecturer." In *Samuel F. B. Morse, Educator and Champion of Arts in America*. New York: National Academy of Design, 1982.

Crary, Jonathan. *Techniques of the Observer: On Vision and Modernity in the Nineteenth Century*. Cambridge: MIT Press, 1990.

Crystal Palace Described and Illustrated by Beautiful Engravings Chiefly from Daguerreotypes by Beard & Mayall. London: John Tallis and Co, 1851.

"The Daguerrean Art—Its Origin and Present State." *Photographic Art-Journal* 1 (March 1851): 136.

"The Daguerreotype." *Bulletin of the American Art-Union* 1 (November 1850): 181–182.

Daniels, George H. *American Science in the Age of Jackson*. New York: Columbia University Press, 1968.

Daniels, George H. "The Process of Professionalization American Science: The Emergent Period: 1820–1860." In *Scientific Enterprise in America: Readings from Isis*, ed. Ronald L. Numbers and Charles R. Rosenberg. University of Chicago Press, 1996.

Darius, Jon. *Beyond Vision*. Oxford University Press, 1984.

Davis, Keith. *The Origins of American Photography, 1839–1885*. New Haven: Yale University Press, 2007.

Dinius, Marcy J. *The Camera and the Pencil: American Visual Print Culture in the Age of the Daguerreotype*. Philadelphia: University of Pennsylvania Press, 2012.

Donné, Alfred, and Léon Foucault. *Cours Microscopie Complementaire de Études Médicales*. Paris: J. B. Balliére, 1845.

Draper, John William. "Experiments on Solar Light." *Journal of the Franklin Institute* 19 (June 1837): 469–479.

Draper, John William. "On a New Imponderable Substance, and on a Class of Chemical Rays Analogous to the Rays of Dark Heat." *London and Edinburgh Philosophical Magazine and Journal of Science* 21 (December 1842): 454–455.

Draper, John William. "On Certain Spectral Appearances and the Discovery of Latent Light." *London and Edinburgh Philosophical Magazine and Journal of Science* 21 (November 1842): 348–350.

Draper, John William. "On the Process of the Daguerreotype and Its Application to taking Portraits from the Life." *London and Edinburgh Philosophical Magazine and Journal of Science* 17 (September 1840): 217–225.

Draper, John William. "Remarks on the Daguerreotype." *American Repertory of Arts, Science and the Manufactures* 1 (July 1840): 401–404.

Draper, John William. *Scientific Memoirs, Being Experimental Contributions to a Knowledge of Radiant Energy*. New York: Harper, 1878.

Draper, John William. *A Treatise on the Forces Which Produce the Organization of Plants*. New York: Harper Brothers, 1844.

Draper, John William. "Who Made the First Photographic Portrait?" *American Journal of Photography* 1 (June 1858): 5.

"Dr. John Draper Dead," *New York World*, January 5, 1882.

Fleming, Donald. *John William Draper and the Religion of Science*. Philadelphia: University of Pennsylvania Press, 1950.

Foresta, Merry A. *Secrets of the Dark Chamber: The Art of the American Daguerreotype*. Washington: Smithsonian Institution Press, 1995.

Frazier, Arthur H. *Joseph Saxton and His Contribution to the Medal Ruling and Photographic Arts*. Washington: Smithsonian Institution Press, 1975.

Gernsheim, Alison, and Helmut Gernsheim. *L. J. M. Daguerre: The History of the Diorama and the Daguerreotype*. New York: Dover, 1968.

Gillespie, Sarah Kate. Samuel F. B. Morse's Daguerreotype Practice. *Daguerreian Annual* 2008: 86–122.

Hentschel, Klaus. *Mapping the Spectrum: Techniques of Visual Representation in Research and Teaching*. Oxford University Press, 1992.

Herschel, John F. W. "On the Action of the Rays of the Solar Spectrum on the Daguerreotype Plate." *London and Edinburgh Philosophical Magazine and Journal of Science* 22 (February 1843): 120–123.

Hills, Patricia, *Perfectly American: The Art Union and Its Artists*. Tulsa: Gilcrease Museum, 2011.

Hindle, Brooke, and Steven Lubar. *Engines of Change: The American Industrial Revolution, 1790–1860*. Washington: Smithsonian Institution Press, 1986.

Howat, J. K., and C. H. Voorsanger, eds. *Art and the Empire City: New York, 1825–1861*. New Haven: Yale University Press.

Howell, Julia Fitz. "Henry Fitz, 1808–1863." *United States Museum National Bulletin* 26 (1962): 165–166.

"Is It Mere Coincidence?" *Scientific American* 38 (June 1878): 362.

Israel, Paul. *From Machine Shop to Industrial Laboratory: Telegraphy and the Changing Context of American Invention, 1830–1920*. Baltimore: Johns Hopkins University Press, 1992.

Jenkins, Reese. *Images and Enterprise: Technology and the American Photographic Industry, 1839–1925*. Baltimore: Johns Hopkins University Press, 1987.

Johnson, John. "Daguerreotype." *Eureka* 1 (October 1846): 23–25.

Keller, C., ed. *Brought to Light: Photography and the Invisible, 1840–1900*. San Francisco Museum of Modern Art, 2008.

Kelsey, Robin. *Archive Style: Photographs and Illustrations for U.S. Surveys, 1850–1890*. Berkeley: University of California Press, 2007.

Kilgo, Dolores. *The Sharp-Focus Vision: The Daguerreotype and the American Painter*. PhD dissertation, University of Illinois, Urbana-Champaign, 1982.

Lowry, Bates, and Isabel Lowry. *The Silver Canvas: Daguerreotype Masterpieces from the J. Paul Getty Museum*. Los Angeles: J. Paul Getty Museum, 1998.

Mabee, Carlton. *The American Leonardo: A Life of Samuel F. B. Morse*. New York: Knopf, 1943.

Marburg, Theodore F. Management Problems of a Small Manufacturing Enterprise, 1802–1852: A Case Study of the Origin of the Scovill Manufacturing Company. PhD dissertation, Clark University, 1945.

Marcus, Alan, and Howard P. Segal. *Technology in American: A Brief History*. New York: Harcourt Brace Jovanovich, 1989.

Marx, Leo. *The Machine in the Garden: Technology and the Pastoral Ideal in America*. Oxford University Press, 1964.

McCauley, Elizabeth Anne. "François Arago and the Politics of the French Invention of Photography." In *Multiple Views: Logan Grant Essays on Photography, 1983–89*, ed. Daniel P. Younger. Albuquerque: University of New Mexico Press, 1991.

McCauley, Elizabeth Anne. *Industrial Madness: Commercial Photography in Paris, 1848–1871*. New Haven: Yale University Press, 1994.

McManus, Howard. "Daguerreian Treasures at the Smithsonian Institution." *Daguerreian Annual* 1996: 252–260.

McManus, Howard. "The Most Famous Daguerreian Portrait: Exploring the History of the Dorothy Catherine Draper Daguerreotype." *Daguerreian Annual* 1995: 149–171.

Montgomery, James Eglinton, ed. *Personal Reminiscences of the Late Mrs. Sarah Breese Walker*. Privately printed, 1884.

Morse, Edward Lind, ed. *Samuel F. B. Morse: His Letters and Journals*. Boston: Houghton Mifflin, 1914.

Morse, Samuel F. B. "Experiments Made with One Hundred Pairs of Grove's Battery, Passing through One Hundred Sixty Miles of Insulated Wire." *Silliman's American Journal of Science* 45 (October 1843): 390–394.

Morse, Samuel F. B. to Sidney E. Morse, "The Dagguerreotipe," *New-York Observer* (April 20 1839).

"New Discovery—Engraving." *Blackwood's Edinburgh Magazine* 45 (March 1839): 382–390.

"New Discovery in Fine Arts—the Daguerreoscope." *The New-Yorker,* April 20, 1839.

Newhall, Beaumont. *The Daguerreotype in America*. New York: Duell, Sloan and Pierce, 1961.

Nye, David E. *America as Second Creation: Technology and Narratives of New Beginnings*. Cambridge: MIT Press, 2003.

Nye, David E. *American Technological Sublime*. Cambridge: MIT Press, 1994.

Oedel, William T., and Todd S. Gernes. "*The Painter's Triumph*: William Sidney Mount and the Formation of a Middle-Class Art." In *Reading American Art*, ed. Marianne Doezema and Elizabeth Milroy. New Haven: Yale University Press, 1998.

Outlines and Sketches, by Washington Allston. Engraved by J. & S. W. Cheney. Boston: 1850.

Panzer, Mary. *Mathew Brady and the Image of History*. Washington: Smithsonian Institution Press, 1997.

Pinson, Stephen. *Speculating Daguerre: Art and Enterprise in the Work of L. J. M. Daguerre*. University of Chicago Press, 2012.

Prime, Samuel Irenaeus. *The Life of Samuel F. B. Morse, LL.D., Inventor of the Electro-Magnetic Telegraph*. New York: Appleton, 1875.

Reaves, W. W., ed. *American Portrait Prints*. Washington: National Portrait Gallery, 1984.

Renie, Pierre-Lin. "The Battle for a Market: Art Reproductions in Print and Photography from 1850 to 1880." In *Intersections: Lithography, Photography, and the Traditions of Printmaking*, ed. Kathleen Stewart Howe. Albuquerque: University of New Mexico Press, 1998.

Rinhart, George, and Marian Rinhart. *The American Daguerreotype*. Athens: University of Georgia Press, 1981.

Romer, G., and B. Wallis, eds. *Young America: The Daguerreotypes of Southworth and Hawes*. New York: International Center for Photography, 2005.

Root, Marcus Aurelius. *The Camera and the Pencil, or the Heliographic Art*. Pawlet: Helios, 1971.

Rudisill, Richard. *Mirror Image: The Influence of the Daguerreotype on American Society*. Albuquerque: University of New Mexico Press, 1971.

Sachse, Julius. "Early Daguerreotype Days, an Historical Remembrance." *American Journal of Photography* 13 (1892).

Sachse, Julius. "Early Daguerreotype Days, an Historical Remembrance." *American Journal of Photography* 14 (1893).

Sachse, Julius. "Early Daguerreotype Days, an Historical Remembrance." *American Journal of Photography* 18 (March 1897).

Sachse, Julius. "Philadelphia's Share in the Development of Photography." *Journal of the Franklin Institute* 135 (April 1893): 271–284.

Schaff, Larry J. *Out of the Shadows: Herschel, Talbot and the Invention of Photography*. New Haven: Yale University Press, 1992.

Sekula, Allan. "The Traffic in Photographs." *Art Journal* 41 (spring 1981): 15–25.

Silverman, Kenneth. *Lightning Man: The Accursed Life of Samuel F. B. Morse*. New York: Knopf, 2003.

Smith, Merritt Roe. "Technology, Industrialization, and the Idea of Progress in America." In *Responsible Science: The Impact of Technology on Society*, ed. Kevin B. Byrne. San Francisco: Harper & Row, 1986.

Snelling, Henry Hunt. "The Daguerrean Art: Its Present State and Future Prospects." *Photographic Art-Journal* 2 (August 1851): 99.

Staiti, Paul. *Samuel F. B. Morse*. Cambridge University Press, 1989.

Stapp, William. *Robert Cornelius: Portraits from the Dawn of Photography*. Washington: Smithsonian Institution Press, 1984.

Taft, Robert. *Photography and the American Scene, 1839–1889*. New York: Macmillan, 1938.

Talbot, William Henry Fox. *Pencil of Nature*. London: Longman, Brown, Green and Longmans, 1844.

Thomas, A., ed. *Beauty of Another Order: Photography in Science*. New Haven: Yale University Press, 1997.

Thorpe, Thomas B. "Personal Reminiscences of C. L. Elliott." *[New York] Evening Post* (October 1, 1868).

Trachtenberg, Alan. "The Daguerreotype: American Icon." In *American Daguerreotypes from the Matthew R. Isenberg Collection*, ed. Richard S. Field. New Haven: Yale University Press.

Trachtenberg, Alan. "Mirror in the Marketplace: American Responses to the Daguerreotype." In *The Daguerreotype: A Sesquicentennial Celebration*, ed. John Wood. Iowa City: University of Iowa Press, 1989.

Trachtenberg, Alan. "Likeness as Identity: Reflections on the Daguerrean Mystique." In *The Portrait in Photography*, ed. Graham Clarke. London: Reaktion Books, 1992.

Trachtenberg, Alan. "Photography: The Emergence of a Keyword." In *Photography in Nineteenth-Century America*, ed. Martha Sandweiss. New York: Abrams, 1991.

Trachtenberg, Alan. *Reading American Photographs: Images as History, Mathew Brady to Walker Evans*. New York: Hill and Wang, 1989.

Tucker, Jennifer. *Nature Exposed: Photography as Eyewitness in Victorian Science*. Baltimore: Johns Hopkins University Press, 2005.

Welling, William. *Photography in America: The Formative Years, 1839–1900*. New York: Crowell, 1978.

Whitman, Walt. "A Visit to Plumbe's Gallery." In *The Gathering of Forces*. vol. 2, ed. Cleveland Rogers and John Black. New York: Putnam, 1920.

"Who Made the First Daguerreotype in This Country?" *Photographic and Fine Art Journal* 8 (September 1855): 280.

Wood, J., ed. *America and the Daguerreotype*. Iowa City: University of Iowa Press, 1991.

Wood, R. Derek. *The Arrival of the Daguerreotype in New York*. New York: American Photographic Historical Society, 1994.

INDEX

Allston, Washington, 18, 60
American Academy of Arts and Sciences, 112
American Art-Union, 57, 101
American exceptionalism, 2, 135–137
American Institute of the City of New York, 160–165
American Philosophical Society, 112
Aperture development, 121, 123
Apollo Association, 57, 101
Arago, Dominique François Jean, 22, 109, 116
Astronomy, 11, 12, 109, 111, 114, 133, 140
Augur, Hezekiah, 19

Bache, Alexander Dallas, 112, 113
Barnard, Frederick Augustus Porter, 131
Bayard, Hippolyte, 36, 60
Becquerel, Edmond, 111
Bennett, William James, 162
Berzelius, Jöns Jacob, 118
Biot, Jean-Baptiste, 111
Blanchard, Thomas, 19
Boardman, William W., 51
Bond, William Cranch, 116, 133
Boyé, Martin H., 152–163
Brady, Mathew, 50, 65, 68–70, 106, 107, 158, 163
Breese, Samuel, 34, 47

Brewster, David, 110, 111
Broadbent, Samuel, 50, 158
Bromine, 148

Camera obscura, 19, 20, 23, 77, 115
Chemistry, 3, 11, 18, 19, 32, 35, 103, 109, 112–114, 118, 119, 131, 136–139, 142, 145, 148, 152, 154, 158–163
Chilton, James, 139, 160, 163
Coffin, Isaac, 51, 52
Cole, Thomas, 61
Colors, 121–123, 128
Commercialization, 46–51, 139, 158
Composition, 128–130
Copies and reproductions, 70–78
Corduan, Perkins & Company, 31
Cornelius, Robert, 13, 17, 58, 59, 103, 114, 115, 139, 142, 147–159
Crystal Palace Exhibition, 2, 61, 64, 133, 160, 168

Daguerre, Louis-Jacques-Mandé, 16, 19, 22–27, 36, 59, 60, 102, 109–111, 118
Daguerreian Miniature Gallery, 106
Davies, Humphrey, 19
Day, Jeremiah, 18
Day, William, 139
Democratization, 2, 5–8, 11

Developing box, 30, 137, 138, 144, 148
Diffraction spectrum, 122, 124, 127, 147
Diorama, 22, 162
Donné, Alfred, 111, 132
Draper, John William, 12, 16, 32–36, 114–133, 139
Drawing, 3, 15, 26–28, 36, 57, 58, 62, 70, 71, 77, 78, 110, 111, 128, 130, 136, 148, 161, 163

Edwards, Anthony, 163
Electricity, 10, 15, 17, 23, 51–54, 63, 121, 135, 145, 163
Elliott, Charles Loring, 64–68, 101
Engraving, 70, 143, 161–163
Exhibitions, 12, 13, 29, 160

Fear of technology, 62, 63
Fitz, Henry, Jr., 13, 17, 114, 139, 140, 147
Fizeau, Hippolyte, 111, 124
Foucault, Léon, 124
Franklin, Benjamin, 112
Franklin Institute, 130, 131, 142, 161, 164
Fraunhofer, Joseph von, 121, 123
Frelinghuysen, Theodore, 34

Galvanism, 161
Geology, 113
Giroux, Alphonse, 36
Gobrecht, Christian, 143
Goddard, Paul Beck, 17, 103, 114, 115, 139, 148
Goode, W. H., 131
Gouraud, François, 36, 102
Granite Building, 100–102, 139, 162
Gurney, Jeremiah, 158, 163

Hare, Robert, 35, 114, 117, 148
Harrison, Gabriel, 65
Harvey, George, 161, 162
Heliography, 161
Heliostat, 116
Henry, Joseph, 54, 113

Herschel, Friedrich William, 127
Herschel, John, 110, 111, 118, 121, 122
Humboldt, Alexander von, 116
Humphrey, Samuel Dwight, 2
Hunt, Robert, 110, 111
Huntington, Daniel, 101
Hybridization, 54, 55
Hyposulfate of soda, 2

Individualism, 137
Industrialization, 18, 160, 167
Ingham, Charles, 54
Interference spectrum, 122

Johnson, John, 102, 139, 140, 158

Langenheim Brothers, 158, 162, 164
Latent image fading, 121
Lenses, 13, 17, 31, 116, 140, 142, 147
Lincoln, Abraham, 135
Lithography, 57, 63
Lunar daguerreotypes, 116, 117
Lyceum of Natural History, 112, 116

Magnetism, 7, 11, 15, 23, 51–54, 109, 135
Mapes, James J., 139, 142
Mason, William, 17
Mayr, Christian, 161
McAllister, John, Jr., 17, 142, 147, 148, 160
Mechanical reproduction, 18–20
Mechanics, 1, 3, 10, 12, 17–22, 29, 31, 49–54, 60–64, 71, 77, 78, 84, 94, 95, 100, 103, 106, 112, 135–139, 143–145, 150, 158, 164–167
Medicine, 4, 16, 112–114, 132, 150
Mercury, 2, 144
Metallurgy, 2, 12, 17, 142, 145, 148, 154, 158, 161
Microscopic photography, 131–133
Mineralogy, 112
Miniature painting, 58
Mirror, 17, 31, 102, 107, 116, 128, 142, 148

Morse, Samuel F. B., 1, 10, 11, 15–55, 58–65, 70, 82, 88, 95, 96, 100, 103, 107, 110, 114, 115, 118, 119, 128–131, 135–139, 148, 160, 162
Morse, Sidney, 34, 49
Mount, William Sidney, 5

National Academy of Design, 15, 20, 26, 27, 44–46, 53, 54, 59, 61, 64, 103, 161
Nelson, Reuben, 47–49
Networks and collaborations, 16–17, 29, 31–46, 50, 137–148, 168
Niépce, Isidore, 109
Non-achromatic lens, 118, 122

Optics, 17, 23, 46, 52, 59, 109, 111, 116–121, 127, 138, 139, 142, 148, 160
O'Reilly, Henry, 53

Panorama, 162
Parker, Joseph E., 161
Peale, Charles Willson, 52, 53, 112
Photogenic drawing, 26, 27, 110, 111
Plumbe, John, 106, 158, 162, 163
Prime, Samuel Irenaeus, 61
Print culture, 57–107
Printmaking, 63, 68–70, 88
Prints after paintings, 35–38
Professionalization, 61, 94–96, 133, 137, 161, 162, 165
Prosch, George W., 29–30

Richards, Frederick De Bourg, 158
Root, Marcus Aurelius, 7, 127, 158, 163

Sartain, John, 106
Saxton, Joseph, 13, 17, 114, 115, 122, 142–147
Sciences of light, 2, 3, 16–19, 34, 46, 49, 60–65, 109–116, 119, 127, 128, 131, 132, 142, 145, 167
Scientific community, 130–132
Scovill, J. M. L., 30

Scovill Manufacturing Company, 30
Sculpture, 3, 19, 29, 36, 58, 70–76, 82, 95, 102, 128–130
Seager, D. W., 161
Silliman, Benjamin, 18, 19, 110, 131, 132
Simmons, Montgomery P., 158
Smith, Francis O. J., 51, 53
Snelling, Henry Hunt, 2
Solar microscope, 131
Southworth and Hawes, 74–81, 86–89, 96–100
Spectra daguerreotypes, 121–128
Stereoscope, 131
Studios, 7, 12, 16–18, 23, 31, 32–36, 46, 47–52, 57, 63, 65, 90, 95, 96, 100–107, 140, 142, 145, 148, 150, 152, 154, 158, 160, 162, 168

Talbot, William Henry Fox, 16, 26, 27, 36, 110, 111
Technological progress, 2, 12, 15, 17, 32, 34
Telegraphy, 8, 10, 15, 17–30, 36, 51–56, 63, 124, 135
Tithonicity, 121–122
Trompe l'oeil technique, 40–42

Ultraviolet rays, 127

Vail, Alfred, 29, 36, 46–51, 54
Vail, George, 30
Van Loan, Samuel, 139, 158, 164
Van Loan & Mayall, 164

Wedgwood, Thomas, 19
Whipple, John Adams, 12, 116, 133
Whitney, Eli, 18
Wolcott, Alexander S., 12–13, 16, 17, 31, 32, 102, 114, 139, 140, 148, 161
Wollaston, W. H., 121

Young, N. V., 51
Young, Thomas, 114